Rock Art and Ruins
For Beginners and Old Guys

Rock Art and Ruins
For Beginners and Old Guys

Albert B. Scholl, Jr.

Rainbow
Publishing

Published by Rainbow Publishing

6832 N. Spring Wagon Dr. Tucson, AZ 85743

All photographs by Albert B. Scholl, Jr. Copyright ©2001.

Cover photograph: *Land Hill, Utah,* ©2001 by Albert B. Scholl, Jr.

Cover design by Rainbow Publishing

Publisher's Cataloging-in-Publication

Scholl, Albert B.
 Rock art and ruins for beginners and old guys /
Albert B. Scholl, Jr. -- 1st ed.
 p. cm.
 Includes bibliographical references and index.
 LCCN: 00-110965
 ISBN: 0-9704688-0-6

 1. Indian art--West (U.S.)--Guidebooks. 2. Indians of North America--Antiquities. 3. Paleo-Indians--West (U.S.) 4. Rock paintings--West (U.S.)--Guidebooks. 5. Petroglyphs--West (U.S.)--Guidebooks. I. Title.

E78.W5S36 2001 709.01'13'0978

WARNING

Driving, camping, hiking and cooking all involve some risk. This book was written to inform, educate and entertain readers concerning the subject matter outlined herein. We have tried to be as accurate as possible in the information presented but we cannot guarantee its accuracy. There may be mistakes in content, and or, typographical errors. This book is a guide and should be used in conjunction with other information, maps, books and operational instructions for cooking devices. We don't represent that hiking, camping, or using cooking devices for other than their intended purposes are safe.

The author and publisher of this book will not be responsible or liable for any loss, damage or injury caused directly or indirectly from information contained or not contained in this book.

If you do not agree to be bound by the above, you may return this book to the publisher for a full refund.

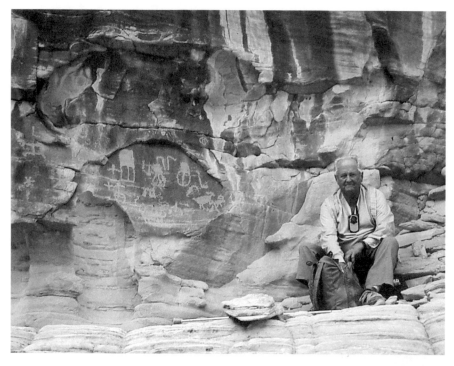

*To
Kirk Neilson
and his dog,
Babe*

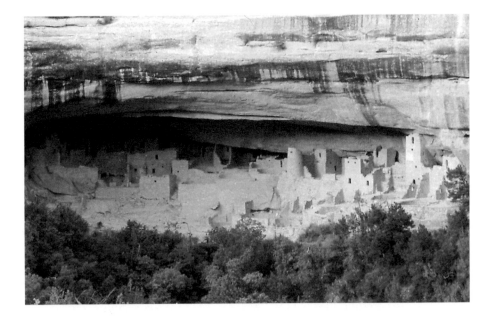

White Settlers Bring Architectural Advances to the Indians

Contents

List of Maps

Foreword

Lots of us in the Southwest have "been there, seen that" but Al Scholl has been there more often and seen everything more completely than most of us. Best of all, he is willing to share what he knows! This book is an absolute "must" for those who wander out into the hinterlands in search of rock art and archaeological sites at every opportunity, usually bearing directions hurriedly scribbled on the back of our checkbooks.

Written by an experienced traveler and explorer, this book shows a real understanding of the folks who live in these somewhat "out-of-the-way" places and their circumstances, as well as those who lived here in the prehistoric past.

Most valuable are the many tips and pointers often left out of other guidebooks....what to do if you've lost your compass...how to predict the weather if you don't have a radio. (Chapter 9)....what roads you should avoid. Al says there is a real reason why nobody seems to use that obvious shortcut to Mexican Hat, Utah. It's so steep, you may need a "parachute."

There are other observations. He says as you walk down the trail in Mesa Verde, Colorado, you will be "overwhelmed" by the fragrance of pine trees and "not much has changed from the way it was 1,000 years ago."

We have sometimes spent three days on the phone trying to obtain information that is readily available in this book. We are looking forward to returning to some of the spots we have already visited, knowing now the best way to get there, where to stay, and how to have a hot meal ready when we're famished.

Many veteran rock-art admirers will discover places they didn't even know existed, in the pages of this book. Those who use this guide for a first-time adventure in the Southwest are going to have a much easier time of it than we who struggled in the "pre-Al Scholl era." And those who are traveling with teens will appreciate Al's tongue-in-cheek philosophy on the disappearance of certain Anasazi populations. Enjoy!

PAT MELLOR

President of the Southwest Indian Museum and
Past Chapter President of the Utah Statewide Archaeological Society.

Acknowledgements

Thank you to all the people who knowingly or unknowingly helped me with this book. Most of you helped me unknowingly, as I didn't know myself that I would write it until this year.

A special thanks to my wife, Annette, who supported me all along the way, did an excellent job of "holding down the fort" and encouraged me to write this book.

Also, a special thanks to friends and publishers, Frank Heeg and Ginny Iadicicco, who made the book possible. It never would have been started or finished without them.

I also want to thank the following medical and fitness people for keeping us going. Doctors: Mike Anderson, Kent Jones and staff, Phil McMahill, Terry Montague, Scott Parry, Bob Rignell and Richard Wintch. Also, Jay Cooper (author of The Body Code), David Corbett, Karen Lessman Hughes and Dean Schmidt.

This is a thank you to all my hiking friends who have taken me to sites and taught me about rock art and ruins. Mary Allen, Bart Anderson, George Atwood, Ray and Suzanne Barnes, John Bettfreund, Craig and Nina Bowen, Ruth Bracy, Mike and Kathy Bruhn, Gary and Janet Burningham, Vern and Jane Bush (author of If Rocks Could Talk), Bryan Cady, Tom and Shirley Cady, Charlie and Clari Clapp, Shirley and Amy Craig, Vera Currie, Dell Crandall, Harold Crawley, Gerry Dean, Jim Duffield (co-author of Kokopelli), Dave and Merle Ferguson, Randy Fulbright, Connie and Gail Fulde, Sharon Graf, Diana Christiansen Hawks, John Herron, Jack and Elaine Holmes, Clay Johnson, Bette Jolley, Lee Jones, Reed and Norma Lance, Chris Larsen, Ron Lee, John and Dorothy Jones Lynn, John and Marilyn Macumber, Ekkehart Malotki, Steve Manning, Geralyn McEwen, Mike McGrew, Roger and Leslie McPeek, Rod and Pat Mellor, Inga Nagel, Ken and Elva Ogden, Jim Olive, Mike Owen, Clifford Rayl, Marilyn Schaugaard, Amy Schilling, Merle and Mary Shorey, Wendy Smith, Dick and Lorna Snell, Jim Starr, Neal Stephens, Glen and Margaret Stone, Larry and Astrid Todd, Don and Jeanne Tucker, Paul Weaver, Nancy Weir and Harold Widdison.

Also thanks to the following people for their help, advice and friendship: Lisa Abrahamson, Scott Awerkamp, Mike Bellows, Blake Budge, Ed Bumpus, Jim and Ramona Cox, Marilyn Davis, Bill and

Erica Eschmann, Mary Estes, Darryl and Jeanne Foreman, Dean and Patti Freed, George Graff, Curtis and Travis Graff, Jim Heldman, Bill and Joan Houghton, Warren Isadork, Marie Amoruso Jackson, Dwight Knapp, Ted Lacina, Bill Linas, Hayden and Betsy Mathews, Jon Meloan, John Morgridge, Mike Moore, Robin Morton, Nate Norris, Bill Patton, Bob Peckham, Rick and Kristy Pierce, D.J. Powers, Joe Roebuck, John Russell, Jim and Alaina Slemboski, Drew Sobek, Nick, Susan, Lindsay and Nicky Sutton, Dick Taylor, Frank and Janet Taylor, Dave Van Den Berg, Ken and Ollie Vick, Skip Yazel.

To my children, Schuyler, Albert and Eric. And my brothers, Peter, Tom and Tim.

To all my old squadron mates from the Hell Razors of Navy Fighter Squadron 174: Ace Acree, Bob Aumack, Lou Baldridge, Dee Butler, Bob Donaldson, John Ellis, Duke Embs (author of Committed), Bob Frech, Deacon Greenwood, Doug Maloney, Joe Moorer, Vic Pongetti, Will Ryals, Charlie Waring, Rip Wasson and Joe Wilfahrt.

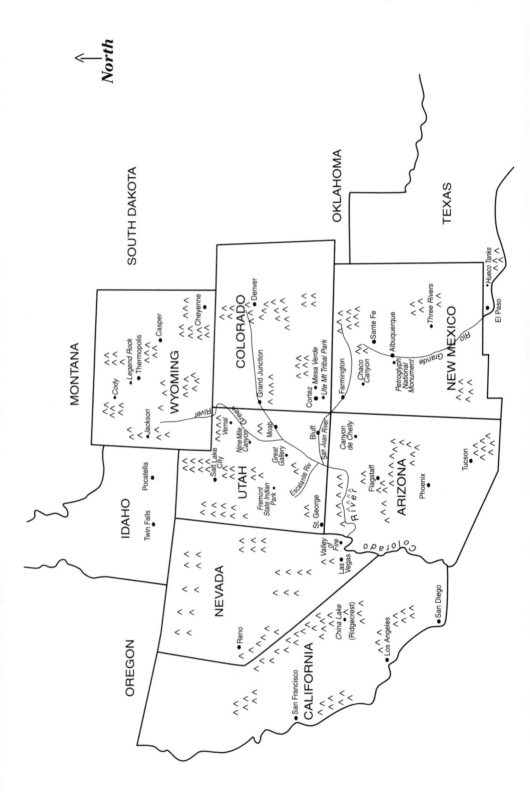

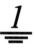

The Adventure Begins

Introduction

Everyone wants to stay healthy, live a little longer, have fun, see a few more things and continue to learn. This book will teach you not only a little bit about the prehistoric peoples who inhabited the West but also how to get to some of the major protected rock art sites and ruins and have fun doing it.

If you live in or visit the West, there is much to do and see in the outdoors plus great weather in which to do it. In this book you'll learn how to get in hiking shape and what equipment you require for your vehicle as well as camping and hiking. You'll learn how to cook on the road and where to stay.

You will see extremely beautiful scenery which you never knew existed and that few other people have seen in the last thousand years. You will see wildlife up close, such as coyotes, antelope, elk, deer, mountain sheep and rabbits galore. Snakes, tortoises, lizards and birds are always around, especially large eagles, hawks, ravens, vultures and

Deer in the Virgin River - Utah

an assortment of small birds. You will smell the sage in the morning and the aroma of pines and the cedars. When you eat, everything will taste better. You will also hear a lot of things if you have your hearing aids in.

You will see red walled canyons with snow-covered peaks in the background. There are buttes, arches, natural bridges, multicolored canyons, magnificent ruins and rock art panels of unbelievable artistry. There will be lakes, rivers, creeks, mountains, valleys and rock formations of every type and description. There will also be hundreds of wildflowers and flowering cactuses. The whole area is also dotted with National Parks and Monuments. You will be able to go rafting, travel on many of the old dirt roads put in by pioneers and miners and tour and hike in some of the same places you saw in the movies when you were young. You will meet neat people who will have some of the same interests as you and discover other people and groups who have the same fascination for prehistoric ruins and rock art.

You will find that the desert is much like the ocean as far as the feeling of serenity you get as you look out over its vast emptiness.

Prehistory

In the Southwest and West, there are thousands of archaeological sites that include rock art and ruins, many times both of them together. They range in dates from 8000 B.C. to around A.D.1300.

Everyone at some point has had their interest aroused to some degree, after reading, seeing pictures or watching a television program about the prehistoric people who left these magnificent dwellings and drawings on the rocks.

- Who were these people?
- How did they survive?
- Where did they go?
- What does the rock art mean?
- How did they do it?
- When did they do it?
- Why did they do it?

There are many questions that are still unanswered today even with all the advances we've had in technology. We will try to answer some of the above questions and give you a little more information on the subject. As you see more sites you will begin to appreciate the different styles of rock art and the beautiful surroundings where these prehistoric people lived. You will also wonder how they survived in some of these

harsh areas. Life was hard. Anyone would be proud to have these people as their ancestors. While they spent much of their time just obtaining food, clothing and shelter, they still loved, laughed, cried and had time for creating beautiful art. Their rock art seems to bring you closer to these prehistoric people.

Reason for the Book

This book is for all the people who live in the West, current residents as well as the new and retired people moving into the area who have an interest in prehistory. Most are active and live in the area because of the outdoor life and great weather the West offers. They like to exercise, eat well, look good and they bring a wealth of interests and knowledge with them.

At the present time, no one knows for sure what this rock art means. Much of it, like some early European art, doesn't seem to mean anything. Even the altar panels of the churches in Europe wouldn't mean much to us if we didn't have the Bible. With all the people coming to the Southwest bringing their own background, experience, expertise, and education in many fields of endeavor, it is hoped that with successful careers in many fields, some will have an interest in rock art. If they do, their help and expertise might contribute to our having a better understanding of what the rock art is telling us.

This book will help you get started and if your interest develops further you will find information about some of the things you will require to survive off the beaten track and to explore more remote areas. You won't have to rely on restaurants for all of your food or motels to sleep and you will be exposed to country and experiences you never dreamed of or had the time to enjoy prior to retirement. We will cover cooking, clothing, camping, hiking, companions, physical conditioning, photography, and prehistory among other things.

Getting Started is Easy

I first started walking and exercising to stay in shape for skiing. It gets pretty boring so I decided I needed to walk and at the same time, do something that was interesting. (Even the dogs got sick of the same old routes).

After a neighbor showed me my first petroglyph, I decided to try to look for more rock art when I went on my walks. Pretty soon, I only took walks in canyons and near rivers and there's not a rock that goes by that I don't give the once over. When you come around a bend or a

corner and see your first rock art site, it is absolutely incredible. You feel like you were the first one to see it in over 1,000 years, but you will probably find out that there are other people who know about the site.

Pretty soon, you find yourself walking several miles and you don't even feel tired. It won't be long before you find yourself going further afield and staying overnight as you find that every site is different, the country is different and you're having more fun all of the time.

Special Considerations

Rock art sites, ruins and other archaeological sites are sacred to the present day Native Americans and should be treated with respect. Treat them as you would your own church. Look around and enjoy the surrounding areas, the rock art and the ruins. All of these places are not like the large cliff dwellings you see mostly in the books. Sometimes they are just small hunting locations near a spring or a stream.

Some of these sites immediately tell you that they were religious in nature. Many other sites give you a happy feeling. They are in beautiful areas with streams and springs where you know wildlife was plentiful. There are trees and bushes to give shade and many times you find pottery shards (broken pieces of pottery) and lithics (stone tools and projectile points or the stone flakes and debris left from making them). There might be caves or rock shelters or the sites just sit out in the open where pithouses used to be, overlooking a canyon or a wash.

A few sites definitely give you an eerie feeling either through the rock art or its location.

When you're visiting these places, site etiquette is very important for the preservation of the ruins and the rock art. Most etiquette is plain common sense but please read the site and rock art etiquette sections in the Appendix before starting your trips.

If after reading this chapter you want to get started on the hikes right away, be sure to read the chapters on Day Hiking and Conditioning before you go. There is always a risk in hiking. Be sure to use common sense, good judgement and especially be sure you're physically capable of making the hike.

As you get more interested you can come back and read a little more about the people, the rock art and the ruins. You'll also probably want to start checking out some of the excellent books in the Bibliography that will give you a lot of additional information that is not contained in this book.

Rock Art

Rock art is a term used to cover all types of markings made on rock or stone, usually by prehistoric people. There are basically two different methods used to put the markings or designs on rock.

Petroglyphs

Petroglyphs are figures, drawings, symbols or pictures on rocks made by pecking, abrading or carving. In some cases they appear to be scratched. On quite a few petroglyph panels, you will see more than one method used which might or might not have been done by the same people or at the same time.

Most of the rock art in the West and Southwest are petroglyphs and they are predominantly of the pecked method which was accomplished by using a sharp stone, somewhat as a chisel and hitting it with another stone used like a hammer to make the designs.

Because of the different hardness of rocks, the results could be very different. Even the same person, using exactly the same method would end up with very different results, depending on whether he was working on soft sandstone or hard volcanic basalt. While there is a definite difference in the quality of petroglyphs because of the ability of the artist, there is also a difference because of the type of rock being used. On the beautiful, patinated, soft red sandstone in much of the Four Corners Area, the artist could obtain some beautiful results.

Many people refer to petroglyphs as just plain "glyphs."

Pictographs

Pictographs are figures, symbols, drawings or pictures on rock made by applying paint to the rock. In the Southwest, where the majority of great pictographs are found, the predominant colors are red and white. Many of the best pictographs combine several colors and are referred to as polychrome pictographs or paintings. To get these colors, they mixed both mineral and vegetable pigments and to make it into paint they used liquid such as animal fats, blood and oils from vegetables. To do the paintings, they used a number of methods of applying the paint to the rocks. They used their fingers (you can even see their fingerprints left in the paint where they put dots on a panel). They also probably used

sharp sticks (like the old dip in the inkwell pens that we had in grade school), and strips of yucca plant that they chewed to make a very fine fiber brush. They could vary the widths of these brushes and actually come up with very fine quality painting instruments. At many of the sites, you will see where they mixed the paints in small holes of adjoining rocks.

A Third Method

A third method not seen too often is a combination of a petroglyph and a pictograph where after a drawing has been pecked into the rock it is then painted to one degree or another.

Why Rocks?

You might ask why they used rocks to put their drawings on. It is no more complicated than the fact that rocks and stones were in abundant supply, especially in the West and Southwest and they probably knew of no other material that they could use to permanently preserve their drawings.

The placing of some of these rock art panels at the mouths of canyons along the trails and trading routes indicate that they might have been intended for long term use much like we see signs today that impart directions and information along our own highways.

This is very obvious with many of the panels that have interaction at solstices or equinoxes. That is where certain symbols, usually

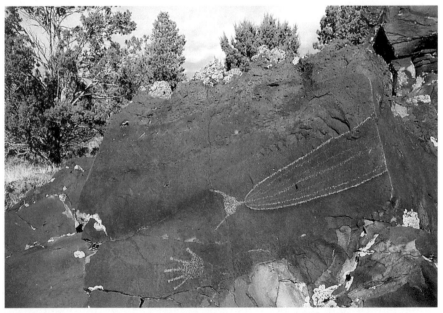

Rock Incorporation - A figure that uses natural parts of a rock in its design

petroglyphs have been put on a rock so at certain times of the year, usually at or near equinoxes or solstices, there are shadows or darts of light that hit the symbols. This in effect creates a crude calendar and in some cases, the interaction occurs exactly on the day that the planting of crops should commence for that particular area and altitude.

Everyone is interested in art to some degree. When you see some of the pictographs done by the Archaic people, thousands of years ago, you can only look in awe. Some of the pictographs such as the Barrier Canyon style, could only have been done by artists of great abilities that are probably on a par with any artist whoever lived, especially considering the culture and the availability of materials during that period. You can only wonder what they looked like when first painted rather than after centuries of weathering by the elements.

As with all art, there were the great artists and the lesser artists, the apprentices and the total amateurs. All of this is evident in prehistoric rock art from the great pictographs to the scratches on stone that look like child's work. (And it might have been child's work). Some of the rock art is human size or larger, such as the magnificent pictographs at the Great Gallery. Others are beautifully done in miniature like the rock art in Little Wild Horse Canyon and Prickly Pear. You can also have both types within yards of each other.

When you first see the Barrier Canyon style pictographs, you are somewhat reminded of the elongated bodies and layered painting technique done by El Greco, one of the first painters of the Spanish school. Born in Crete, he first studied religious painting in Italy in the 1560's and went to Spain in 1577. Some say his eyesight was bad and this is the distorted way he saw things. It makes you wonder about the eyesight of some of the older artists or shamans who did this early rock art. Some of the rock art even reminds you of an eerie Charles Addams cartoon in the old New Yorker magazines.

In Japan, there are several Buddha figures that also give you the same feeling you get from gazing at Barrier Canyon anthropomorphs. (a human form or figure found in rock art sometimes stylized. It could also portray a humanlike figure to non-human things such as spirits or gods.) Though their eyes are closed, the bronze great Buddha at Kamakura, who is in a sitting position, and the wooden standing medicine Buddha from the 9th century in Kyoto, both inspire the same spiritual response that you get from the panels of the Barrier Canyon rock art.

Other comparisons can be made in historic figures such as the Yeis on Navajo rugs, and many of the Kachina figures of the Hopi. Especially

interesting to me was seeing a Kiowa woman at a Pow Wow in Arizona in a long colorful robe that hung to the ground. It immediately brought to mind the Barrier Canyon decorated pictographs that have no hands and feet.

There probably was a need of art in these early cultures as there is in almost all cultures. They needed to express themselves as well as tell stories and give directions among other things.

It seems the people would have done the best work when they settled in more permanent living arrangements and began to cultivate crops. They weren't traveling around like the earlier hunter/gatherers and would probably have had more time to work on the rock art. But in many cases, the older rock art, done by the archaic people is better, more beautiful and more decorative than the later rock art.

Even though the archaic people were supposedly hunter/gatherers, spending most of their time hunting for food and game, they might have been more sedentary in certain areas of the Southwest. They might have had more time to work on the beautiful examples of rock art, especially the Barrier Canyon style that we see today.

The later people, who did settle in one place, would have had more time to spend on rock art, however, this is the time when they were building more impressive structures and it is possible that the talents of the best artists were used for architecture instead of rock art.

Another theory is women may have done some of the best rock art during periods when the men were out hunting. This could also make a lot of sense in that many of the women were also picked to be shamans.

Rock Art Content, Style and Age

All three of these things are intertwined and each affected by the other to some degree. Even in the same area, the content and style of rock art changed from the earlier periods, i.e. Archaic to the later periods. Also, the natural differences between content and style is evident from the differences in geography, climate, vegetation, animals and most probably social structure and religion.

Even though there is much evidence of trading, most of the prehistoric people had no way to see all the different rock art that we can see today. They didn't have the luxury of comparing and putting these drawings in perspective. Today, we can travel four hundred miles in eight to ten hours and see many of the rock art sites that they wouldn't see in a lifetime. Even in Europe it wasn't too long ago that people with different languages and dialects lived just fifty miles apart.

It's reasonable to assume that the content of much of the earlier rock art is probably religious in nature. Most art, either painting, sculpture or architecture originally reflected images of the particular religion of that culture. This is very apparent in Greece, China, Japan, Egypt, and Italy and also in isolated parts of the world such as Easter Island.

Much of the earlier rock art seems to reflect sources of survival and particularly food, i.e., rock art panels of animals in that area. These animals not only provided food, but clothing, tools, medicine and might have also been part of their religion.

Tied into all this you get a feeling that much of the rock art might have been done because of the fear of the unknown. They lacked an understanding of the scientific forces of nature. This could also be a basis of shamanism and a type of religion that would include the worship of nature, fertility, and the spirits of their ancestors among other things.

Shamans

It's interesting that the name shaman comes from the Tungus language of Siberia where along with the Mongols and other tribes, shamanism is practiced today. This would tie into the land bridge theory where the first Americans came to North America from Siberia about 12,000 B.C. This is covered further in the next chapter.

Today the name shaman is used by many to mean medicine man or healer but in prehistoric times, they probably did much more. As the spiritual leader of his tribe, he probably used two main methods in order to help his people solve problems and predict the future. One method was to have the spirits take possession and control of his body and the other was for his spirit to leave his body and get the answers from a higher plane. The different spirits he contacted taught him several things which included predicting the weather, i.e., rain, storms and lightening; where to hunt game; whereabouts of their enemies; protection, blessings and even relationships within the tribe, plus the healing of sicknesses or illnesses.

The shamans accomplished the spiritual communication by entering a trance using various methods such as chanting, drumming, dancing, fasting, hallucinogens and isolation.

Most tribes had different or slightly different religions but they all seemed to believe that life should be lived in balance with nature and the world. In addition to healing illnesses, the shaman used his power with the spirits to restore that balance after catastrophes and tragedies.

The prehistoric people and even Native Americans today, believed in a form of Pantheism where the Creator is a part of everything and that even trees and rocks have spirits residing in them. They believe a shaman as well as themselves can merge with these spirits which can be in the rocks, animals, ancestors or anything. As an example, by merging their spirit or soul with an eagle, they would be able to fly. They might have pecked sheep on the rock to attract them and encourage a good hunt.

In the eastern United States, you can find carvings on trees. In the West, where rocks were plentiful, you would of course find carvings and paintings on the rocks. In prehistoric times, religion, shamanism, rocks and spirits all seemed to be linked together. They might have used the spirits of the rocks as a method of communicating with the spirits of the pictures that they put on the rocks. They also might have used these pictures, or rock art, as a method of communicating with each other. This could have been a major factor for the abundance of rock art in the West and Southwest.

As time went by, the content didn't seem to vary too much, but different styles of rock art appeared. Some of this could have been from the ability of the artist (or lack of ability) but probably some if it occurred from influences from the contact with other cultures. The rock art varied from natural looking animals and human forms to more original forms. While there were different interpretations of the same subjects, all are beautiful in their own right. Many of the masks used in ceremonies seemed to reflect an individual need to be different as well as contain their impression of what they were trying to represent, i.e., a certain animal, a god, etc.

As time progressed, some of the rock art became more secular and you can even see a sense of humor in some of the panels, as well as people hunting and farming. This is almost like some of the art in Europe after the time of the reformation in the 16th century. At that time, the people were trying to reform the Roman Catholic Church and establish their own Protestant religion. Much of the Italian and Spanish religious art was despised in certain circles for its rhetorical or showy quality. More and more northern European paintings showed more realistic, everyday scenes with people at work and play.

The rock art in the West and Southwest contains thousands of different symbols. Some are easily recognized as human forms and/or shamans, animals, vegetables, weapons, birds, masks, hand and foot prints, reptiles and on and on. Others are completely baffling as to what they represent.

They could be figures from dreams, spirit visions, maps or just about anything.

Dating

Scientific dating of rock art is getting closer and closer. But for the present, the age can be roughly determined or speculated on by the age of the dwellings, which are nearby, the style of the rock art, and whether some rock art is superimposed over other rock art. The presence of baskets and no pottery indicates an older site. Finding certain types of projectile points, like Clovis or Folsom points, etc, might indicate the rock art was done at that time, but is no guarantee.

Without getting into a lot of detail, there are now five or six dating technologies that will help pinpoint the age of both petroglyphs and pictographs. One of the major problems is getting enough of a sample to accomplish the dating without damaging the rock art.

What Do They Mean?

Everyone wants to know what the rock art means, but nobody knows for sure. We cannot bring understanding to this art with the baggage we bring from today's world with our education, European ancestry, government and many other influences. The prehistoric people lived in a totally different world from us. Their culture was entirely different from ours. Especially different were their interests, training, physical skills, tastes, art and social structure. They were mainly taken up with the basics of life, which were acquiring food, clothing and shelter.

Even some paintings you see today mean absolutely nothing to the viewer, other than they can be a pleasant (or unpleasant) relationship of forms and colors.

Rock art is found all over the world and some of it is very similar even though there was no way the people could have communicated with each other from these different continents.

The oldest reliably dated rock art are the cave paintings of Chouvet, France. They are 32,000 years old. Just recently, they discovered down under in Australia, petroglyphs that could be 75,000 years old but are at least 50,000 years old. This opens up a bunch of questions concerning the theory that Homo sapiens originated in Africa 100,000 years ago. If he did, how did he cross the oceans at that time? Some of the Australians like to hear about our rock art up over in the United States.

As no one knows for sure what any of the rock art actually means, it is fun to speculate. When you see a mountain sheep on a rock art panel, it could be symbolic of a god, indicate a hunting area, or been pecked

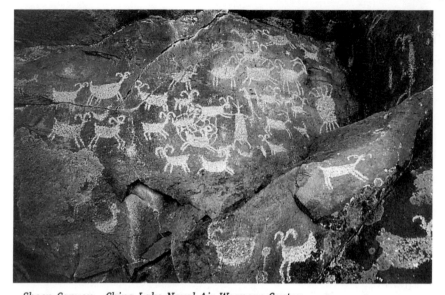

Sheep Canyon - China Lake Naval Air Weapons Center

on the rock to attract the sheep to the area. It also could have been put there before a hunt for good luck or put there after the hunt as appeasement to the spirit of the dead sheep. Many of these could have been put there during ceremonies. There are all kinds of theories.

Ethno -

The following are areas of anthropology that might help us understand more about rock art.

Ethnoarchaeology - is roughly the study of living people who use the same materials, tools, utensils and weapons as found in archaeological digs and excavations as a means of finding out more about those prehistoric people.

Ethnology - is one of the four main branches of anthropology and is the study of the culture of a particular group of people. It includes their thinking, behavior, and relationships and is more theoretical than ethnography.

Ethnography - is more of a descriptive and observational branch of ethnology. Ethnographies are books, articles, papers or notes that describe cultures and their environment. They cover all aspects of their life, including but not limited to art, customs, geography, food, shelter, clothing, religion and products.

All of this might sound a little confusing, especially when you find that ethnology and ethnography are sometimes used interchangeably. All three of these fall generally under cultural anthropology. We are primarily interested in the study of primitive people living today as their

ancestors did, and the records, written or oral, of anyone who were members of or lived with and observed these tribes a hundred to two hundred years ago. These would be the tribes who lived primarily in the western United States before they were exposed to the Europeans.

Some symbols we find in prehistoric rock art are used today and might have been passed down thousands of years. They are used on teepees, sand paintings, dolls, kachinas, clothing and shields among other things.

It would be really nice to have someone discover an Anasazi family living today in some hidden canyon or valley, unexposed to any other people over the last few hundred years. Since this is very unlikely, the only primitive tribes like this today are found in South America, Africa and Australia. Some of the rock art in these other countries is similar to that found in the Southwest and more research in this area might be very helpful.

Even with good information, you have to be very careful. The exact same type of spirals put on rocks by two different people could have been put there for entirely different reasons, depending upon their location, environment, age and beliefs. In the same manner, many mountain sheep could have been put on the rocks by different people for entirely different reasons as outlined in the section above, "What Do They Mean?"

You can also have people that want to portray exactly the same thing on the rocks but end up with symbols looking quite different. For example, today, you might ask five different people to draw you a map to a rock art site and they probably will give you five sketches that are completely different. You wouldn't believe the differences you get in direction, terrain, distances and ways to get there.

You also have to be careful when reading ethnographic documents that were written a hundred to two hundred years ago, because the writer might have unintentionally injected some of his own ideas into the research. Any thinking person can't help but inject some ideas into their research. Also, at this time there were language barriers and lack of interpreters and some of this information was even obtained from the Indians by sign language

It is also very difficult for today's reader to interpret ethnographic documents that are one hundred to two hundred years old without being affected by his own education and the new knowledge discovered during the last fifty years.

Useful information about the past can be obtained from Native Americans today, but because of their exposure to our society, sometimes this information has to be filtered in order to get accurate data. Some Native Americans won't give you certain information because they just don't want you to know; others will give you information and you know they are just "pulling your leg."

One of the funniest things I can remember is a trip that Kirk arranged for a group of URARA (Utah Rock Art and Research Association) people. We had to be led by a Native American guide because it was on the reservation and Clifford Rayl was talking to him the whole time and explaining some of the prehistory of the area, the pottery shards, lithics and other things the guide obviously didn't know about. After the hike, the guide thanked Clifford and said it was great having this information. The guide said: "Thanks for all the info - I'm going to use this when I take the next group in here."

Rather than go deeply into the subject of interpretation, I recommend the following two books: *A Field Guide to Rock Art Symbols* by Alex Patterson is a great book and one I always carry on my trips. It covers interpretations by over a hundred rock art people who include Native Americans, archaeologists and anthropologists and covers over six hundred rock art symbols found in the West and Southwest. Another book is *The Rocks Begin to Speak* by LaVan Martineau, who died last year. He was part Indian and spoke several languages.

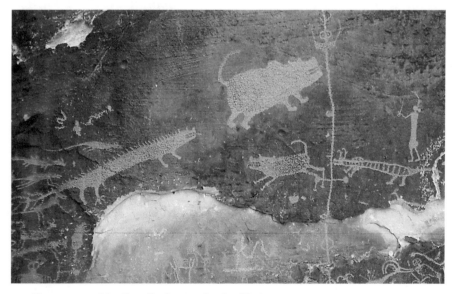

Homeowners Meeting, Rochester Creek - Utah

3

The First Americans

This chapter will give you a short snapshot of prehistory in the West up to approximately 1000 B.C. The next chapter will cover from 1000 B.C. to approximately A.D. 1300. Since most of the rock art and ruins in the U.S. are in the Southwest and West, this is the area that is covered.

New information is always being discovered and new methods being employed which changed the thinking of how our West was first inhabited.

Paleo-Indians (approximately 40,000+B.C. to 6500 B.C.)

This is the name assigned to the original settlers of the North American continent. Up until just a few years ago, the theory about how they came and when they arrived was pretty cut and dried. The old view and the view still held by many is that the first people who came to North America crossed a land bridge from Siberia to Alaska about 12,000 B.C. (That land bridge is now the Bering Strait - between Alaska and Siberia).

They were probably bands of big game hunters who then moved south during the glacial retreat and arrived and spread throughout North America between 10,000 and 9,000 B.C. The Clovis were thought to be the first people, or culture, in North America, and were named after an archaeological site called Black Water Draw which was excavated near Clovis, New Mexico in 1934. The beautiful and fluted projectile points called Clovis Points were uncovered many feet below the surface among many bones of the woolly mammoths. Carbon 14 dating from the charcoal at the campfire at the same depth dates approximately to 9,300 B.C. Petroglyphs have been found in southwest Utah that resemble these mammoths. The Clovis Points were used on spears, sometimes called darts that were used with an atlatl or throwing stick. Later came another projectile point called the Folsom Point which was somewhat smaller, and used primarily for bison.

Recent discoveries in Chile indicate, through charcoal dating, that a site might have been occupied between 13,500 B.C. to 12,000 B.C. Another site on Santa Rosa Island, off of California, contained the human

bones of a woman that were dated 11,000 B.C. This means people were here earlier than originally thought and challenges the Clovis Theory.

Now, it is believed by some, that the reason nothing older has been found is that many of these people came by crude boats along the coastline, living by fishing and harvesting abalone. Or, they came across the land bridge, and then stayed along the coast. Now, much of that coastline is under water as the sea rose about 300 feet with the melting of the glaciers. Very little underwater archaeology has taken place in North America at this time, but as it develops, additional discoveries could change a lot of the current thinking.

Another theory believes that the first North American people arrived about 16,000 B.C. by boat across the Atlantic from what are now southwest France, Spain and Portugal. They then spread over much of the country from the East Coast and by 10,000 B.C. arrived in New Mexico and in the southwest United States. The projectile points found in Solutrea, France are exactly like the famous Clovis Points first found in New Mexico, and later found in the eastern United States.

With all the modern, scientific and technical capabilities available today, i.e. DNA, etc. we will probably be seeing many more discoveries, as archaeologists keep an eye on all the new developments and theories.

Archaic Period (approximately 6500 B.C. to 1000 B.C.)

The Archaic period is a term used today to describe a cultural period with certain differences and characteristics from the Paleo -Indian period and the more settled cultures which were to follow. The Paleo period seemed to end with the decline of big game, like the mammoth. This was probably due more to the warming weather patterns, rather than over hunting. The Archaic period happened at different times in different parts of the country. As the warmer and dryer period developed, commencing about 6500 B.C., the new climate definitely affected the plant life and animals which brought about the beginning of the Archaic culture.

The Archaic people traveled in small bands along the waterways of the West and relied on collecting plants, berries, seeds, nuts and roots. There is also evidence of them storing this food. They also hunted small game such as rabbits, birds, deer and mountain sheep. They moved from area to area with the seasons and are also referred to as the hunter/ gatherers.

The large number of sites discovered seems to indicate a growth in population. Trading must have been present because at certain

archaeological sites, archaeologists have found projectile points and tools made from stones that came from another part of the West. They couldn't possibly have come from the site area. The projectile points scrapers and knives and other tools were not quite as well made or beautiful as the Clovis and Folsom points.

They learned to build crude shelters called pithouses and used caves and rock shelters for protection from the elements. The Archaic way of life seemed to keep the people very healthy and their nomadic wandering in small bands kept them from diseases that flourished in more concentrated societies. Later on, there's evidence of much trading and, because of these shelters and the dry climate, we are able to find well-preserved atlatls, snares, and nets, along with wood and bone artifacts and baskets.

The Barrier Canyon style pictographs from the Archaic Culture are probably the most beautiful ever done on rock. You will see examples of these in the color sections and the chapter on The Great Gallery.

About 6,000 years ago, corn was discovered. This corn was not like the corn we have today, but resembled a wild form of natural grass. It was first planted in Central America and probably moved to the southwest United States about 1500 B.C. Corn, to America, was like wheat was to the Europeans and rice to the Asians. The first manos and metates dating way back to the Archaic times were found in Arizona in 1926. These are stone implements used mostly for grinding corn. The metate is a flat stone with an indentation and the mano can either be a one handed or a two handed grinding stone.

Toward the end of the Archaic period, as the population grew, the people began to live in more permanent settlements where they could raise corn, beans and squash to feed their people. This led to the cultures described in the next chapter.

Atatl (at lat al)

The atlatl came from the Aztec word for throwing stick or spear throwing device. It was used all over the world and preceded the bow and arrow by at least 20,000 years, probably longer. It was usually about 2 feet long, had a handle at one end, and a hook or socket on the other end. If the atlatl had a hook, the spear or dart would have an indentation at the end of the dart to fit into this hook. If it had a socket or a large groove in the atlatl, the end of the dart would fit into that socket.

The atlatl and dart were held in one hand and then it was thrown overhand retaining the atlatl which sometimes had leather finger holes

around the handle to make it easier to retain. The effect was to increase the velocity of the dart or spear tremendously as well as the distance it could be thrown. Some say the velocity was increased one hundred times more than throwing a spear by hand.

Atlatls are still used today by Eskimos and some of the Aborigines in Australia.

4

The Later Cultures

The following cultures, like the Paleo-Indian and Archaic, were assigned these names by archaeologists for various reasons. They needed to be distinguished from each other because of certain cultural differences that have been discovered over the last 100 years or so. On the fringes of these cultures there seems to be a blend of some or all of these cultural differences. Some of the differences might be just because of the altitude, the rainfall or proximity to rivers and springs. It is not uncommon, in the Southwest, and West, to gain or lose several thousand feet in the matter of 20 or 30 miles. We will concentrate mostly in the Southwest where a majority of the rock art and ruins are.

Anasazi (approximately 1500 B.C. to A.D. 1350)

The Anasazi are the best known and most extensive culture in the prehistoric Southwest covering an area roughly the size of New York and the New England States combined. They have become very popular in the Southwest because of the mystery surrounding their "disappearance" on or around 1300 A.D. They lived mostly along the San Juan River in the Four Corners area where Utah, Colorado, New Mexico and Arizona meet. But there is evidence of them as far west as Nevada, along the Virgin and Colorado Rivers. The name Anasazi is derived from the Navajo language and means "Ancient Enemies." Today, people sometimes refer to them as Puebloan Ancestors or Ancestral Puebloans. The Hopi, who many people think are the direct descendants of Anasazi, call them Hisatsinom or "ancient people." We will use the word Anasazi to avoid confusion because it has been in use for over a half a century.

This is a little like what's happening at the present time with the name "Pilgrim" in the East. A few Easterners are beginning to refer to the first people who came to our shores from England as "Ancestral Villager Anglo-Saxon Caucasian Aquatic Wanderers." We don't know whether this is because of the rather unflattering use of the name "Pilgrim" by John Wayne in his movies, or if a few Easterners are against the use of the name "Pilgrim" because it is what the English called them. Either way, it hasn't yet caught on with the majority of Americans.

The Anasazi evolved from the Archaic Culture and have been divided by archaeologists into the approximate periods listed below.

These dates have changed some since the original periods were set up at the Pecos, New Mexico Conference in 1927 as more is learned from excavations and new dating techniques. So these dates are fluid and will probably change more rapidly and accurately with all the new scientific advances we've had in the last few years and will have in the future.

Basketmaker II (1500 B.C. - A.D. 500)
Basketmaker III (A.D. 500 - A.D. 750)
Pueblo I (A.D. 750 - A.D. 900)
Pueblo II (A.D. 900 - A.D. 1150)
Pueblo III (A.D. 1150 - A.D. 1350)
Pueblo IV (A.D. 1350 - A.D. 1600)

There is no Basketmaker I since that now comes under the late Archaic period. Many of my friends like to refer to recent graffiti and vandalism such as carved names at rock art sites as Basketmaker I.

The Basketmaker II Period saw the cultivation of corn and squash. This triggered a change from the primitive archaic hunters/gatherers to a relatively stationary semi-agrarian people. They used crude planting sticks and began to store their produce in small cisterns. They made beautiful, finely woven baskets (Today, they would be the Martha Stewarts of basket weaving), and used atlatls, spears and snares for the hunting of small game. They lived in crude and shallow pithouses as well as rock shelters and caves.

The real turning point in Anasazi development came about A.D. 500 at the start of the Basketmaker III period. In those years the Anasazi either invented their own pottery or more probably learned about it from the Mogollon to the South. They still made baskets but relied more and more on pottery for cooking and carrying water. Since they didn't need the finely woven baskets lined with clay for carrying water and cooking, the construction of the baskets became cruder and they were probably used only for collecting nuts and berries.

The bow and arrow made its appearance in this area for the first time and began to replace the atlatl as the main weapon for hunting. The construction of large kivas for conducting ceremonies also appeared about this time and shows the influence of the Mogollon to the south. They began to construct deeper pithouses and small villages started to appear.

The Basketmaker Period was first identified by the famous amateur archaeologist Richard Wetherill who discovered Mesa Verde. While excavating in Utah, he noted the differences in the well preserved artifacts in dry caves from the artifacts discovered at Mesa Verde, especially the lack of any pottery and the beautiful, finely woven baskets.

Beans were introduced about the same time. Corn, squash and beans were ideally suited to grow together because the squash leaves shaded the corn seedlings until they really got going and the beans used the stocks of the corn as a trellis to grow on.

During the Pueblo I Period, the first above ground block dwellings appeared with some masonry work and black on white pottery began to appear more frequently. Large structures like Pueblo Bonito in Chaco Canyon began to appear in the Pueblo II Period. They were called great houses and contained many large kivas (a kiva is usually a large, round structure that was used for religious ceremonies or meetings and thought to possibly house visiting tribal members from outlying areas) built underground. The stone masonry was especially excellent and there must have been some highly trained and intelligent architects working on these large projects. They built roads and trade was flourishing in turquoise and in black and white and polychrome pottery. (Polychrome pottery is decorated in several colors, mostly red, orange and black.) The Anasazi were living in fewer areas at this time and seemed to be congregating in the larger pueblos.

The period of Pueblo III saw the building of the magnificent cliff houses of the type found at Mesa Verde and other places in the Four Corners area. About the end of this period, the Anasazi all seemed to disappear. They left many artifacts as though they just got up and decided to leave on the spur of the moment. Even food was left. In their later years, before they disappeared, the Anasazi seemed to have a complex social world with road systems and much trading.

The Pueblo IV Period covers the time period where the surviving people migrated to the present day pueblos by the Rio Grande River area of New Mexico and what is today the Hopi Reservation in Arizona and the Zuni Reservation in New Mexico. These people are no doubt the descendants of the Anasazi.

Anasazi Rock Art

The rock art in the Basketmaker periods is quite beautiful and somewhat similar to the archaic Barrier Canyon style, except the anthropomorphs are usually smaller and have arms and legs. This gives them a more human quality than the ghostlike figures of the earlier rock art.

The rock art done during the Pueblo Periods, for the most part, is not as large, not quite as well done, and lacks much of the detail of the earlier Archaic and Basketmaker Periods. This is probably due to the population increases and the trend of building and living in larger population centers. More time was spent building and it could be that the gifted artists turned their talents to architecture rather than to rock art.

At the same time, the cultivation of crops to feed the larger populations took up more of their time. Hunters probably had to go further afield to find more game as it thinned out near these large centers. Much like our present day living, it seems there was more time to do things in the old days than there is today.

Some of the large, Anasazi archaeological sites mentioned in this book are:

Arizona	Canyon de Chelly
	Grand Canyon
	Homolovi Ruins
	Petrified Forest National Park
	The Raven Site
Colorado	Anasazi Heritage Center - Dolores, Colorado
	Crow Canyon Archaeological Center
	Lowry Ruins
	Mesa Verde National Park
	Ute Mountain Tribal Park
Nevada	Valley of Fire
New Mexico	Aztec Ruins
	Bandelier National Monument
	Chaco Canyon
	El Morro
	El Malpais
	Salmon Ruins
Utah	Butler Wash Overlook
	Edge of the Cedars Museum
	Hovenweep
	Mule Canyon
	Newspaper Rock
	River House Ruins

Fremont (A.D. 650 to A.D.1250)

The Fremont lived to the north of the Anasazi in what is now almost all of Utah and part of eastern Nevada. The lines kind of blend because Fremont rock art can be found in northern Anasazi areas and some Anasazi style rock art is found north into the Fremont areas.

The Fremont were much like the Anasazi and could have been a northern offshoot. Both grew corn and made dwellings called pithouses, although the pithouses were a little different in construction. The Fremont wore moccasins of leather, rather than the fiber woven sandals of the Anasazi. The Fremont were more dependent upon hunting and gathering, were more mobile and traveled in small groups.

The rock art of the Fremont was quite extraordinary and different from the Anasazi. The Fremont never clustered in large commercial areas and seemed more warlike than their southern neighbors. They also used a different technique for making baskets and a different kind of mano and metate. The Fremont disappeared at the same time as the Anasazi. Some believe the Fremont became the Ute/Shoshone and the Anasazi became the Hopi, the Zuni, and other New Mexican tribes of today.

Fremont Sites in this Book

Fremont State Indian Park
McConkie Ranch
McKee Springs
Nine Mile Canyon
Potash Road
Dinosaur National Park

Mogollon (pronounced Muggy-Own, approx. 200 B.C. to A.D. 1450)

Another major culture, the Mogollon Peoples, covered quite a large area of the Southwest and it was the same size and equal to the Anasazi cultural area. Sometimes, in certain areas, these two cultures seem to overlap. It covered southern New Mexico, northwest Texas, southeast Arizona and spread into Chihuahua, Mexico.

In the early years, they lived much like the Archaic culture from which they descended. They were hunter/gatherers and roamed their huge area, which consisted of mountains, valleys and plateaus. They also raised corn and the Mogollons were probably the people who passed this knowledge onto the Anasazi to the north, along with their knowledge of ceramics.

Like other cultures of the Southwest, they first lived in pithouses. Originally round, they changed over time to a square shaped pithouse and were living in small villages consisting of several pithouses and kivas.

About A.D. 1000, there was a change in their building. They started using stone and building pueblos above the ground. Many think this was the influence of the Anasazi culture spreading southward.

The Mimbres Branch of the Mogollon lived mostly in the western mountains and later some settled in the valleys. They were famous for their black on white pottery, which also shows some Anasazi influence with whom they no doubt traded. The Jornada Mogollon were the desert people who lived mostly in the eastern areas including southern New Mexico and part of Texas and Mexico. Jornada style rock art covered all the Mogollon area and many of the figures you see at the Three Rivers site in New Mexico are exactly like the figures on the black on white pottery.

Mogollon Sites Mentioned in this Book
Three Rivers Petroglyph Site
Gila Cliff Dwellings
Casa Malpais, Arizona
Petrified Forest National Park
Hueco Tanks, Texas

Hohokam (approximately 300 B.C. to A.D. 1400)
The Hohokam, the third major culture along with the Anasazi and the Mogollon, occupied a large area in the south central part of Arizona and northern Mexico, part of the Sonoran Desert. This is an extremely dry area but does include the Salt, Gila, Verde, Santa Cruz and San Pedro Rivers.

The Hohokam are famous for developing a complicated system of canals to irrigate their land, which carried water to their fields which were miles from the rivers. Some of the canals are in use today in the Phoenix area to water orange groves and other fields and follow the old irrigation systems of the Hohokam. The rock art of the Hohokam is spread throughout the area and there are several nice sites near South Mountain in Phoenix, the Gila Bend area and the Tucson area. The Hohokam are also famous for their ball courts and might have had some influence on all of the cultures, especially, the Sinagua from the Flagstaff area and Waputki National Monument. It is known that they traded with

these people because shells from the Gulf of California turn up in Anasazi, Mogollon and Sinagua archaeological sites.

Sinagua (means without water - approximately A.D. 400 to A.D. 1425)

The Sinagua occupied a relatively small area of central Arizona, but is still the size of New Hampshire and Vermont combined. The northern Sinagua lived mostly in the high country around Flagstaff and the southern branch lived around the Verde Valley down to about present day Phoenix, near the Hohokam.

Probably a blend of the three major cultures, they have seemed to have borrowed basic pottery making, pueblos, cliff dwellings, ball courts and basic crops from the Anasazi, Mogollon and Hohokam.

Their rock art is very well done, especially in the area that has the very nice red patinated rock. The petroglyphs in Red Tank Draw, Beaver Creek and in and around Wupatki National Monument are especially well done. The Sinagua seemed to disappear about the same time as the other cultures.

Sinagua Sites Mentioned in this Book

Wupatki National Monument
Walnut Canyon National Monument
Tuzigoot National Monument
Montezuma Castle National Monument
Montezuma's Well
V-Bar-V

Salado (approximately A.D. 1000 to A.D. 1450)

The Salado culture lived in the Tonto Basin of Arizona, which is centered about 80 miles west of Phoenix at the confluence of the Salt River and Tonto Creek. Today, Theodore Roosevelt Lake occupies some of this area because of a dam, which was erected in early 1900s.

The Salado, as with the Sinagua, seem to be a blend of Anasazi, Mogollon and Hohokam cultures. They are most noted for their polychrome pottery, which was distinctive when compared to other cultures. After a relatively short period of occupation, they seemed to have moved on or disappeared as the cultures to the north and east.

The Latest Theory on the Disappearance of the Anasazi

For years archaeologists have tried to determine what caused the prehistoric cultures of the Anasazi, Fremont, Mogollon, Hohokam, and

Sinagua to mysteriously disappear at approximately the same time, around A.D.1300.

Some rock art enthusiasts (especially the ones with children) have concluded that these cultures were trying to escape from their teenagers.

The constant drumming, acid flute music, rap chants and wild all night dancing, drove the game that they depended upon for food away. That, in conjunction with sleeping all morning, messy pithouse rooms and calling everyone "Mana" ("Dude" in today's English), angered Tlaloc the Rain God, and resulted in a severe drought.

The people left early one morning and traveled fast while the teenagers slept in. To this day, no one knows for sure if the teenagers ever caught up with them or started their own tribes.

Automotive Type and Equipment

You will be able to get to all of the major sites outlined in this book by a regular car unless noted. But as you become more interested in rock art and ruins, you will find that a 4-Wheel Drive vehicle will be required in order to navigate some of the dirt roads going into other rock art sites. This is more for their high clearance rather than for the 4-Wheel Drive.

It is also a safety factor. You only need to be caught in a thunderstorm and find a low spot where a dirt road has become a swimming pool in order to have a problem. Or, after a flash flood has hit, you will find the wash you went through on your way to the site might be impassable when you return. Don't forget that the sky could be perfectly clear but it could have rained or still be raining fifty miles away and that water is on its way to you. This happens especially in the months of July, August and early September, which is the monsoon season in the Southwest. BE ON THE ALERT.

You will probably find a full sized sport utility vehicle or a pick up truck with a shell top will be your best bet. They don't have to be brand new but you have to keep your automobile in good condition. If you break down in some of the canyons, it could cost you between $500 and $1,000 to get hauled out. You have to carry quite a bit of gear for safety, backup, camping, hiking and cooking. We will cover automobile equipment in this chapter. The later chapters will cover camping equipment, hiking equipment and cooking equipment and food preparation.

Probably the best combination for the type of driving and exploring you're getting involved in, is a 4-Wheel Drive, high clearance, full size SUV. They can go almost anywhere. Combined with a tent, sleeping bag and other equipment, you never have to worry about where you're going to spend the night.

Even if you plan on staying at a motel, and this gets more attractive the older you get, in an emergency you have an alternative to fall back on. There is a great feeling of not having to make reservations and hurry to get someplace. This gives you all of the flexibility in the world and

the feeling of not having to be any special place at any specific time. That's what it's all about, especially when you get older.

Below is the listed equipment you'll need in your SUV for safety precautions when heading out on a trip. While it is not all-inclusive, it might also contain a few items that you are think are unnecessary. You can acquire this equipment over time as your trips get longer and spend more time on dirt roads. Your wife's birthday is a good time to get her something you need.

Permanent Auto Equipment
- Compasses
- Altimeter
- CB radio
- Cellular telephone (3 watt battery pack type)
- GPS
- First Aid Kit
- Extra sunglasses and regular glasses
- Lawn chair
- Flashlight and batteries
- Cigarette lighter floodlight
- Matches and propane lighters
- Insect repellent
- Sunscreen and chap-stick
- Ice pick
- Cassette tapes or C.D.'s
- Maps - road and topographical
- Extra car key
- Fire extinguisher
- Small voice recorder (for dictating directions and distance while driving)
- "Rescue" (emergency fuel additive by Penzoil. It can be carried inside your car. It is not gas or alcohol and can give you an extra ten miles in an emergency.)
- Portable potty with plastic bags
- Toilet Paper

Auto Equipment - Mechanical
- 6th wheel and tire
- Tow rope
- Spare hoses
- 2 or 3 cans of flat tire inflaters
- Tools

- Shop manuals
- Jack and tire irons
- Extra oil
- Flares
- Tire repair kit
- Jumper cables
- Two electric air pumps and tire gauge
- One hand pump
- Extra battery for long trips or Prestone "Jump It"
- Duct tape
- Extra air filter
- Spare fan belts
- Shovel
- Nylon rope
- Brake fluid

Survival Equipment
- Water (usually 10 gallons)
- Food case
- Tent with rain fly
- Tarp
- Two sleeping bags (1 summer bag and 1 three season bag)
- Blanket
- Poncho
- Knife
- Hatchet
- Extra boots
- Old running shoes
- Two guns
- Snake Bite Kit
- Whistle
- Extra sweaters, watch cap and jackets

Keep checklists of the equipment you need or want so you don't forget anything.

Before you start on your trip, always tell your wife or husband where you are going. If they are already going with you, tell another person where you are both going and give them an itinerary. Take an extra map, use a highlighter pen to layout your route and planned stops. If things change, be sure to call and update them on your trip.

It's best if you have another person and especially another vehicle with you if you're going off the main roads. Also, an extra person is

handy if you sprain an ankle or have some other problem because they can get help.

With the improvement and quality and the number of cell phone towers, it's fairly easy to keep in touch except when you're in canyons or low spots. Always make your calls at the higher elevations if possible, before you go into the canyons. If you have a problem, you can always take your cell phone and battery pack and hike to a high spot to see if you can get reception.

If you're using any of the interstate highways going to or from your trips, another way to communicate is through e-mails from the several of the major truck stops you are going by. You can also receive e-mails there. Kinko's Copy Centers also have these facilities in any of the towns you might be passing through (if there is a Kinko's). Also, there are more places offering this convenience all of the time. And I have heard the post office might even get involved...Can't Wait.

Tips for Driving
- Wet sand roads are good.
- Wet clay roads are bad.

You won't believe the lack of control you have on a clay road after a rainstorm. You might have to wait up to 24 hours to drive on them. So, it's nice to have your tent and equipment with you.

Dry sand roads sometimes get pretty deep. You might have to let the air out of your tires to about 15-20 pounds. This helps with the traction. Be sure and pump them back up when you get back onto the paved roads or they will overheat.

It's also good to let the air out of your tires on roads that contain sharp rocks and are very bumpy. It helps improve the ride and the chance of a rock going through your tire is reduced.

Watch your sidewalls. Many tire problems occur, when sharp objects penetrate your sidewalls. If possible, try to get 6-ply tires. They don't cost much more, are tougher and have a deeper tread.

If something happens to your vehicle out in the boonies, you have to know where you are to get help. The American Automobile Association (AAA) doesn't come and get you based on GPS readings of latitude and longtitude. (I'm not going to tell you why, just believe me). There are lots of dirt roads that aren't on topo maps and lots of roads on the topo maps that aren't there. Try to keep track of where you are and distances you travel.

Main Road Drivers

If you're not going to stray off the main, paved or good gravel roads, you might want to consider a used hearse. There are many advantages to driving a hearse.

- You can sleep in it
- There's lot of room for all of your gear and kitchen equipment
- They ride like a dream
- They are relatively inexpensive
- They have low miles
- You don't need a tent (just an inflatable mattress and sleeping bag)
- They're warmer and don't leak

But the *coup de grace* is getting up in the morning. All hearses have rollers in the back. If you can get a rear loader, you just roll your air mattress out the back door while you're lying on it. It tips up and you are standing upright. Just step out of your sleeping bag and you are ready to go without all the effort you have getting out of a tent with sore knees and a stiff back. You have to experience getting up in a tent after you are 70, especially if you've had a decent hike the day before.

Some of the old hearses didn't have handles on the inside of the back door but all the new ones do. I don't imagine in the old days, they expected anyone to want to get out that way. When you go to bed, if you don't have a handle, just leave it cracked a little bit for ventilation and in the morning, you just push it open with your foot and out you go. Or just crawl out of a side door if you want to keep the hearse closed up.

Try and get a white or silver hearse if possible because they are a lot cooler and don't show the dust and dirt like black ones. Or, just spray the top a light colored white and it helps quite a bit.

The Cadillac Superior Coach, 3 Way Side Loader, with Suicide Doors (hinged at the rear of the door with a handle in the front), is a great hearse. They have a Y shaped track so that with the rollers on the casket table, you can roll out on either side of the car through the side doors or the rear door. Most hearses seem to be End Loaders and they come with Black Crinkle Tops, Four Doors with Windows on the Side with Curtains. Just be sure it has four doors so you can get your equipment in and get it out easily.

You can't go wrong with a Superior, M&M (Miller Meteor), or S&S (Sayers & Scovill) coaches made using Cadillacs or Lincolns.

You might get enough people interested in rock art who drive hearses

and get an association together and have annual get togethers to look at rock art. It might be quite an undertaking but it would be appropriate for the first one to be either in Tombstone, Arizona - Death Valley, California or Deadwood, South Dakota. Plus, there's rock art in all three places.

Just like the Harley Davidson Rallies, etc, you could have contests and some of the categories could be:

1) Best Paint Job
2) Greatest Number of cars with lights on that follow you in an hour
3) Fastest to roll out of a sleeping bag from a rear end loader
4) Best license plate
5) Best internal decorations
6) Prettiest vases and flower arrangements

Music - in the Middle of Nowhere

When you're out driving to ruins and rock art sites, much of the time you can't get good radio reception during the day where you can listen to any station for any length of time. At night, you get too many stations. That's why CD's or Cassette players are on the checklist. Sometimes it's nice to have it quiet and at other times, you'll appreciate having some music or listening to an audio book.

Sometimes you can receive the Navajo Station at 660 AM for quite awhile and if you are near major towns, you can get a few stations. In Texas, you can get the powerful station out of Del Rio, Texas and around Nevada, you can get KJUL at 104.3 FM. Below I've listed a few ideas for you to consider when getting your cassettes or CD's together.

Audio Books

Both Tony Hillerman and Edward Abbey have some of their books on audiocassettes though I haven't been able to find Abbey's *Desert Solitude*. They do have his *Monkey Wrench Gang* and *Hayduke Lives*. They have almost all of Tony Hillerman's on audiocassette.

Here are some suggestions for people born before 1940 or 1930:

Time/Life Hit Parade series from the 40-s through the 50's

- Frankie Lane
- Joe Stafford
- Della Reese
- Harry James
- Waylon Jennings

- Willie Nelson
- The Four Lads
- The Four Freshman
- The Four Anythings
- Fleetwood Mac
- Herb Alpert
- Jimmy Buffet
- Beach Boys
- Mary Chapin Carpenter
- Doris Day
- Nakai (Indian Flute Player) (One night we listened to him at the O.C. Tanner Outdoor Theatre at Zion National Park with the flute music echoing off the canyon walls. You can imagine what it might have been like thousands of years ago.)

6

Food and Cooking

It's important for everyone who's out hiking and exploring to eat well and keep well nourished. Food is especially important to older guys, maybe more important, than their "all in one" wristwatch with the altimeter, temperature and compass. Many of us have trouble eating in restaurants away from home for various reasons and it's always easy to pick up new germs, upset stomachs, flu and cold bugs. Others just like to take a shower if not camping, put on sweats, relax and just eat in the motel room where they can plan the next day's hikes and the rest of the trip.

Staying and eating in some of the small towns, where you end up while pursuing your rock art or ruins trips, leaves a little bit to be desired. You'll be staying at motels that don't have complimentary newspapers and never appear in the travel columns or magazine articles as "not to be missed". Many restaurants change chefs often during the years and the regular chef's days off are on Sunday and Monday. Those are great days to do your own cooking. Also, many times you won't be near a town where there is a restaurant and you're going to have to do your own cooking.

For consistent meals and food that you are familiar with, we will cover the buying and preparation of food on the road. This doesn't mean you can't stop at a great restaurant or a fast food place once and awhile. But, for the most part, you can cook all your meals easily and they are a lot less fattening.

Food is so important to your morale that it's going to take a few pages to cover the major items. You have to have ways of carrying your food and equipment and one of the best ways is to use stackable 12-15 gallon storage boxes. That size is not too heavy when full but can still be used for tables or to sit on. Get the kind you can see through so you don't have to remember what's in each one. Your memory doesn't get any better with age. By using all the same boxes for all of your equipment, you can stack them and they take up less room in your vehicle.

Basic and Emergency Food/Ice Chest

Always take enough food for at least two weeks. If something happens, or your car breaks down, you'll feel better with some food in the car although water, not food, is your biggest worry. You can go a long time without food, but not water.

Basic and Emergency Food Box

The following should all fit in one box easily:

- Canned beef, ham, chicken, Vienna sausage
- Canned vegetables and fruits
- Canned soups and stews
- Dry soup mixes, macaroni and cheese mixe
- Canned tortellini and ravioli
- Crackers
- Peanut butter and jam
- Coffee
- Cookies
- Power bars
- Salt, pepper and mustard
- And anything else you happen to like
- Dinty Moore American Classics

Dinty Moore American Classics are dinners in plastic containers that look like frozen food but don't need refrigeration. They can be heated in a microwave in 1-1/2 to 2 minutes or warmed up any number of ways. There's quite a variety and they include:

- Roast Beef and Mashed Potatoes
- Beef Pot Roast with Potatoes and Carrots
- Salisbury Steak with Sliced Potatoes and Gravy
- Beef Stew with Potatoes and Carrots
- Chicken and Noodles with Carrots and Peas
- Turkey with Dressing and Gravy
- Chicken Breasts, Gravy and Mashed Potatoes

You probably won't use all of this food so every six months or so, it's nice to put what you have in a paper box and drop it off with some of the Native Americans who are living on the reservation. They are nice enough to let you look at the rock art on their land. The West is covered with these reservations.

Ice Chest

You can get by with one cooler or ice chest of about 50-quart size but it's also best to have another smaller cooler. A 12 to 16 quart cooler with

a handle is small enough to carry into your motel room or put up front with you in the vehicle to hold soft drinks, water and Gatorade while you are driving. If you're going to stay in a motel, you can switch whatever cold food you're going to use for that night and next morning from the large cooler to the small cooler and carry it easily into your room.

In the 50-quart cooler, keep block ice and add cubes or more block ice as needed. Be sure it has a drain on the side towards the bottom so you can let water out. Also, get one with a tray to keep the meats, cheeses and sandwiches out of the water in the bottom of the cooler. Keep everything in jars, bottles or zip lock bags. If you're going to have steak the second or third night out, it's best to freeze it and put it in the cooler when you leave home. Use this same rule of thumb with sea bass, halibut, salmon steaks or lamb chops.

Contents
- Soft drinks
- Gatorade
- Pickles
- Olives
- Teriyaki sauce or fajita sauce
- Mustard and ketchup in squeeze bottles
- Cooking vodka - Absolut Vodka seems to cook up the best
- Sliced cheeses and meats
- Orange juice
- Milk
- Whatever dinners you have, i.e. steaks, stir fry, fajita mix
- Apples and fruit

After you have been out for a few days, if something walks out of your ice chest, let it go.

Small Open Food Box

This is for lunches and snacks. Be sure to keep this box in the back seat. The worst thing you can do is to start snacking when you're driving. Whether it's out of boredom or whatever, you tend to eat everything within reach. Keep the following in this box:
- Peanut butter and jelly
- Bread, crackers, cereal for breakfast
- Pita bread, bagels, tortillas
- Paper plates, bowls, plastic utensils

- Beef jerky
- Pretzels
- Cookies
- Nuts
- Hefty bags or zip lock bags
- Paper towels
- Sharp knives and metal utensils
- Matches
- Coffee mug
- Purell instant hand sanitizer
- Plastic glasses

Just keep anything in here that sounds good to you. It's the little things that count.

Carburetor Cuisine (Cooking on your engine)

I first saw Kirk Neilson cooking on his engine while we were camping at Sand Island near Bluff, Utah. Kirk had the hood of his 4Runner SUV up and I thought he might be having some sort of engine trouble. While I was eating my peanut butter sandwich, he popped out with a whole dinner, nice and hot. Needless to say, I picked up on this right away. Truck drivers have been cooking on their engines for years but they tend to just heat up canned food like stew or hash. We're going to try some different things.

Your car engine will be your own little stove or oven for long or short trips. You can adjust your menus as needed, sticking to mostly pre-cooked foods like sausages, ham, etc. that need some preparation before you leave home.

Cooking on your engine is not an exact science so you will have to experiment. First, find out how much space you have on your engine and how hot it is. Some cars have a lot more space then others. But you can always make little packages and space them around your engine. You have to experiment with which are the hottest places.

The only extra equipment you need for Carburetor Cuisine are Reynolds Hot Bags/Extra Heavy Duty Foil Bags and a roll of extra heavy-duty foil. You put what you're cooking in the bag and double or triple fold the open end depending on the size of the dinner. Then, to be safe, wrap the whole bag in a long piece of foil. Bring the sides up and then double fold both ends. The one thing to be sure you do is don't wrap the bag too tightly. There has to be air inside the bag for the heat to circulate and have the meal cook evenly. When you stop for a restroom

break, or for gas, turn the package or packages over. When you get where you're going, you can use your motel or camping equipment to serve it.

Many people love sausages. They are really easy to warm up and most are previously cooked so you don't have to worry about any problems, except the temperature you want. The best seem to be Bavarian Bratwurst, Knockwurst, or just plain old good hot dogs.

I can't understand why hot dogs come 10 to a package and hot dog buns are only 8 to a package. It only takes about half- hour to an hour to heat these through on a moderately hot place on your engine. You just have to experiment with the food and your engines until you get it right. In case you haven't had it on the engine long enough, you will be able to zap in the microwave which we'll be talking about in a later section. You will come up with all kinds of ideas for what to cook, depending on what you like. You could do any pre-cooked meats, mixed with about anything you want and not have to worry about undercooking.

Inverters
I used to cook all the time on the engine but found out I could get a 12 volt DC to 110 volt AC inverter which allows you to use a crock- pot in the car. This is a more practical way to cook than cooking on your car engine. The best crock -pot I've found is the oval, Rival crock-pot. It's large enough to handle most anything you want to do including half of ham or turkey.

There will be a crock-pot recipe in each rock art chapter for the first night's dinner. Even with an inexpensive 300 watt inverter, which you can plug into your cigarette lighter, it is best to direct wire it to your battery through your ignition to be on the safe side when you run a crock-pot. Pretty soon, they won't be calling them cigarette lighters anymore. Perhaps they will be called "Ancestral Tobacco Igniter Receptacles" or ATIR'S.

No matter what size inverter you have, when using any appliance of over 200 watts, the inverter should be directly wired to the battery to be absolutely safe. It's best to have the inverter installed professionally as it hooks up directly to the battery through your ignition switch. But if you know how to do it yourself, be sure to use a fuse or a circuit breaker. Keep the inverter in the car itself, so it stays cool. A 1000-Watt inverter is only about 15 inches long, 9 inches wide and 3 inches high. Most have at least two grounded AC receptacles so you can run two appliances, i.e. the crock-pot and bread maker at the same time, if the combined

wattage is less than what the inverter is rated for. You can keep the inverter under the dashboard or under the front passenger's seat.

There are several other ways to cook in your car when you go for the 600-Watt, 1,000-Watt, 1500-Watt or greater inverter. These allow you to use the appliances while the engine is running. Always check the maximum wattage on the appliance and make sure it doesn't exceed the wattage of the inverter. Most of the following operate on a 1,000-Watt inverter. Be sure you don't plug in two at the same time unless the total input wattage is less than 1,000. Since all inverters are a little different, be sure and follow the directions that come with it.

Appliances	Approximate Wattage
• .6 cubic foot microwave (It outputs 600 but takes 1,000 watts to run it)	1,000 watts
• 1.7 cubic foot refrigerator freezer	300 to 400 watts
• Blender (use 10 speed or less)	400 to 500 watts
• Electric can opener	150 watts
• 13 inch Television/VCR	70/45 watts
• Laptop Computer/Fax-Printer	70/170 watts
• Small toaster/oven broiler	500 to 1,000 watts
• Crock-pot	225 to 275 watts
• Bread maker	500 watts

The 1,500-Watt is a little more expensive than the 1,000-Watt inverter, but will run a full size Mr. Coffee Elite Coffeemaker, which takes 1,025 watts, a little larger microwave, a clothes iron, a larger toaster oven broiler and a hot air popcorn popper. These are also the same things you will be using in the motel rooms. NOTE: Be sure and check the wattage on your appliance because all makes are different.

Crock-Pot Cooking

If you're going on a long trip on good roads and have an inverter, you can also do a crock-pot meal. I keep the crock-pot on a non-skid rubber mat on the floor of the passenger side of the car so I can plug it right into the inverter that is under the front passenger seat. If you have a passenger, they need to sit in the backseat of the car and another plus is that the crock-pot doesn't tell you how to drive. You will notice there is a crock-pot recipe in each chapter that has a rock art site or ruins.

Corn beef is a good choice as leftovers make great sandwiches. Also, you can do stew, pot roast, chicken, beef brisket, jambalaya, etc. You

can throw in everything including potatoes, vegetables, etc. You will always have enough to serve your friends on the first night.

If you are taking a shorter trip and leaving later in the day, start the crock-pot in the house in the morning and plug it into your inverter when you leave and let it cook for the remaining time of the recipe.

Remember, stay off the 4 Wheel Drive roads because of the bumps and don't make any erratic turns when you are cooking in the car. In addition, if you happen to have a car accident, there is a possibility of getting badly burned by some hot gravy, etc. that could spill on you. The point is to use caution when you're cooking in the car.

Motel Cooking and Equipment

The secret to motel cooking is to have everything ready so when you get there, you can carry it right in. The best way is to have a large "coffee duffel" with a shoulder strap to make it easy to carry. Also, you need an empty duffel to carry in food and or anything else you might need for that night or the next morning. Besides the duffel bag, it's also nice to have a couple of other appliances in the car that you can use.

Coffee Duffel
- Mr. Coffee, 12 cup, elite, coffee maker
- Extra coffee decanter - keep this in one of the storage boxes
- Coffee - regular for the daytime, decaffeinated for nighttime
- Coffee filters
- Small bottle of dish detergent (the one made with real lemons)
- Bottle of lemon juice (the one made with artificial flavor)
- Clothes iron and aluminum foil
- Acrylic old fashioned glass
- Microwave safe coffee mugs and large bowls
- Lysol disinfectant spray-(Crisp Linen scent is good.)

When you first go into the room, spray the phone, light switches, sink handles, bathroom, television switches and anything else that looks good. Howard Hughes taught me this.
- Clorox or Lysol disinfectant towels are great for wiping down phones, etc.
- Salt, pepper, sugar
- Metal thermos bottle (fill up with coffee in the morning and take with you)
- Can opener
- Bottle opener

- Paper plate and bowls
- Plastic knives, forks and spoons
- Sharp knife with small wooden cutting board
- Aluminum foil and zip lock bags
- 170 watt reading bulb or several 100 watt bulbs (some of these motels have such weak bulbs, you need a flashlight to find the television.) After you change these, don't forget to take it with you in the morning. (I think it was George Gobel who said "if it weren't for electricity, we'd all be watching television by candlelight.")

Coffee Pot Cuisine

The Mr. Coffee 12 Cup Elite Model has an adjustable hotplate and you will use it for much more than making coffee. It also beeps when it's finished. I use small, bubble wrap around the carafe and wedge it in place when carrying in the duffel bag. Some of my favorite dinners made in the coffee maker are:

- Chicken or beef and vegetable stir-fry
- Chicken or beef fajitas
- Ravioli or tortellini - Shrimp and scallops
- Little smokeys or cut hot dogs
- Small boneless chicken breasts

You can also use the carafe to warm up chili, soups, stews, etc.

The chicken or beef fajita or chicken or beef stir fry all have the same directions. You can make your own but most of the grocery stores have one or the other already cut up and prepared in the meat section or you can thaw several of the frozen kinds. Get a pound and then you can figure out about what a 1/4 pound is. Keep these in ziplock bags in your cooler.

When you're ready for dinner, put about 1/4 pound of the stir-fry or fajita mixtures in a filter in the filter box. Fill the reservoir with cold water to 10 or 12 cups and turn it on.

While this is cooking, get out your clothes iron and heat it up on the linen or high setting. A 1/4 pound of mix is about right for two tortillas or one pita bread. When the meal is cooked and all the water has drained through check it, it will probably be done but if it isn't, run a couple of more cups of water through the coffee maker. At the same time, get out about a 12-15 inch piece of foil and fold it in two and put a tortilla between the sheets of foil. Put the foil with the tortilla between it on a towel on the counter of the bathroom sink. Iron it for about 20-30 seconds.

Remove it and fill it with one-half of the fajita mix, hit it with some salt and pepper, fajita sauce or terikai sauce and roll it up. Then do the same for the second one. If using pita bread, just iron it for about 30 seconds, cut it in two and fill both sides with the mixture and whatever sauce you want. Discard the filters and wash out the carafe.

With tortellini or ravioli, get the soft kind that you find in the refrigerator section like Contadina or Di Giorno. This cooks with about 6 cups of water. If you use the dried kind, it takes the whole 12 cups plus another 2 or 3 to cook al dente. After it is cooked, leave it in the basket to stay warm, discard the water and add whatever sauce you like to the carafe. This should be pretty warm in about 10 minutes on the high setting.

Shrimp and scallops take about the same time to cook so sometimes you can do a little of both. Put about a 1/2 pound in the filter in a basket and run through 6-7 cups of water. Check and they should be done. Take them out while they are good and hot and put just a little butter and sprinkle a little lemon on them. If you have parsley, just sprinkle on a few leaves for color.

Hot Dogs

Hot dogs or pre-cooked sausages are easy. Cut up hot dogs in the filter and put in the filter basket. Run about 6 cups through and they'll be good and warm.

Vegetables

Asparagus is easy to do also. Cut to fit the filter basket and run about 10 cups through. If the asparagus stalks are real thick, it might take a little longer. You can also heat up 8 - ounce cans of peas, beans, corn, etc in the carafe before you start the rest of the meal. Put in a bowl and cover to keep warm.

Potatoes

Always carry Idahoan Real Potatoes or Idahoan Roasted Garlic Complete Potatoes. With these, you only have to mix two waters to one flakes. All you do is run the amount of water you need through the coffee maker, pour the hot water in a bowl, put the flakes in and wet and wait one minute and stir and you have your mashed potatoes.

If it's hot out and you just want a cold salad or something, just cut up some chicken breasts and cook in the coffee maker. While that's going on, you can use the Dole Complete Salad package with croutons and dressing, put the salad in a bowl, add the chicken and dressing and toss

and throw the croutons on top. If you want to, you can also make a shrimp, scallop or even sausage salad.

Don't forget - you can also make coffee.

The Iron Chef

All the other things are self explanatory except for the iron. Besides heating the tortillas and pita bread, it's great for making sandwiches. One of my favorite sandwiches is the Reuben, but there are all kinds of variations. If you have any leftover beef, ham, corned beef, etc., or you have this stuff from a deli, you can make some of the following sandwiches. Or invent your own. The basics are all the same.

Sliced Beef, Horseradish Sauce and Cheese Sandwich

First, lay out a long piece of foil and put one piece of buttered bread, butter side down on the foil. (You have to use butter or the bread will stick to the foil). Put some mayonnaise and mustard on it, then the beef. Spread with horseradish sauce; put the cheese on top of that (any kind of cheese you like is fine - provolone or jarlsburg works really well). Put the other piece of bread on top. Butter the top of the bread and fold the foil over the sandwich.

In the meantime, you've been heating the iron on cotton setting. Put the iron on top for 3-4 minutes, then flop the whole foil package over and iron the other side for 3-4 minutes. All irons are different so check after 2-3 minutes for brownness. The thicker the sandwich, the lower you want the setting and the longer you leave it on each side to be sure everything melts and is warm inside. So, for a thick sandwich, turn the iron down to the wool setting.

Other great sandwiches are:
- Corned Beef, cole slaw and Jarlsburg cheese
- Corned beef, sauerkraut and cheese
- Smoked turkey, coleslaw and cheese
- And of course, just a plain old grilled cheese never tasted better

Every time I'm ironing my dinner, it reminds me of the story of the little girl in a Talent Contest at her Elementary School. When it was her turn, she went up on the stage where the Principal was introducing each of the contestants over the loudspeaker. He introduced the little girl who said she was going to do a dance and then the Principal commented on what a beautiful dress she had on. The little girl spoke loud and clear into the microphone and said: "Thank you and my Mom says it's a bitch to iron."

Appliances To Use From Your Motel Room (if you don't have an inverter and have not had the pleasure of cooking in your vehicle.)

- Small microwave oven
- 100 foot heavy duty grounded extension cord
- Bread maker (life is too short to forego fresh baked bread)

Find a permanent place in your vehicle for the microwave. Keep it fairly level so the turntable works, usually in the rear of your SUV near the cooler. When you get to the motel, you can run the extension cord from your room out to the car and either do a frozen Stouffers, Marie Callendar or a Swanson's dinner or finish off whatever you might have under the hood if it needs it.

The newer, interior corridor motels are the best. They have grounded sockets and you can park outside your window on the first or second floor and just hook it up. Most of these motels also have indoor hot tubs. If you're going to have a hot fudge sundae, you can zap it in the microwave or take in the hot tub with you to warm up. Be sure the top is off in the microwave and it's on tight in the Jacuzzi.

If you're going to make bread in your bread maker on the fast bake cycle, which takes about an hour on the machines they have now, it might be nice to ask the desk if it's okay or just take the bread maker to your room in an extra duffel bag or beach bag. One thing to remember is, if you're baking bread in the car and plugged into the inverter, don't stop it once you've started or it messes up the cycle and starts all over. It can be very messy. Or you can make bread overnight in your room and have fresh bread for the next morning, sandwiches for lunch and some left over for dinner that night.

One of the best ways to prepare bread is to have the mix and all the dry ingredients, except for yeast, in a large zip lock bag. You can do two or three types of bread in zip lock bags (sourdough, whole wheat, white, etc.) one for each night, ahead of time if you want. Then when you're ready to make it, put in the water, milk, butter, etc. in a bowl. Pour the dry ingredients in and then the yeast, and then let it go.

The easiest way is to just use prepared bread mixes and all you have to do is add water. Krusteaz has some bread mixes out that make excellent bread. Since you will be about 5,000 feet all of the time you're on these rock art trips, you might have to reduce the yeast by a half of teaspoon or so or else take out a teaspoon or so of water. Be sure the temperatures of the water and liquids are correct or the yeast doesn't work. You can try the fast bake feature if you are baking in the car. If you are baking in

the motel room it's best to use the regular cycle. On fast bake, you can do the whole loaf in one to one and one half-hours depending on the machine and the size of the bread.

We never had much luck with the fast bake feature but the small bricks that come out are good for weighing down your maps on the hood of the car when you're trying to find out where you are. Some years, we even have enough bread bricks to wrap and send to our friends for Christmas. They appreciate this more than the Christmas newsletter we used to send. Whole wheat makes the best brick for this as it is coarse and won't slip off the maps. Another great Christmas gift is a gallon jug of French's mustard that you can get at Costco for two dollars and something. It's fun to see the expression on people's faces when they unwrap it.

Appetizers

Sometimes you feel like a little appetizer. My mother got this recipe from a friend of hers with whom she went to lunch one day. The friend, when asked if they'd like an appetizer, replied to the waiter " I was in here about a week ago with my son and I had this marvelous appetizer but I can't remember the name." The waiter asked her to describe it and she said it was a cold appetizer in a glass with two olives covered by a crystal clear sauce. The following is my mother's recipe that she adapted for her cooking and handed down to her sons:

It is listed once under sauces and again under appetizers:
- 6 green olives stuffed with jalapenos, pimentos, onions, etc.
- 1 toothpick
- 1 drop olive juice
- 1 drop water
- 1/3 cup of cooking vodka

Spear two olives with a toothpick and set aside. Put the rest of the olives in the bottom of the old fashioned glass. Measure carefully 1/3 cup of cooking vodka; add one drop each of olive juice and water. Stir sauce until well mixed (about 20 seconds). Pour slowly over olives in the glass. Add several ice cubes. Return two olives on a toothpick to the appetizer and enjoy.

Another variation is to follow all the directions above, then strain the liquid into another glass, throw away the ice and olives (or use the olives on a salad), and add a piece of lemon rind. This makes a nice clean lemony sauce.

Desserts

If you're staying in a motel, and stopping at the grocery store to pick up something you need, also pick up a pint of vanilla Haagen Daz ice cream, hot fudge sauce and diced almonds from the baking section of the store. The ice cream is really frozen hard so it will soften up while you're having dinner and as you heat the hot fudge on the hot plate of your coffee maker.

After dinner, flop the whole pint of Haagen Daz into a bowl, cover with hot fudge and sprinkle with the diced almonds. This will help fill you up, as unfortunately you have to eat it all because it won't save without a freezer. We used to put whipped cream on it, but figured we had to cut back on the calories and fat somewhere.

One thing I've never been able to understand is how you can eat a pint of Haagen Daz, which weighs 16 ounces and end up gaining two pounds. General Mills recently bought Lloyds who make the precooked baby back ribs. So, with General Mills owning Haagan Daz and Progresso Soup among other brands, you can survive for weeks on General Mills products and you have a great selection of cereals for breakfast.

Camping Food and Equipment

As you get more involved in going to rock art sites, many of your trips will take you far away from any towns, motels, restaurants or even gas stations so go prepared. The following list of equipment fits in one of your storage boxes and you will use it when you are camping out in the boonies.

- Propane stove (either single or double)
- Propane bottles (two or three of the 16.4 ounce camping bottles)
- Coffee pot - stainless steel percolator, 8 cup
- Coffee - coarse ground (the motel coffee is auto drip)
- Small sauce pan
- Small frying pan
- Spatula, tongs, silverware, short knife
- Big bowl and cup, plastic
- Propane lighters and matches
- Trash bags

You can use the sugar, salt and pepper, utensils, coffee mugs, etc. from your motel duffel bag when you're camping. In addition, you can carry

separately in your vehicle a charcoal grill. Son of Hibachi is a heavy but great little cast iron grill with adjustable grill heights. It folds up as it is hinged in the middle and has carrying handles. It is small and can tuck in anywhere in your vehicle. It does a great job on steaks, chops, chicken, etc. You can use regular charcoal and lighter fluid but the best is the self- starting charcoal where you put the whole bag in and light it.

If you don't want to carry around charcoal and not have as much of a mess, you can get a Weber Smokey Joe Propane Kettle Grill with a hood. It looks just like the big Weber Kettle and works pretty good. You can use the same propane bottles that work on the stove or a lamp. You might want to carry a couple of more bottles of propane if you use it a lot.

Blowtorch Cooking

If you're getting into camp late and feel like a steak, try this quick recipe for cooking your steak. It's amazing how fast it cooks and how good it tastes. Buy yourself a Bernzomatic Trigger Start BlowTorch with adjustable flame and a clip on stainless steel flame spreader. This screws right into to one of your 16.4 ounce propane bottles. You have to hold the propane bottle upright so, when cooking a steak, hold the steak on a fork at arm's length from your body. You'll have to judge how long to cook it depending upon the thickness of the steak. Just keep the flame moving slowly all the time just like you were taking paint off a canvas canoe. It usually takes about 4 or 5 minutes on a side for about a one inch steak for medium rare. This is just about like a charcoal grill but be careful you don't overdue it. If you like it well done, forget about it and have a can of tortellini.

With a little practice, you'll be an expert in no time. You can also use it for chops and some kinds of vegetables like asparagus.

Desserts

When you're camping, it's nice to have something sweet for dessert. At some of the smaller towns in the Southwest, the safest thing to get is some Hostess Twinkies. They are the basic desserts in the West. Don't be surprised if they're right next to the movie rentals and fishing worms.

Thursday's Baked Alaskan

Sometimes when you stay in a motel that is close to a grocery store, you might want a special dessert for a birthday or just because it's Thursday. Go to the grocery store after dinner, and buy the package of three Twinkies, a pint of Haagan Daz chocolate or strawberry ice cream and

some Betty Crocker "soft whipped fluffy white frosting" in a can.

Put a piece of aluminum foil on a plate, lay the three Twinkies touching each other on the foil, and put the Haagan Daz on the Twinkies, the top side down (Haagan Daz is frozen really hard when you get it). Now, cover the ice cream and Twinkies with the frosting. Blowtorch the frosting quickly until light brown and it runs a little into the Twinkies. Light a camping candle on top and after singing whatever is appropriate, cut the dessert with a sharp knife into four pieces. Or sing Happy Thursday to you and eat the whole thing yourself.

This cures your sweet tooth for about six months.

Random Comments

When you arrive home, you can stack all of your boxes in the Dining Room. This way you can remember where they are and if you're anything like us, you probably ate dinner in there once or twice in the last couple of years. You can probably move them out for Christmas dinner.

Many wives of retired friends of mine have thanked me over and over for getting their husbands out of the kitchen and into their cars with their inverters.

One day, after Kirk and I had camped out a couple of nights, Babe hadn't eaten is a restaurant in awhile. I caught her on my cell phone calling the dog abuse hotline. She hadn't had a Big Mac in over two days.

One good friend of mine is a widow who lives in a retirement community where the men outnumber the ladies by 5 to 1. Many gentleman callers keep bringing her casseroles from old outdated recipes with loads of fat. This is tending to break her garbage disposals. She can't wait to get on a rock art trip so she can cook in her car and not hurt their feelings.

One day, after hiking around Mesa Verde, I was on my way down to Sante Fe in Old Blackie, my Cadillac Superior Side Loader. I was going via Mancos and Durango in Colorado and Aztec, Bloomfield and Cuba, in New Mexico. I had the crock-pot full of stuff for stew that I picked up that morning at the City Market in Cortez and the bread maker going on the floor of the passenger side of the front seat next to the crock -pot. I was pulled over by a policeman outside a little town about 4 o'clock in the afternoon. He thought I'd missed the turnoff to the

cemetery. After I did a little explaining, he went back to his auto and he must have been checking me out on his computer. While he was doing that, I picked some of the wild sunflowers along the road to put in my flower vases. The smell of the bread baking and the stew cooking was incredible.

He came back and said everything was okay. He had just never before seen an old guy driving a hearse, cooking stew in a crock-pot, baking bread, playing Waylon Jennings on the cassette player and looking for prehistoric petroglyphs.

He seemed like a nice guy, but a little strange. He was interested in my hearse and asked me if I had speakers in the back. (I think he wanted to look in the back of the hearse again), but I told him the hearse hadn't been changed since I bought it and I didn't think there was a use for them originally.

It just kind of made me realize how many strange people you run into on these rock art trips.

Medicine Bag

If you go out on an extended trip, you might want to take some over the counter medicines that you won't find in the boonies or in some of the small towns you come across on your journey. Keep it all in one small duffel bag and put the duffel bag in one of the storage boxes so you always know where it is.

Below is a **sample** list of things you might find helpful and, in some cases, you may find necessary. This is in addition to your required medications and what you might carry in your shaving kit or first aid kit.

- Extra 2-3 days or more of your prescription pills
- Allergy pills if required
- Tiger balm, Ben-Gay or something similar
- Nyquil - if a cold comes on during the trip
- Phillips Magnesia
- Pepto-Bismol
- Band-Aids
- White cloth tape
- Dr. Scholl's Moleskin Plus Padding for unexpected blisters
- Antacid pills or liquid
- Hand and body lotion like Eucerin
- Breathe Right nasal strips
- Cortisone 10 (stops itching of mosquito bites, no-seeums, etc.)
- Neosporin antibiotic ointment
- Imodium Advanced
- Eye drops - i.e. Visine, etc.
- Scissors
- Cold-eeze zinc lozenges for oncoming colds
- Riccola herb cough drops
- ZYCAM homeopathic nasal gel
- Ibuprofen (kind of an anti-inflammatory, aspirin, etc.) or any fever reducer
- Air cast for emergency broken bones

Rascal--looking for spaceman - Utah

John Bettfreund and Dave Ferguson - Nevada

Jim Duffield, Sharon Graf and Mary Allen - Utah

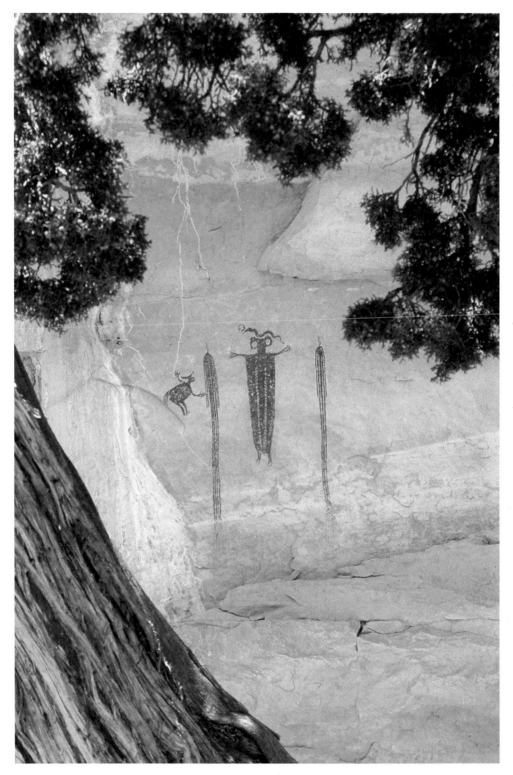

Head of Sinbad, San Rafael Swell - Utah

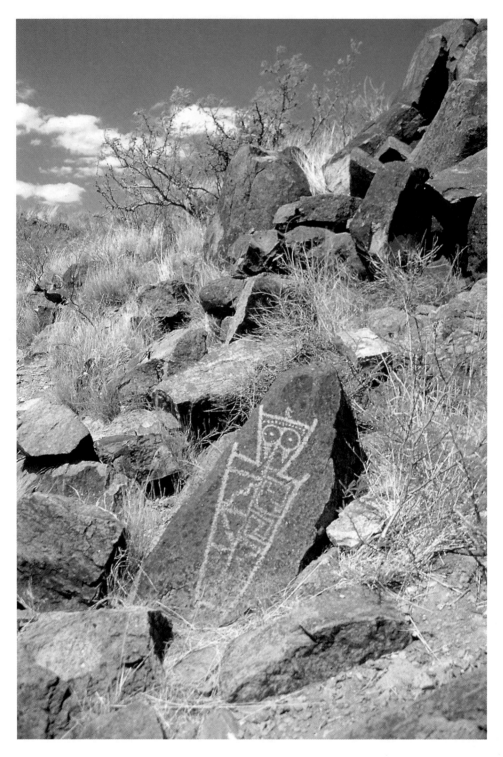

Tlaloc, The Rain God - Three Rivers - New Mexico

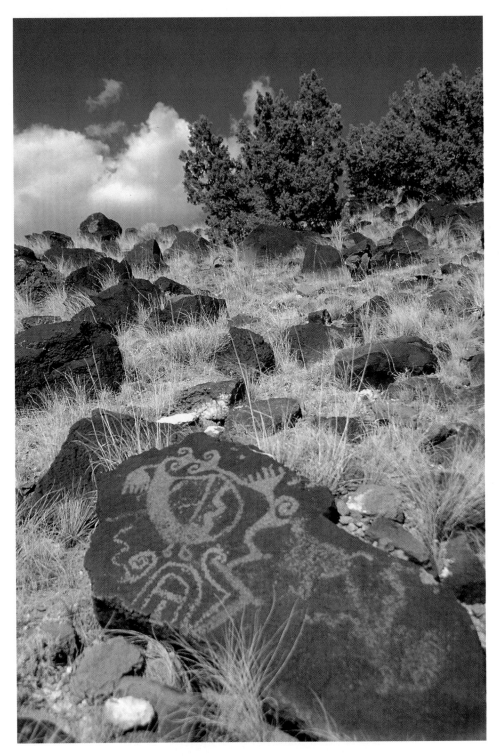

Prehistoric Impressionist Petroglyph - near Santa Fe - New Mexico

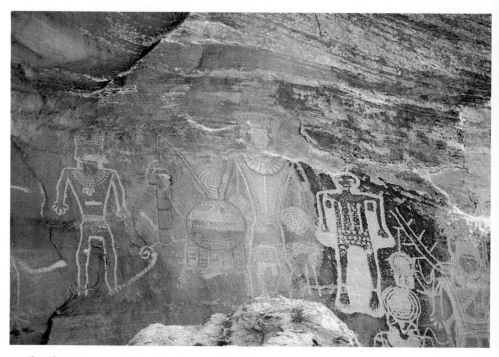

The Three Kings - McConkie Ranch - Utah

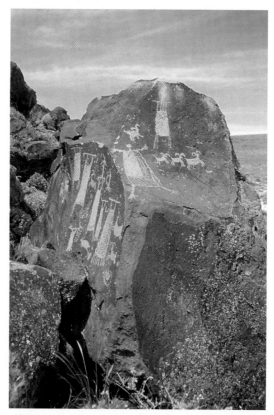

China Lake Naval Weapons Center - California

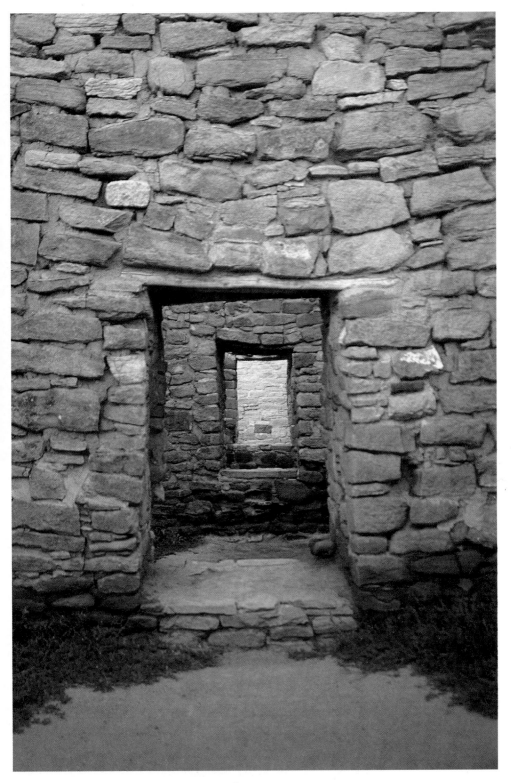

Aztec National Monument - New Mexico

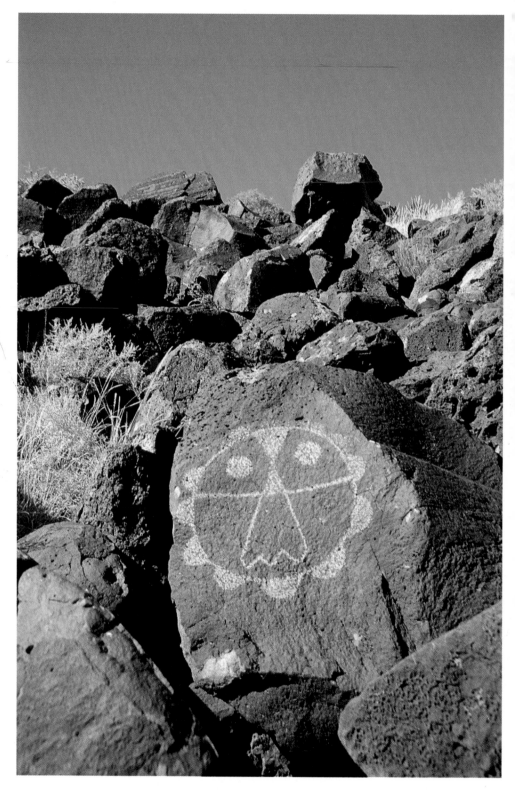

Petroglyph National Monument - New Mexico

Of course, you are the judge of what goes into your Medicine Bag and choose whatever brands and medications you think you need.

It's also nice to carry the paperback book, *The Complete Guide to Symptoms, Illnesses and Surgery (for People over 50)* by H. Winter Griffith, M.D. If you can't find it at your bookstore, you can order it from your bookstore or Amazon.com, etc. Don't read this at night or you will think you have five or six major problems.

Random Comments

Take care of yourself because nobody wants to hear "That's the way he would have wanted to go."

Some mornings you just know there are people in the hospital that feel better than you do.

Conditioning

Once you decide that you like to walk or hike and see rock art and ruins, you are on the first step of getting in shape. Being physically fit enough to hike to some of the sites that aren't right next to the road takes some preparation, precaution and training, especially if you are older.

You don't need to hurt yourself to get in shape. It consists basically of just three things. Walking for cardiovascular fitness, strength training program and stretching for flexibility.

Before you start any training, especially if you've been a couch potato for awhile, you should see your doctor and get his okay.

Most people tend to overdo it when they first start exercising. You have to start out slowly and work up to your full program. You don't need to do heavy weights. It's best to join a health club or gym where you can get some qualified instruction and some supervision. If you have a reason to exercise, such as hiking to see rock art, it makes it much easier to take than if you're doing it because your doctor or wife decided you should do it.

I used to get in shape for downhill skiing by biking, playing golf and tennis for most of the year. Then, I would start an exercise program specifically for skiing in September. I would do this up to about Thanksgiving or when the first ski resorts opened. At age 50, it dawned on me that this was not working. And I was able to only ski about 4 hours a day before my legs gave out. I had to go to a year-round program of conditioning if I wanted to ski safely and get my money's worth out of the lift tickets - mostly to get my money out of the lift tickets. Also, years ago, you used to have to worry about the short ski hot doggers and today it's the snowboarders. You sometimes have to move fast to keep out of their way.

You might find that you want to stay in shape even if you're not skiing or hiking. If you decide to take up cross-country skiing rather than downhill, be sure you start with a small country.

Almost immediately, upon exercising regularly, you discover that you feel better and look better. Clothes begin to fit that were getting a

little snug and you will save even more money by not having to buy larger and larger clothing.

You sleep better, have more energy, handle stress better, have fewer colds, injure yourself less frequently, and most importantly, you can eat more without gaining weight. The doctors even will tell you that regular exercise helps control blood pressure, reduces hardening of the arteries, and lowers cholesterol and the risk of strokes and heart attacks.

Try to go to the gym three days a week, Mondays, Wednesdays and Fridays seem to work out the best for most people. Make an appointment with the free fitness instructor and do everything in moderation.

1) Work up to about 30 minutes on the treadmill, adjusting the speed and incline to keep your pulse rate at the proper level.

2) Use the exercise machines that work all of your major muscle groups. You do about 10 repetitions and the instructor will show you how to do them right as well as how to breathe during the exercise. You also might get into some weight training, especially for the legs. They will start you out at the low weights and then increase them as you progress.

3) Stretching - This works better for me after the workout. They will show you how to stretch the different areas. Just be sure to do them slowly and don't use a bouncing motion.

This whole program will probably take 1 hour and 15 minutes to 1 hour and 30 minutes if you don't talk too much to the other people at the gym.

On Tuesdays and Thursdays, work up to walking about 3 miles a day. This takes about an hour on regular surfaces. Try to vary it depending on what hikes are coming up. Let's say you're going to do the Great Gallery, which is about a 6-mile hike, with 800 feet elevation change up and down. The canyon is soft sand for about 2 or 2-1/2 miles each way.

A couple or three weeks ahead of the trip, find an area with soft sand to walk in. Along a river or in a wash is usually a good place. Also, walk up and down some hills of about an 8% grade. On weekends, you might try a little longer hike for about 2-3 hours. Try to go see something that you wanted to see but haven't been able to do before. A rule of thumb that works for most is that if you walk or hike 2 miles a day on the

average, it is easy to do a 6-mile walk or hike once a week. Be sure the terrain is similar to what you have been doing on the 2-mile hikes.

The main thing is to keep active so find some exercise you like to do and keep at it.

Random Comments

Sweat is nature's way of showing you your muscles are crying.

When you go to the gym, you will notice that all the cars are parked right close to the entrance. Some of them park illegally just so they don't have to walk too far to go in and exercise.

On these hikes, be aware of everything around you. If you see buzzards circling and following you, it's a pretty good bet that they know more than you do. This is not a good sign. Stop and go home.

Day Hiking

Tips - Equipment - More Tips - Companions - Weather - GPS

Tips

Hikes are usually described as easy, moderate, difficult or strenuous. All of the hikes covered in this book are on established trails and will be easy to moderate except for The Great Gallery. This could be described as moderate to difficult, especially for older people. As your interest in rock art and ruins develops, you will probably want to go to more sites that are not on established trails where you will encounter a variety of hiking conditions. In this chapter, we will cover information you might need for day hiking, not only to the sites outlined in the book, but also to future sites which might include talus slopes, canyons, plateaus or washes.

Always have maps of the area in which you are hiking. When you leave your car, always landmark it with your GPS, especially when you're in the Pinion Pine, Juniper altitudes of approximately 5,000 feet and above. You can walk 50 yards and your car will disappear. The GPS has a "GO TO" button, so at any time, you hit the button and it gives you the direction and the distance to your car. This might sound unnecessary but I've had several friends, who while not lost, couldn't find their cars (including me).

The GPS will be one of your most important tools. If you don't use it all the time you forget, so be sure to keep your small user handbook with you. For those who aren't familiar with the GPS, see the end of this chapter. By the time this book is out you will probably be able to buy a GPS wristwatch made by Casio.

If you haven't been in the West except for vacations or have never been here at all, when you do any of the hikes in this book, remember you will be at about 5,000 feet or over most of the time. If you're from the East, you won't believe that you can be hiking along a flat area or canyon and be at 9,000 to 10,000 feet. You don't have to be at the top of a mountain to be at a high altitude.

The most important thing is to have lots of water. You can get dehydrated, and not even know it, with the low humidity and high

temperatures, especially in the summer. You might not even perspire so there won't be any physical evidence of dehydration. Remember that older people do not tolerate the heat as well as younger people. You will lose approximately 1 pint to 2 pints of water for every hour you are hiking in the spring and fall - more in the summer. Try to drink the same amount of water or a little more every hour. You can't wait for 2 to 3 hours and drink, because your body doesn't absorb the water that quickly.

Food is also important on a hike. You will be using a lot of energy and losing a lot of electrolytes. Food will give you energy and replace those electrolytes. Handle food like you do your water. Eat a little every half-hour to one hour rather than a lot at one time. The best foods are nonfat energy bars, fruits, bread or trail mixes. Stick mostly to these carbohydrates.

You can run into all kinds of weather. In the summer months, it can be hot one minute and within a half- hour there can be a thunderstorm with hailstones the size of golf balls. The temperature can drop 20-30 degrees with winds up to 60-70 miles per hour. It can even snow at night and you can have temperatures in the high 30's and low 40's. The next day, it will be 90 degrees. Never go anywhere without a wind-breaker and layer your clothing.

If there is lightning, get in a low spot or find some kind of shelter. If you're near your car, get back to it. During the monsoon season, normally in the summer, you might find the best hiking times are early in the

It's an easier hike now.

morning until early afternoon. Not only is it cooler then, but the thunderstorms usually start in the afternoons and evenings. You're liable to see all kinds of animals. Most of them will be afraid and run from you. Don't approach them or especially, don't try to feed them. Some of the animals in National Parks are fairly used to seeing people and you can get close to them, but leave them alone.

Equipment

Always wear long pants and a long sleeved shirt, even in the summer. Your legs can get ripped up hiking through scrub-oak, the various bushes with big thorns, and cactus. Some of these cactus needles seem to jump several inches just to get into you. Be sure your clothing is large and roomy so it layers easily and you can put water and lots of stuff in your pockets. It also makes it look like you've lost weight. Put on sunscreen in the morning and again at lunch-time.

Always wear high, sturdy hiking boots, especially when you get older. Your ankles can turn over very easily on the rough, rocky surfaces. Buy the best boots you can get because you spend a lot of time in them. It's like having a good bed. Keep an old pair of boots for wading in streams. Take a quarter inch drill and drill several holes at an angle of about 45 degrees in the bottom of the boot for the water to drain out.

You should have two or three knapsacks - a small daypack for short hikes, medium sized for half-day hikes and a larger one for all day hikes because you have to take more water, food and survival equipment. Also, in the winter, a larger pack is necessary to carry heavier clothing. As a rule, when you get older, you also don't do overnight backpacking where you have to carry about 50-60 pounds of equipment and food.

The following is a list of what you might use in your backpack for a long one-day hike. You can adjust these items for your particular need. Keep the following items in a storage case and only take what you need for the particular hike.

- Binoculars
- Water - 3 to 4 quarts or liters
- Water purifier pump
- Topographical maps
- Small radio for weather reports
- Small flashlight with extra batteries
- Windbreaker
- Food + energy bars

- 2 cameras - one for backup
- Compass
- Small first aid kit
- Hearing aids
- Whistle
- Wide rim hiking hat
- Gaiters*
- GPS and user's guide and extra batteries
- Sunscreen/insect repellent
- Cell phone
- Matches and propane lighter
- 10 feet of 1/4 inch nylon cord
- Knife
- Snake Bite Kit
- Extra car key
- Small notebook and pen
- Pills - extra day of regular pills
- Ibuprofen or aspirin
- Toilet paper
- Walking stick or walking poles
- Motorola 2 mile range radio with extra batteries
- Poncho
- Leather gloves - elk or deerskin seem to be the best

* Gaiters can be found at a sporting goods store. They are a cloth covering for the ankle and keep dirt, foxtails and cheat grass out of your boots and socks. They are much like spats.

More Tips

Before leaving on hike:

- Plan your trip
- Match your skills and endurance to the trip
- Use a checklist
- Pull off weather reports off computer or check in newspaper
- Buy maps of the area you will be hiking in or obtain maps off the computer

One word of advice, once you get older and you are asked to go on a hike, check your maps carefully. If you see a whole bunch of lines close together across your route, find some excuse for not going. Those close lines mean steep, up and downs.

A good way to judge the distance you travel is to walk at a normal pace around a 1/4 mile track at one of the local schools, with a backpack on and boots, and see how long it takes you. Wave at all the people who stop to look at you so they don't think you're strange. Normally, it's about five minutes to go 1/4 mile for older people so that you can do approximately three miles on a flat surface in an hour. Younger people will do it a little faster.

One thing to remember though, is that one mile on a topographical map doesn't mean it's a twenty-minute hike. You might have to go down 100-200 feet or up a few hundred feet in what looks like one mile across the map. This can double or triple your time. Also, you have to zigzag around objects, bushes, rocks, climb over rocks, walk through sand, etc. It might be much longer than a mile by the time you get to what appears to be one mile on the map.

Tell someone where you're going and when you plan to be back. As outlined in the auto section, it's best to give them a map of where you are going, marking the exact hike with a highlighter pen.

Listen to your body. If you don't feel well that day, don't go. If you're on the trail, be sure and drink enough water. It's always best to drink before you're thirsty, eat before you're hungry and rest before you're tired. When you get tired, it's easier to injure yourself. You might find that when you rest, keeping your legs up would help the circulation.

Just take what you need for this particular hike. Try to keep your backpack as light as possible.

If you forget your compass for some reason, the following will give you general directions. It might sound obvious but in the morning the sun is to your east, mid-morning, it's southeast. At noon, the sun is south, mid-afternoon is southwest and in the evening, it's west. Also, if it's cloudy and you can't see the sun, you will usually find lichen or moss on a tree or a rock. They are almost always on the north side.

Know when to turn around and start back to you car. Keep listening to your body. Also, be sure other people in your group are doing okay.

Old guys should remember that Medicare does not cover helicopter rescues. Keep track of everyone. If everyone has a Motorola 2-mile range radio, you'll be able to keep in contact. It's also good to use in your cars as you drive along.

If you think you're lost, most of the time you're not. Just stop, check your map and get your bearings. Don't get upset or panicked. Use your whistle so that the others can hear you. And if you have a GPS, see what

direction and how far you are from your vehicle. Start back if you don't see or hear anyone.

On the hike, tread lightly. If there is a trail, stay on it and don't create new trails.

Take only pictures and leave only footprints. Pack it in and pack it out.

Follow site etiquette for rock art and ruins.

Never wear Levi jeans. They put waist sizes in big numbers right on the back pocket and it's embarrassing to have everyone know how big your waist is and how short your legs are.

If you have hearing aids, ALWAYS wear them when hiking. You can't rely on seeing rattlesnakes and they don't always rattle but most of the time they do, and you want to be able to hear them.

When driving, turn your hearing aids down a little or you will hear noises like you have never heard before. You'll be a nervous wreck wondering if your car will ever get you back to civilization.

If you hike alone, which is normally not a good idea, try to go on weekends when there might be more people around. If you go with others during the week, you have a great chance of never seeing anyone.

Weather

The one weather tip that is almost never wrong in the Southwest is called the mackerel sky. When you see high, scaly type clouds, it usually means rain within the next 24 hours. Also remember, in this area, you can go four months or so without any rain.

At night, you can get all kinds of radio stations in the Four Corners area. They come from Los Angeles, San Francisco, and Phoenix areas. Try to get the weather forecast. If it's raining in San Diego, you can expect the weather coming from the west to east, to hit where you are in a day or so.

You can always get KNX at 1070 A.M. from Los Angeles on your radio at night. Not only do you get weather reports, it's also fun to hear about all of the traffic jams on the Hollywood and San Diego Freeways as you're eating your steak cooked over a mesquite fire and watching the sunset and the stars come out. KCBS at 740 A.M. out of San Francisco always comes in and you can hear about the cars on Highway 101 being backed up to San Rafael from the Golden Gate Bridge or the eastbound traffic on the Bay Bridge is at a complete standstill. Try not to smile.

In the monsoon season, July, August, and early September, you get big buildups of clouds that start in the blue sky in the morning. They usually mean thunderstorms will move through and move pretty quickly. Clouds that start as high cirrus and buildup over a day or two mean longer rain storms.

If you get a lot of dew, it usually means clear weather. Check the grass in the morning if there is any, and if there's lot of dew or steam coming off the river or lake, it should be a great day.

One day, back during World War II, my friend, Hayden Mathews and I were hitchhiking (was okay back then), from Camp Teela-Wooket in Vermont back to our camp in New Hampshire. It was raining cats and dogs and we were out in the boondocks on a dirt road near Corinth Center, Vermont. An old farmer came along in an even older pick-up truck and stopped for us. Soaking wet, we got in the truck and said, "Boy it's a rotten day out". We'll never forget when he said to us in his Vermont accent, "It's a good day for its ki-und". Since then, I've never complained about rain. I think that old guys make up 81% of the people who watch the weather channel.

Lightning and Thunder

You normally don't have to be told when a storm is directly overhead, but if you see lightning, count the seconds, i.e., ONE THOUSAND-ONE / ONE THOUSAND-TWO. And if you hear thunder in 10 seconds, the lightning is 2 miles away. In other words, divide the seconds by 5 to get the distance.

Also, check wind changes. Everyone knows when a front passes as it clears up to the northwest. Keep in mind, if the wind is shifting clockwise, it usually means good weather. Shifting counter clockwise is bad. Usually, it will bring a storm.

Cell Phone and GPS

Just recently, Qualcomm bought Snaptrack for one billion dollars. This doesn't mean much to you unless you follow the technology sector but Qualcomm is San Diego based and supplies chips and technology to the cell phone makers, like Motorola and Nokia. Snaptrack, from San Jose, uses the GPS System to locate the positions of all cell phones, pagers and hand-held computers. This is going to create a whole new industry combining the wireless Internet with position location.

If you are on a hike, you'll probably be able to hit one button on your cell phone for emergency, i.e., 911 and the phone will broadcast your

exact position to search and rescue people, who you can talk to about your problem as they come to get you. There will be all kinds of applications and uses that nobody has even thought of. For one, you could be driving along and hit a restaurant key on your phone. This is relayed to a computer and takes your position, and gives you a list of restaurants by category in your area.

The new devices will also have speech recognition, which will go to a computer that translates your voice into printed words. You'll be able to ask where the closest gas station is and within seconds, it will come back and give you directions on the phone display or tell you verbally over the radio.

Right now, some of this book is done by a program called Dragon Speech. You can talk into the microphone up to 100 words a minute and it types out what you say on the computer.

The mapping and hiking applications that will be available in the future will probably boggle your mind. With an inverter in the car, you'll be able to run a computer, printer, and obtain weather, maps, topographical maps and stay in touch with everyone by e-mail. I had hoped I wouldn't live this long. Today, even Motorola and Clarion are already putting some of this capability in cars and it will all be voice activated. A Company named Gentex Corporation in Michigan has put together almost all of the same capabilities in a rear view mirror with a microphone that is also voice activated.

Companions

I used to hike alone to most sites when I was younger, mostly because it was difficult to find anyone else who had the time, the interest, or the inclination to want to pick up on the spur of the moment and take off for parts unknown. A lot of people work and some of the trips you can't complete in a weekend. Also, older people can't plan very far ahead because they never know how they're going to feel.

You should always have some companions along just in case you sprain your ankle or have some other problem. You always have to look for the right hiking partners. It is not only a science but also an art to determine whether or not you have the right people. You want someone to hike with you who will still be your friend after the hike.

Qualifications:

1) They should be in good health, in shape and preferably walk or hike a little slower than you.

2) If they are the Leader, be sure they know where the site is.

3) If one of them has a helicopter and you can avoid a long hike - go in the helicopter.

4) Try to have one young person with good legs who can explore the side canyons and higher sites while you find some shade and wait for them.

5) If they take pictures, stand next to the biggest guy you can find so you will look thinner. Never stand next to a tall, thin person when they are taking pictures.

Hike Leaders

If you have over three or four people on your hike, you need a Leader and a "Tail End Charlie" or "Sweep" to bring up the rear. It is desirable to have everyone in touch by 2-way radios. If you are not the Leader, be sure that the person who is leading is qualified.

A Leader is like the Captain of a Ship and is responsible for the following:

- That everyone is physically capable, equipped and has enough food and water.
- That he knows where he is going
- Knows when to rest
- Knows when to eat
- Knows what pace is suitable for everyone
- That everyone stays together
- When to turn back if necessary because of weather or other problems

The Leader is not always out front, as he has to keep an eye on the other hikers to monitor their condition. Tail End Charlie is responsible for seeing that all the people are in front of him and always carries first aid equipment. If there is a large group, you can always have scouts out in front to find the best and easiest way to get where you are going if there is not a trail. When you are going to a rock art or ruins site where there are no trails, try not to make a trail. Walk along side other people and keep out of each other's footprints. A new trail can lead possible vandals directly to a site.

More Companions

Sometimes old guys will be asked by women to go on one of their hikes. You have to be very careful. Almost all of them are in better shape, tougher, faster and can leave you in the dust. It's nice to go with them because they usually bring hors d'oeuvres, know where a lot of the best rock art sites are and are absolutely fantastic at opening and closing cattle gates.

But they still walk too fast, so it's best to let them carry the extra water and food to slow them down a little. If they carry about 15-20 pounds more than you do in their backpacks, it's just about right. Increase the weight one pound for every year they are younger than you.

Private Property - Self-explanatory

Excuses

You won't believe the excuses you get when you call someone to go on a trip with you. I think I've heard them all and then some. I called a friend one night to schedule a trip and he told me he was going in for brain surgery. I thought "I've heard them all now" but actually he did and he is now well and hiking with me again so the surgery probably didn't take.

Sometimes you don't get an excuse, but people never call you. There's probably a message there somewhere. Many times when you call, you don't get an answer, but you get to know the ones who have Caller I.D. Some of the others have gone to unlisted numbers.

In the same manner, you might want to keep a list of excuses right next to your telephone, so if someone calls and you don't feel like going, you scan it for the best excuse to use. I just added a new one that in fact actually happened. I opened up the refrigerator one morning and a huge jar of peanut butter fell out and broke my toe.

Random Comments

At *www.topozone.com*, you can print off 1:100,000 and 1:24,000 topographical maps for free. Be sure to run some off for the hikes you are going to take. This is especially nice because you can't get topographical maps at your local stores or Bureau of Land Management (BLM) etc. for hiking areas that aren't fairly local.

You can ask a rancher for directions, but unless you know the name of every wash, fence, rock and hill in the area, you're better off trying to find whatever you're looking for yourself. But be very nice to them because "HE NEEDED HANGIN'" used to be a valid defense in the Old West.

Old guys get free passes to National Parks, Monuments and many State Parks. Young people have to pay.

Spray-paint your maps with Thompson water seal to protect them from rain, ketchup, mustard, etc.

If a woman says something when she's out hiking alone and her husband is not there to hear it, is she still wrong?

It's easier to walk in sand when it's wet after a rain or a flashflood. If you can plan your trip to hike a sandy area, after a front has moved through, and the sand is wet, it'll be twice as easy to walk.

You have worn out your welcome with the Park Service, the BLM, or Forest Service when you go in to get a map or some information and

YOUR picture is on a wall behind the desk and underneath it says, "DO NOT TALK TO THIS MAN."

If you have a problem, look around for anybody with a whole bunch of keys hanging from their belt. This will normally be a Ranger and he or she can help you.

More Random Comments

We hike with an old guy who moved out West from Back East and is interested in the prehistoric Southwest. He brought artifacts from many of the Eastern Tribes that were handed down in his family over the years. His ancestors were the third group to arrive in the New World aboard the Julyflower.

We have a friend from Canada who keeps saying that if he had to do it over again, he wouldn't change a thing. BARF ALERT. If I had to do it all over again I'd be born anywhere in the West or Southwest where you didn't have to shovel snow or wear anything more than a sweatshirt. La Jolla, California looks like a pretty good place to be brought into the world.

We stopped hiking with this one old guy who began to "lose it a little." He went on a trip to southern Utah with us where one night we stayed in a motel. As we checked in we noticed at the bottom of the motel registration, where it says, "Sign Here" he had put Aquarius.

Global Positioning System

GPS stands for Global Positioning System. When we mention GPS in the book, we are referring to the hand-held GPS Receivers that are about the size of a camera and you can now buy for around $100.00 or more. You get them at Walmart, or any sporting goods store.

Without getting into a lot of detail, the Global Positioning System is a group of satellites orbiting the earth and they are constantly transmitting their location by radio signals. The GPS Receiver receives this information and translates it very quickly to tell you your position and altitude at anytime, 24 hours a day, anywhere on the planet, and in any weather. Clouds and rain don't interfere with the radio signal.

To do this, you have to pick up a certain number of satellites. Since the radio signals from the satellites travel in a straight line, you need an unobstructed view of the sky. If you are in a narrow canyon or under trees, you won't get reception from enough satellites. You can usually get to a clear spot within a few yards to get proper reception.

Since all navigation is based on time and the position of the satellites, you have to be sure your GPS is initially set up according to instructions

and it is especially important to get the correct time of day. After that, you don't need to do anything unless you travel more than 300 miles away and then you just initialize it again.

While this is all great, the GPS won't do you much good unless you have a compass and maps so you can use the information provided by the GPS. There are many uses for the GPS, like recording landmarks. Once they are saved, you can determine from your present position the direction and distance to that landmark.

Like any other instrument, you must use it continuously and remember how to operate it to obtain its full capabilities. Don't forget to always bring your user guide. It's easy to forget one little step or procedure in obtaining the correct information.

The government has just recently taken the scrambler off the system so that now, when you take a reading, you will more accurately find your position within a few feet. Before, it could be as much as 100 yards off or about the length of a football field when the scrambler was in use.

10

Camping

Camping isn't as easy as just getting a motel room, but most of the time it is more fun and peaceful. You become more aware of nature and your surroundings - when the sun comes up, where the moon is and a Milky Way that looks like you can touch it.

As you travel through most of these remote areas, it will be much like what the Indians saw and experienced a thousand years ago.

Everyone has his or her own idea about what camping is. We watched a motor home pull into Homolovi State Park Campground in Arizona one night just before dark. It seemed like it was longer than a football field and was towing a Lexus SUV. On top were two Satellite T.V. Dishes (one for the kids and one for the parents) and two air conditioners and there were lights coming out of every window along with music. It must have had a V-24 engine.

If you camp like me, you're going to do it a little differently. Most of the time you won't be in a campground, but out in the boondocks all alone with no boom boxes blaring half way into the night and flies and little animals frequenting the campsites where people have left food. Try to keep it as simple as you can. During the season, you will probably go to bed when it gets dark and get up when it gets light.

If you're older and used to camp as a kid, you will find that things have really changed. No more blankets and blanket pins and ponchos. Today, you get to use a tent that goes up in a couple of minutes, sleeping bags, inflatable air mattresses, pillows and you can cook over a propane stove. Below is a list of what you will need. Start your own checklist for what you think you will require.

- Tent - two man tent with rain fly and windows all around
- Tarp
- Two sleeping bags -Summer bag plus a 3-season bag
- Air Mattress - with an electric and a hand pump
- Therma Rest Self Inflating Mattress
- Japanese Pillow (filled with buckwheat)
- Propane Lamp - 2 mantle type

That's about all that is required except for the cooking equipment that you will carry which is covered in the Cooking Chapter. To be sure your tent is waterproof before you leave on a trip, get inside and have someone spray it all over with a hose. This way you will find the seams that need to be sealed. If you get in a large thunderstorm with high winds, don't worry about it. You're going to get wet anyway. But, in the West, it's amazing how fast things dry out. If you're camping in the East and you get wet, you can be soggy for days.

Always set up camp as soon as you get to your spot. And, always use a two-man tent with windows on both back and sides for ventilation. You need a two-man tent because by the time you get yourself and your pills and some other gear in there, you will fill it up.

Put the tarp down first, on some pretty level area, then put the tent up and throw a knapsack or something heavy on it to keep it from blowing away if the wind is up. Then you can put some spikes on the corners to hold it down. It's always nice to put the entrance to the east or southeast like the Indians did with their pithouses. Plug your air pump into the cigarette lighter and blow your mattress up. Put this inside the tent; unroll your Therma Rest self-inflatable mattress and put it on top of the air mattress. This gives you extra insulation from below if it's cold. Put your sleeping bag and pillow in the tent along with a flashlight, your medicine bag, water, pills, guns and whatever you think you will need during the night. The Japanese pillow is filled with buckwheat and adjusts easily to your neck and shoulders. It can also be used in lieu of a tripod to set in your car and support a camera with a telephoto lens. It acts much like a beanbag.

After everything is in, be sure to keep your tent zipped up all the time. You never know what might crawl in when you're getting dinner.

The reason for the two sleeping bags is that in the summer, you use the light one. Fall and spring, you 'll probably use the 3-season bag. But on some colder spring and fall nights or in the winter, you can put the summer bag in the 3-season bag and it gives you that extra warmth. You don't need expensive down sleeping bags. The bags you use, you won't even roll up, and you'll just fold and put in your vehicle.

After you get the tent up, get the folding chair out of the vehicle along with your camping box. You can use that for a table after you get everything going. It's nice to just sit around and watch what's going on. You might see all kinds of things including great sunsets and especially curious animals. There's always a hawk or eagle flying around looking

for dinner. Camping out alone reminds me of the time Hayden and I snuck out of our cabin at Camp Idlewild on an island in Lake Winnipesaukee, N.H. one night to get night crawlers on the golf course to go fishing the next day. As we were collecting the worms, we saw the Northern Lights shooting in colors for the first time. Normally, they were just white. You can imagine what the Indians must have thought when they first saw this. Aurora borealis is the scientific name.

Sometimes you have time to do something before it gets dark and you have to go to bed. Some things that I always carry with me that you might use are:

Fishing Equipment

If you're near a stream or someplace like Lake Powell, you can spend an hour or so near Sunrise or sunset casting surface lures for bass. Remember the old saying, "Give an old guy a fish and he will eat for a day, but teach an old guy to fish, and he will sit around all day in his boat drinking beer."

Gold Pan

You might find a little gold dust panning in a small stream or dry panning in a wash. You almost always find at least a speck

Atlatl and Dart or Spear

You can find it fun to pick out a target and just practice a little. It doesn't take long to figure out how difficult it was for the prehistoric hunters to get close enough and stalk game in order to get their dinner.

Wood Bag

Carry a little hard wood and kindling to have a small fire. This is more for atmosphere than anything else. Be sure there's no fire watches up and you put it out completely before going to bed. On cooler nights, it's nice to set the fire up and then start it up in the morning for the extra warmth.

Keep a pair of old running shoes for changing to from hiking boots. It helps your feet and lets your boots dry out. Keep the hiking boots in the car and when you get into the tent, be sure to put your running shoes inside and then zip up. Things tend to crawl in your shoes if you leave them out all night, like spiders, lizards and snakes.

Campsite Etiquette

Follow the "leave no trace" policy and don't camp near rock art sites or ruins. Try not to disturb the vegetation and pack out all waste and trash.

Also, do not set up your camp too close to a river, stream or spring. It disturbs the animals coming down to drink at night.

Don't ever camp in a wash.

<div align="center">**********</div>

Random Comments

If you're going to a National Park or a Monument the next day, you might want to talk to the wall of your tent, or if a motel, the wall of the room for a few minutes in the morning. This will get you used to the responses that you will get from Rangers when you ask them questions about rock art sites.

Don't take your dog camping. Babe is the only dog I know you could take because she's had lots of experience. Most of the time they growl all night long and your imagination can run away with you as to WHAT'S OUT THERE? It's hard to sleep when you think your life is in danger.

Keep your tent zipped up. Tarantulas aren't poisonous but when they crawl up your arm, they can scare you to death.

In the West, on the Interstates, you will find many truck stops. If you get yourself a Peterbilt Hat, you get really fast service in the driver's restaurant section. In California though, where they are a little more yuppyish, go for a Volvo Hat and dark glasses.

Power Toothpicks

Toothpicks are sometimes very important in the West, just like Twinkies. They come in several colors - red, blue, green, yellow and plain. It's important what color you choose depending upon what the situation is. It is a great way to communicate. After a power lunch of a peanut butter and jelly sandwich, you definitely need a power toothpick.

If you're going into a restaurant, the best one to chew is red. It shows control, passion, power and leadership.

Use the blue when asking directions at National Parks and BLM Visitors Centers. It shows that you are a sensitive, caring, sincere and honest person.

Yellow reflects that you are happy, outgoing, friendly and appreciative. This also works quite well at Visitors Centers and asking other people for directions to rock art sites.

White or natural means peace, patience, understanding and tolerance. That's for talking to people from the East with New York or Boston accents.

11

Photography

You will probably never be at a rock art site at the perfect time of day or year to get the best pictures. Some are morning sites; others are afternoon and some sites you can never get a good picture of because they are faint, in a crack in a rock or at an angle where there's no way to get a good shot.

Some people just like to look at rock art, ruins and the surrounding areas. They are only interested in getting a few pictures. Others like to get the best pictures they can, including close up details of the interesting art.

The people interested in serious photography already have their equipment and know how to use it. This section is for people who want to get good pictures to show friends or relatives, but don't want to get too involved or spend too much money.

Most people are still partial to 35mm cameras and film. This is because you have a large range of films, camera bodies and lenses to choose from. You can also interchange regular print film of all speeds as well as transparencies or slide film. If you have more than one camera (it's always best to have a backup), be sure they all use the same film size.

Starting at the low end, a simple, good fixed lens point and shoot camera will probably cover 75% of all the pictures you will take when shooting rock art and ruins. If you only take one camera, an Olympus Stylus Epic is a good choice. It is small, weighs less than 5 ounces and has a relatively wide angle 35mm f/2.8 razor sharp lens. It also has flash options and an excellent auto focus and auto exposure. You might have to climb a little to get close to the rock art, but you can take pictures of everything from thirteen inches away to infinity. They cost under $100.00 and are almost foolproof. It might be best to carry two of them for backup on longer hikes. You can carry print film in one for sending prints to people and making enlargements, and the other to carry transparency film incase you want to show slides on a large screen.

Another option is some of the point and shoot cameras with zoom lenses. This gives you a little more versatility without losing too much in quality. You will see some great pictures taken with some of the newer

point and shoot 38-105mm and 38-140mm cameras. If you're going this route though, many people feel that the wider-angle zoom lenses give you more flexibility. Olympus makes a 28-80mm zoom and it takes excellent pictures. Also, the Rollei Prego Zoom 90 with a 28-90-mm zoom is a good choice. In some places, you will require at least a 28mm wide-angle lens to get a whole panel in the picture. Sometimes you are on ledges and can't get far enough away to get the whole panel or even parts of it in the frame with a 35mm or 50mm.

To make consistently good pictures, you should probably have a 35mm SLR (Single Lens Reflex) camera, a good lens and importantly, a circular polarizer. There are so many good cameras and lens around today; you have lots of choice and capabilities as well as price. All the major companies like Nikon, Canon, Minolta, Pentex, Olympus and Sigma have a large selection.

A Canon camera body with a zoom image stabilizer lens would be a great choice. If you don't want to carry a tripod, or are a little bit shaky like a lot of us when we get older, this lens can save a lot of pictures you would otherwise miss. A Canon Rebel 2000 Body with a 28-135 mm IS Zoom Lens is a good combination and won't run you too much money.

Also, Sigma and Tamron make excellent zoom lenses that fit all the major camera bodies. They both have 28-200 mm and 28-300 mm's which cover a great range of pictures you would be taking. With this wide range you won't have to change from one lens to another when you're hiking.

Digital cameras are also coming into their own. Right now, though, you seem to get better pictures from scanning in 35mm slides and them printing them than you do from the actual digital cameras. But things are changing quickly and by the time you read this, they could have some really mega-pixel cameras on the market at reasonable prices. New chips designed by Foveon, Inc. for digital cameras are scheduled to be on the market by early 2001. They have 16.8 mega-pixels compared to the two to three mega-pixel cameras generally available today. The process to make these new chips will be much cheaper than the image sensors being built today. This should put professional quality digital cameras and imaging on the market at reasonable prices. At 16.8 mega-pixels, they have almost twice the resolution of today's 35mm film and will be able to provide exceptional quality in prints and especially in enlargements.

Other Equipment

Camera Cases

Always keep your camera in a padded case when you're not using it. You can keep small point and shoot cases on your belt and your SLR in a holster type case with a shoulder strap or on your belt.

Lens Cleaning Kit

After a day of tramping around in the West, you can pick up a lot of dirt and dust. You should clean your lens every night.

Air Blaster

This is good to use during your hikes to get dust particles off the lens, especially if the wind is blowing.

Tripod

Get a good sturdy tripod with a ball head.

Walking Stick and Monopod

A combination walking stick and monopod is not as good as a tripod but works well and can save you a lot of pictures.

Nylon Cord

In a pinch, if you don't have a tripod, you can use the quarter inch nylon cord that is in your knapsack. Make a loop around one end of the nylon line and hold it with your foot. Wrap the other end of the nylon cord around your hand and pull it up tight. Then clutch the camera with the hand that has the cord wrapped around it; press it against your forehead and point and shoot. You'd be surprised how steady your hand is. I use my right foot and right hand. It's almost as good as having a tripod. This helps steady the camera for long shots.

Backup Cameras

It's always good to have 1 or 2 depending upon the length and type of hike.

Extra Batteries

Always take a couple of spares for each camera. Even if you don't use them, for some reason, people always need them and you might be able to lend one to somebody in a pinch.

Extra Film

People are always running out of film. Be sure and take enough which is about twice as much as you think you need. You will always be able to use the film so don't cut corners here.

Illuminator and Shade

A folding illuminator will help you get pictures of darker or shaded panels by reflecting light onto the panel. When a panel is half in shade and half in the sun, you can also use it to shade the whole panel so you can get good pictures.

Circular Polarizer

This filter is almost a necessity to get pictures when the sun hits the rock art and either washes it out or causes a glare. It works best when the sun is on your left or right side about 90 degrees and you will be amazed at how it brings out the detail as you turn the circular polarizer on your lens. It's especially satisfying to say "WOW, this really brings it out," and when you know no one else in the group has a polarizer except you.

Tips

If you're driving along and you see antelope, deer or a coyote, etc., and want to get a quick shot with your zoom, keep your Japanese pillow handy. Just set your pillow on the hood of the vehicle and settle your camera on the pillow and in most instances it works just as well as a tripod.

If you run across a rattlesnake, you need an image stabilizer lens or you won't get a good picture. Your hand is shaking too much.

Auto Focus - You will find out that auto focus works better most of the time than your eyes.

Mother's Day is always a great time to get your wife a new camera or lens.

You will find it almost impossible to capture the beauty of some of the places you go with your camera. I have found that Fred Hirschmann, David Muench, Craig Law and Tom Till and a few others take pictures of rock art, ruins and scenery that you or I only wish we could. They all have books out as well as calendars, which are well worth getting. They take the time to get to the sites at the right time of day for the best light. In most cases, that would mean backpacking for old guys like us to do the same thing. Until you hike to some of these sites, it's hard to appreciate the beautiful pictures and how difficult it is to take them. They also have to carry large and medium format cameras, tripods, and gear over some rough terrain to get to some of these sites.

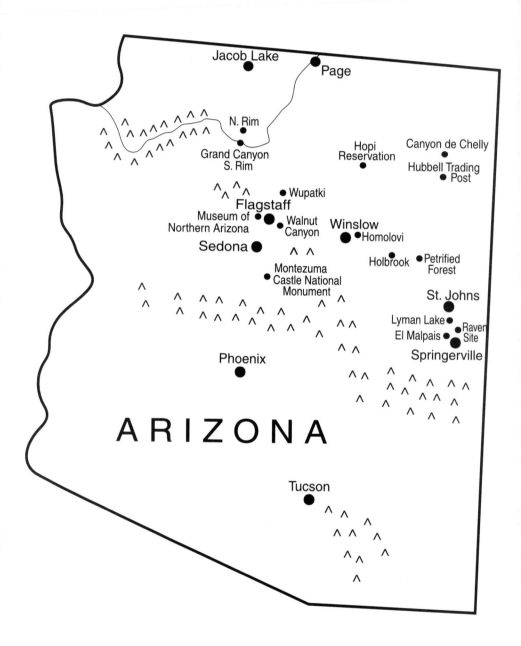

Canyon de Chelly National Monument

Arizona

Hubbell Trading Post - Lyman Lake - The Raven Site - Casa Malpais

Canyon de Chelly (da Shay) (520-674-5500) is probably one of the most beautiful places in the Southwest. The Monument not only includes the actual Canyon de Chelly, but several other canyons containing rock art and ruins. The whole Monument encompasses 130 square miles.

The canyons, with sheer, red sandstone walls with streaks of desert varnish, contained the homes of the Anasazi for a thousand years, from about A.D. 300 - A.D. 1300. Before that, there is evidence of the Archaic peoples, the classic hunter/gatherers, who occupied the area from about 2500 B.C.

There are several ways to see Canyon de Chelly, and you will need a minimum of two full days to do it justice. Most people take the half-day or one-day tours that operate out of the Thunderbird Lodge. The Lodge Tours use 6-wheel drive army trucks reconditioned from the Korean War days. You sit in rows in the uncovered rear of the vehicle. The half-day trip is about 5 hours long and costs about $30.00. It is well worth taking the full day tour which is about $50.00 including lunch.

The full day trip takes you down Canyon del Muerto, stopping at a couple of rock art sites of both Anasazi and Navajo pictographs and ends up at Mummy Cave and Massacre Cave. As you proceed down the canyon, the walls get higher and higher. Then you backtrack to the junction of Canyon del Muerto and Canyon de Chelly and head up Canyon de Chelly for the White House Ruins. After spending some time there, you continue east to Speaking Rock and Spider Rock. As you proceed east, the walls are now reaching about 1,000 feet above the canyon bottom. And you can see rock art and ruins all the way. Along the canyon bottom, you will see hogans, where the Navajos still live and the land where they raise their sheep and crops.

After a snack, on the eastern side of Spider Rock, which is almost as tall as the rim of the canyon, you return to the Thunderbird Lodge. The trucks are sometimes pretty bouncy so that by the time you return you are pretty tired. If you hit a thunderstorm, they provide you with large ponchos with hoods, which are surplus from the West German Army.

Either before or after the trip into the canyons, you should take the drives up the north and south rims. You can do this in one day. Both of the drives are about 35 miles round trip and each has marked overlooks into the canyon which gives you a totally different perspective than you get from down below. The south rim along Canyon de Chelly has the most stops, with eight stops. Be sure you have binoculars and camera equipment. If you don't have time for a guided trip in the canyon, you can walk down to the White House Ruins from the overlook on the south rim. It is 2-1/2 miles round trip on a switchback trail that goes all the way down to and across the canyon to the ruins. And of course, it's uphill all the way back. (It always is). The total elevation change is about 600 feet and takes about three hours.

The longest walk on the south rim overlook road is to Spider Rock, which is just about 1/4 of a mile through some great scenery. This is the last stop on the south rim road.

On the north rim road, you have four stops. The first is the Ledge Ruin Overlook. At the second stop, you will have about a half mile walk to the Antelope House Overlook and Navajo Fortress. Both are well marked. At the Mummy Cave Overlook, you can see the cave across the canyon where, if you took the full day tour, you would have had lunch. The last overlook is Massacre Cave, where the Spanish killed between 50 and 150 Navajos in 1805.

Directions

From Interstate 40, take Exit 333 in Chambers, and then take Route 191 north about 75 miles to Chinle, Arizona. The Visitors Center is 3 miles east of Route 191 through the center of Chinle. To put it in perspective, the Chamber's Exit, 333, is about 50 miles west of Gallup, New Mexico and about the same distance east of Holbrook, Arizona. Canyon de Chelly is also about 330 miles north of Phoenix, via Payson and Holbrook; about 215 miles east of Flagstaff, via Interstate 40 to Chambers and 138 miles south of Cortez, Colorado.

Time of Year

Late spring and fall are great times to see Canyon de Chelly. It is less crowded than in the summer, but the days are still very warm in October. Early spring and summer are also good times but in the summer, you can have days over 100 degrees down in the Canyon.

Type of Hike

The only hike you can do on your own, is the one to White House Ruins. In the spring, or in the summer, after a thunderstorm, you may have to wade across the creek to get to the ruins once you get down in the canyon.

Guided hikes are available from the Navajo Guides who you can hire at the Visitor Center Desk. (520-674-5500)

Twice a week, there's a 3-1/2 hour rock art hiking trip to the Tunnel Canyon Area. This is a moderate hike on a trail. You should sign up ahead of time. It leaves Tuesday and Saturday at 8:30 a.m. and returns about noon and is guided by one of the Monument Rangers.

You may also hire a Navajo Guide to take you and your own 4 Wheel Drive vehicle into the canyons for a private tour. This is the best way to see more of the rock art that Canyon de Chelly is famous for. Check at the Visitors Center for availability and rates.

Photography

You will definitely need at least a 28-200mm zoom lens or a 300-400mm telescopic lens if you have one. Take your tripod because some of the shots are quite long and the rock art is shaded during all or part of the day. You can't get as close to some of the rock art and ruins as you used

Flash flood claims a Department of Fish and Wildlife SUV in Canyon de Chelly. In case you can't read the sign on the back, it says: "How's My Driving? 1-(800) 354-6788" I called three times to give my opinion but no one answers.

to be able to, so the tripod is a must. You won't have to carry it often so bring your sturdiest and heaviest one.

Please don't take pictures of the Navajo people or even their hogans without asking permission. While most don't mind, it's just a courtesy to be extended, as you will be passing several hogans and Navajo's on your trip in the canyon.

Accommodations

Camping

They have a nice little campground at Canyon de Chelly with no camping fees. It's called Cottonwood Campground and is available on a first come, first serve basis. The best thing to do is try and arrive about 3:00 or 4:00 in the afternoon and set up your tent on one of the sites and unpack what you need. Then you can take off and do one or maybe both of the rims overlook roads that afternoon and evening in order to get some great photographs before it gets dark.

The campground is quite close to the Visitors Center and the Thunderbird Lodge and very convenient if you're going to take one of the guided tours in the morning.

One night about five years ago, I was camping here after an all day trip into the canyons. It was supposed to be after the monsoon season. There were very few people in the campground and next to me were a young Swiss fellow and his wife who rented a big RV in Salt Lake City and were touring the West for a month. He had come over the night before to ask for some directions and some other places to go.

About 3:00-4:00 a.m., the wind started to howl and we had thunder and lightening all around us. Then it began to rain. By 6:00 a.m. it was still raining and the sleeping bag and I and everything not in the SUV were completely soaked. It also started getting a little cold.

I got out of the tent and just collapsed it, picking it up with everything in it and jammed into the back of the SUV. I was just finishing up when I looked over and the Swiss fellow was standing in the lighted picture window of the RV with a cup of coffee in his hand waving at me. With water dripping off me everywhere I waved back. If there had been a RV Dealer in Chinle, he would have had his first sale of the day.

Motels

The Thunderbird Lodge (520-674-5841) also has 70+ rooms and a cafeteria that opens at 6:30 in the morning. It is quick and easy so you can get on your way. Be sure and get reservations at the Thunderbird for

the guided tours, especially in the summer. The Thunderbird has a great gift shop and was formerly a Trading Post.

The Best Western Canyon de Chelly Inn (520-674-5874) is just east of Route 191 on the right, on the way to the Visitors Center. It has about 100 rooms, a restaurant and an indoor pool.

The Holiday Inn (520-674-5000) is about half mile west of the Visitor Center and has about 100+ rooms and a restaurant.

Crock-Pot Recipe

Canyon de Chelly Corn Beef and Cabbage

 1 Corned Beef in a package with seasoning - about 3 lb Flatcut

 2 cups of water

 8 small white potatoes

 couple of handfuls of carrots

 1 small white cabbage

Put the corned beef and the water in the crock-pot; add the potatoes, carrots and cabbage on top and cook on low for 9-10 hours. This is also great for sandwiches the next day. Don't forget to pick up some cole slaw and some good sliced cheese for sandwiches.

Other Attractions

Hubbell Trading Post - Natural Historic Site (520) 755-3475)

About 38 miles south of Chinle, is the Hubbell Trading Post. Still running today, under the supervision of the National Park Service, you can buy outstanding Navajo rugs, baskets, pottery and jewelry and see Navajo women weaving the actual rugs in the building next door. The Trading Post is still much as it was in the late 1800's. If you're in the market for a rug, check out the Ganado Red. They're absolutely beautiful.

You can also tour the home of John Lorenzo Hubbell who was probably one of the best friends the Navajos ever had. He helped develop a market for the Navajo goods and even helped in the design of some of the rugs so they would be saleable to the public.

This is a place that shouldn't be missed to get a feel of the way they lived a hundred years ago on the reservation.

Lyman Lake State Park (520) 337-4441

In the area of St. John's and Springerville, Arizona, there are three places to see. They are south of Interstate 40 on Route 191. From the Hubbell Trading Post, go south on 191 to Chambers, Arizona. Take Interstate 40 east for approximately 6 miles to Exit 339, which is Route 191 South.

Go south to St. John's and then about 10 miles to Lyman Lake State Park that is about 6,000 feet in altitude. If the water is high enough, you can go across the lake to see the petroglyphs, which are above the dock. If the lake is down, you can walk around to the site and back in about 2 hours. There's a small herd of buffalo, right as you go into the park.

The Raven Site (520) 333-5857

About 6 miles south of Lyman Lake, you hit Tucson Electric Power Plant Road. Turn left or east and follow the signs. The ruins of about 800 rooms are located in a beautiful little site overlooking the Little Colorado River. The petroglyph tour usually leaves about 1:00 p.m. and takes a couple of hours. They have a neat store and several other programs that you can attend. Open from May to October, this site is a combination of the Mogollon and Anasazi Cultures.

Casa Malpais (520) 333-5375

This is another great ruins site a couple of miles north of the center of Springerville. The site sits on volcanic rock at 7,000 feet, also overlooking the Little Colorado River and was occupied by the Mogollon for over 200 years until approximately A.D.1400. They have a museum and guided tours that leave at 9 a.m., 11 a.m. and 2:30 p.m. daily.

The main attraction is the great kiva made from volcanic rock and a rock staircase that goes up a crevice in the red cliffs to the top of the mesa.

Random Comments

After leaving Canyon de Chelly, if you're headed up towards Lake Powell, go via Kayenta and Tsegi Canyon on Route 160. From Route 160 you turn right on Route 98 to Page, Arizona. As you drive along, you see these wonderful high tension wire towers that look like Fremont Style anthropomorphs.

13

Flagstaff Area
Arizona

**Grand Canyon National Park - Wupatki National Monument
Walnut Canyon National Monument - Homolovi Ruins State Park
Hopi Reservation - Petrified Forest National Park - Rock Art
Canyon Ranch - Holbrook Petroglyph Park - Montezuma Castle
National Monument - Montezuma's Well - The V-Bar-V Ranch
Petroglyph Site - The Museum of Northern Arizona - Palatki Ruin**

The Flagstaff area has many areas and attractions for anyone interested in beautiful country and prehistoric Indians. Most of these places are short drives from Flagstaff which is like the hub of a wheel. You can easily set up base camp here or in nearby Winslow and take several day trips exploring the area. You can go north, east and south to enjoy some of the best scenery, ruins and rock art in the Southwest.

Flagstaff sits at about 7,000 feet at the base of the 12,000+ foot San Francisco mountains - about 140 miles straight north of Phoenix, Arizona. But it is a different world from Phoenix, being much cooler and forested by ponderosa pines and firs. The famous old route 66 goes right through Flagstaff which has many coffee shops and some excellent restaurants. There are now about 50,000 people living in Flagstaff and it is the home of Northern Arizona University.

We shall start north and work our way around clockwise, but you can do them in any order you like depending upon the weather and your interest and priorities.

North

Grand Canyon National Park
Not much is left to be said about the south rim of the Grand Canyon. It is about 120 miles north of Flagstaff and is visited by about 5 million people a year. To avoid the crowds, try to go in the early spring or late fall. And even at those times, go during the week and early in the morning. The Grand Canyon Visitors Center, South Rim's number is (520) 638-7888.

If you're in the area in the summer, pass on the South Rim and go over to the North Rim through the Navajo reservation to Lee's Ferry

and west to Jacob Lake on the Arizona Strip. From there, it's about an hour drive to the North Rim. In all, the trip would take between 4 to 5 hours one way. The North Rim averages about 8,000 feet in altitude and is only open from about May 15 - October 15 or if they get a big snowstorm, it might close prior to October 15.

Wupatki National Monument (520) 679-2365

Wupatki is about 30 miles north of Flagstaff off Route 89. This is the land of the Sinagua who originally lived on this land in pithouses between an altitude of 5,000-6,000 feet. From around A.D. 500, they raised some crops and lived off large and small animals, pine nuts and other nuts and berries. Sunset Crater erupted about A.D. 1064 and forced these people to leave. A little after A.D.1100, they discovered that the ash, which had spread over the area from the volcano, had improved the soil. They moved back into the area and together with some of the Anasazi from the north, they started building above ground pueblos. Some of these were 3-4 stories high. About A.D. 1300, the people were all gone, leaving hundreds of ruins in the area.

Wupatki is famous for its large ball courts, which reflect the influence from the cultures from the south and into Mexico. There are several ruins you can see with the self-guiding trail brochures available at the Visitor Center. There are many petroglyphs in the area that usually can be seen only on ranger led backpack trips.

East

Walnut Canyon National Monument (520) 526-3367

Many people we know would rather go to Walnut Canyon than the Grand Canyon. It is only 3 or 4 miles east of Flagstaff on I-40. It is a magical and beautiful place. The Sinagua occupied this canyon only for about 100 years from A.D.1125 -1225. They lived in natural rock shelters and caves on shelves of limestone rock on the sides of the cliffs. For further protection they even built walls of stone and mud in front of these shelters.

On the rims of the canyon, there's land for farming and evidence of irrigation from that period. Also above the canyons are forests of ponderosa pines, pinion pines, Douglas fir, juniper and oak. Here they could hunt deer, big horn sheep and many small animals as well as raise squash, beans and corn. But because of the altitude, it was a very short growing season.

Down by the creek, they could get all the water they wanted and that is also where the black walnuts are found for which the canyon is named.

There are two self-guided trails that begin at the Visitors Center. The rim trail is about 3/4 of a mile and takes you by ruins and several overlooks into the canyon. The other trail takes you down about 200 feet to the "island" or peninsula and is about a mile long. You actually walk around the cliff on a trail and are right next to many of the natural shelters where these people lived centuries ago. Look across the canyon and you will spot other shelters.

There's a famous twin Kokopelli petroglyph near the bottom of the canyon but unfortunately, the area is now closed.

Homolovi Ruins State Park (520) 289-4106

Just past Winslow, Arizona, going east, at Exit 254 on Interstate 40 are the Homolovi Ruins. There are also several Anasazi petroglyph sites outside the park and in the surrounding area. Ask at the Visitors Center and they will tell you where the best sites are. It also has a top-notch campground. There are several trails in the park and as you wander around, keep your eye out for petroglyphs as well as ruins. When you are in your car and you see a rock face that looks promising, stop and it will probably have rock art on it.

The Hopi Reservation is only an hour or so north of Homolovi and they consider the ruins to be sacred to their people, so as you explore the park please respect this sacred place.

Hopi Reservation

The Hopi live on three high mesas in northern Arizona called First, Second and Third Mesa. They are believed to be the descendants of the Anasazi and Sinagua and have lived in these mesas for a thousand years. These mesas served as protection from the warlike Navajo and Apache tribes who moved into the area and spoke a totally different language.

The Hopi Reservation is totally surrounded by the Navajo reservation but most of the land disputes have now been resolved. The Hopi Cultural Center is located on Second Mesa and contains a nice museum as well as a motel and restaurant. You need reservations. (520) 734-2401

If you're interested in the beautiful Hopi overlay silver, you can buy this directly from the silversmiths who do the work. They have signs directing you to their shops on the different mesas.

Photography is prohibited on the mesas. But there are a few Kachina dances that are still open to the public.

Petrified Forest National Park (520) 524-6228

The name of this National Park is a little misleading. There's not only lots of colorful petrified wood around, but the park was also a haven for prehistoric peoples who built pueblos and left an abundance of rock art. Dinosaurs also roamed this area 200 million years ago.

Rather a barren place, the portion of the park you can drive is about 27 miles long from the north entrance off of Interstate 40 to the south entrance on Route 180. Entering the park from the north, there is a Visitors Center, restaurant and gift shop run by Fred Harvey Company of Grand Canyon fame. A couple of miles further south, stop at Kachina Point and the Painted Desert Inn. Inside the Inn you will see the famous cougar petroglyph of Petrified Forest. Unfortunately, it is now enclosed in a glass cabinet and difficult to get a decent picture of. In the old days, it was down at the south end and was easy to photograph.

About 8 or 9 miles south of here, you will find the Puerco Indian Ruins on your left just after you pass the railroad tracks. There are many petroglyphs as well as the ruins. The petroglyph that people like the most is the bird, probably a heron, with a frog in its beak.

From here, a mile or so south is the pullout on the right and the overlook at Arizona's Newspaper Rock. Unfortunately, you are not allowed to go down for a close view and take pictures anymore. You can still get a fairly good shot with a telephoto lens. Along the route south, there are all kinds of viewpoints and other attractions you might be interested in.

You can even ask a ranger about petroglyph sites or hikes.

Rock Art Canyon Ranch (520) 288-3260

This is a fairly large Anasazi Petroglyph site down on Chevelon Creek which is a little south of the Little Colorado River between Winslow and Holbrook. It is only open for tours in the afternoon Monday through Saturday by appointment. The fee charge depends upon the number of people and the group for that day. There is one panel of beautifully decorated anthropomorphs with horns or headdresses. This is well worth the trip.

Holbrook Petroglyph Park

There are some nice petroglyph panels in the park in Holbrook, which is on the eastern side of the golf course, north of Interstate 40. Take Exit 283 and go north to Golf Course Road. This road starts east and then turns north and winds around the golf course. About half way there you pass a ranch on the left and high up on the cliff, near the road is a nice

panel. Keep on going to the golf course, and just before you get to the parking lot, turn right and then left again going north to the park. There are petroglyphs all along the base of the red cliffs. Also straight west from here on the cliffs across the golf course, there is a nice panel.

South

Montezuma Castle National Monument (520) 567-3322

Early settlers mistook the ruins of Montezuma Castle as probably being built by the Aztecs from Mexico. This is actually a Sinagua site and quite impressive. Much of it has been stabilized but you are not allowed to go up into it. You can look up at the ruins that are about 100 feet from the ground in a cliff, sheltered by a large overhang. Built around A.D.1100-1250, using blocks of limestone and mortar, it sits in a beautiful setting with large sycamore trees and Wet Beaver Creek running along the bottom. Look for other ruins in the cliff face.

Montezuma's Well (a detached section of Montezuma Castle National Monument)

Some people like this site better than the castle, probably because you can get much closer to the ruins. About 10 miles northeast of Montezuma Castle, it is a big water hole about 500 feet in diameter and over 50 feet deep. You can actually walk down a trail along the edge and into the well, and there are ruins along the way where the Sinagua lived. At the end of the trail, look up and around the wall to the west and you will see other ruins and shelters below the rim.

The ducks love this little lake in the winter and must spend the winter here along with all the Arizona snowbirds. You can still see some of the irrigation ditches that were dug 800-900 years ago.

V-BAR-V Ranch Petroglyphs (520) 282-4119 (The Sedona Ranger Station)

This site is north of Montezuma's Well and contains over a thousand Sinagua petroglyphs concentrated on six or seven rocks. It is right next to Wet Beaver Creek and is easy to get to. Take Exit 298 off Interstate 17 and go southwest on Forest Road 618 (the other direction to the northeast is the road to Sedona). Go down the hill about 1-1/2 miles and you will pass a Ranger Station on your left and then you will see a campground also on your left. Keep going across two small bridges and turn right into a parking area. I haven't been there since they opened this for tours, but the last time I went by, there was a sign for the V-BAR-V Petroglyphs.

The hike is about a 1/2 mile almost straight west. In the last year or so they opened the site for tours so be sure and call to find out what time the tours are. Unfortunately, the site has a mesh fence around it with openings too small to get a 72mm.lens clearance to take a picture. When you are on the inside you will be very close to the rock art so try to take a wide-angle lens with you. You can't get far enough away to get the main panels on one shot. Also, try to get there in the morning because when the sun hits the panel through the trees in the afternoon, many of the glyphs disappear and are impossible to see. There are some very unusual herons and turtles in the main panel.

Other attractions in the southern area:

The Beautiful City of Sedona

Besides the red rock country around Sedona, which will remind you of Utah, there is one site called Palatki that contains both rock art and ruins. From the center of Sedona go west on Route 89 which continues down to Cottonwood and Prescott. About a mile or so from downtown Sedona, turn right on Dry Creek Road where there is a traffic light. Continue on this road following the signs to Palatki which will contain a couple of left hand turns and will be approximately 8 miles or so until you reach the intersection of Forest Road, 525. Turn right and go about 1/4 of a mile to a fork and turn right as the sign directs for Palatki.

After you check in at the Visitors Center, head up the trail to the rock art site that is a short walk to the base of the cliff. There are many pictographs, some of which are badly faded along the walls and rock shelters. They are mostly Sinagua except for one unusual pictograph for this area which is a Barrier Canyon red anthropomorph.

After returning to the Visitors Center, head across the meadow to the ruins. Don't miss the two shield petroglyphs above the right side of the ruins. There will usually be a volunteer there to answer any of your questions.

The drive, plus about an hour at the site, will take approximately 2 hours from downtown Sedona, depending upon the condition of the road. It turns to dirt a few miles from the intersection of Dry Creek Road and Route 89A.

The Town of Jerome on Mingus Mountain

It's well worth the drive to see this old copper mining town with all its new shops. This road can be difficult in the winter if its been raining or snowing.

In Flagstaff:

The Museum of Northern Arizona

You can't miss this museum. It is not only a museum but also a research and education center and has an outstanding gift shop that includes a great book section. It covers about everything on the Colorado Plateau as well as related subjects and contains lots of rock art books. The exhibits there are also extremely well done and this has been the home of many of the best known archaeologists in the Southwest. There are many people who come to Flagstaff just to see this museum.

Time of Year

Since most of the country you are traveling in is about 4, 000 - 7,000 feet or higher, most anytime of year is okay. But plan to stay in a motel in Flagstaff if you are there in the winter. As usual, it's probably best to visit these places in the spring and fall, but summers aren't too bad at all.

Types of Hikes

You will not encounter any long hikes visiting any of the places mentioned here. Most are 1/2 to 1 mile walks in and around ruins where you are never too far from your vehicle.

Photography

Since there are relatively short hikes, you can carry equipment without too much trouble. You will need a telephoto lens at Petrified National Monument for the places where you're not allowed to get close to the petroglyphs.

Accommodations

There are several ways to cover the Flagstaff area. One of the best is to camp at Homolovi State Ruins State Park for a couple of nights to see Petrified Forest National Park, the Hopi Reservation, Holbrook and Homolovi itself. They have hot showers, water, electricity, tables and grills at the individual camping spaces. There are also several motels in Winslow and Holbrook.

After you've seen the sights in this area, head west to Flagstaff and with the money you've saved from camping a couple of nights, you deserve a treat. Stay at Little America in Flagstaff on Butler Avenue - (520) 779-2741. Located on 500 acres of Ponderoso Pines, it has everything you need. It has large luxury rooms with refrigerators, coffee

makers, irons and room service. It also has a great coffee shop, gift shop and a regular dining room along with an Olympic size pool and a hot tub. There are other Little America Hotels in Salt Lake City, Utah; Little America, Wyoming and Cheyenne, Wyoming. The same people own the Sun Valley Ski Resort in Idaho, Snow Basin Ski Resort in Utah and the Westgate Hotel in San Diego.

To get to the Little America in Flagstaff, use Exit 198 off Interstate 40 which is Butler Avenue. The hotel is on the south side of I-40. Everyone needs a nice place to stay once in awhile and these are among the best hotels and motels in the West.

There are also many other options in Flagstaff.

Crock-Pot Recipe

Babe's Beef Back Ribs

 1-1/2, 2 lbs. Beef back ribs cut into single ribs

 1 cup beef broth or water

 1 onion sliced and pushed into rings

 1 bay leaf

The night before you leave, brown the backribs under the broiler to get rid of some of the fat. Put onion in the bottom of the crock-pot; put the back ribs on top of the onions, cover with broth and toss in bay leaf. In the morning, on your way to the Flagstaff area, cook on low for 8 hours or on high for 4 hours. That night, remove the ribs and let cool. Scoop out the onions and throw away. Put the kibble in Babe's dog dish and pour some of the gravy on it from the crock-pot. Put all but two ribs in zip lock bags and keep in your cooler. Give Babe the two ribs and go out to dinner. She can have the others in the next couple of days.

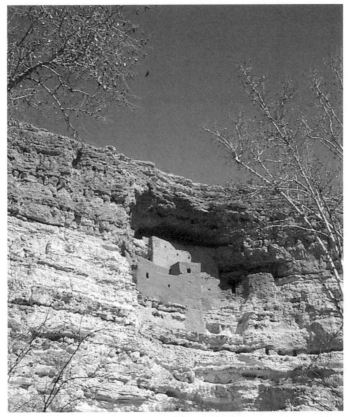

Montezuma Castle - South of Flagstaff

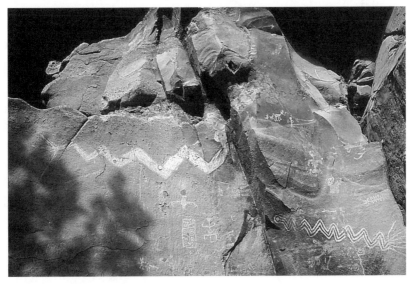

Casper the snake near Sedona

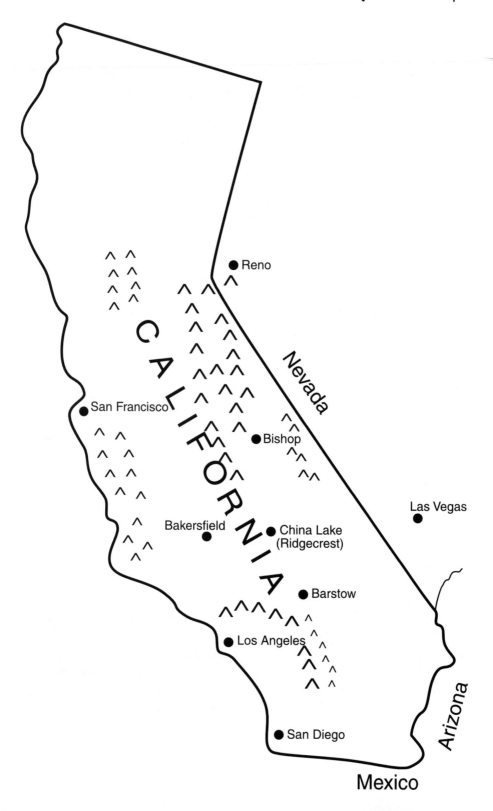

China Lake Naval Air Weapons Center
Ridgecrest, California
Bishop Petroglyph Loop - Yosemite National Park

The Coso Mountain Range within the China Lake Naval Air Weapons Center contains one of the most concentrated artistic and skillfully done collections of rock art in the world. You are extremely lucky that the Navy lets people see this wonderful rock art under the direction of the Maturango Museum (760) 375-6900 and its docents.

The museum schedules trips into the canyons on weekends. There are thousands of petroglyphs centered in three major canyons, Big Petroglyph, Little Petroglyph or Renegade and Sheep Canyon. There are also many other rock art sites in outlying areas. Most of the trips go to Little Petroglyph Canyon and it takes a full day to get there, hike the whole canyon and back, travel back to the Naval Weapons Station and depart by 4:00 p.m. On this trip, you will see over 6,000 petroglyphs in that one canyon.

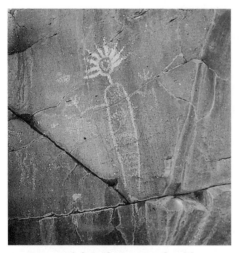

Ceremonial Anthropomorph with headdress--or he stuck his finger in a light socket - China Lake

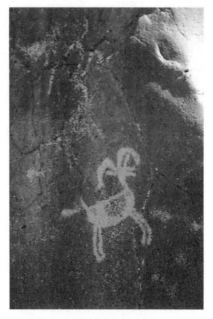

Happy Lamb - China Lake

China Lake is known for the large numbers of big horn sheep petroglyphs and especially the unique style of these petroglyphs with the horns going in opposite directions, as you will note in the picture (page 105 bottom). These are unlike the ones found further east where the horns are done normally.

No one knows for sure who carved or pecked these petroglyphs but they were undoubtedly Native Americans who are ancestors of the Paiutes and Shoshones and other Indian tribes in the area. While it's impossible to date these petroglyphs exactly, the presence of many atlatls suggest that the drawings were started before 500 B.C. to A.D. 300. The bow and arrow came into this area about A.D. 100, as arrows have been found dating from that time on. These petroglyphs were probably done over a period of about 3,000 years. New methods of dating are coming very fast and some of these experimental methods indicate that some of the rock art found here could date from 8,000 B.C.-14,000 B.C.

Time of Year

You need to have reservations well in advance. Don't call the Naval Weapons Station. Be sure to call the Maturango Museum at (760) 375-6900, as this is an extremely popular trip. You also have to give them your full name and your social security number so you can be cleared to go on the Naval Station. By all means, take the extended all-day trip rather than the half-day trip. The all-day trip gives you about seven hours in the canyon. It takes that long to see the whole canyon and get pictures of the best petroglyphs in the best light.

They normally run the trips from March to June and September to November. Taking the trip in the fall will also let you explore the Bishop, California area and take Route 120, The Tiogo Pass Road across to Yosemite Park and into Merced. As the ski season starts in November, an early snow could close this road which is only open from early summer to late fall.

Type of Hike

The hike up and down Little Petroglyph Canyon is relatively level and fairly easy. You will be walking in some sand and moving back and forth and up and down a little to take pictures. It is approximately 3 miles round trip depending upon how much back and forth and up and down you do.

There always seem to be rattlesnakes so be careful. The docents will mark rattlesnake sightings with colored tape so if you see a snake, be sure to tell them. Take lots of water - two to three liters, lunch or a snack

and layer your clothing. The altitude averages about 5,000 feet. At the south end of the canyon is a good place to have lunch. There is a drop-off of over 100 feet and you can go no further. As you're having lunch you look out over the whole China Lake Basin.

Photography

Since this could be a once in a lifetime hike because of its popularity and limited access to this site, be sure to take a backup camera, zoom lenses, circular polarizer, illuminator, tripod and plenty of film. You can easily shoot 10-20 rolls of 36-exposure film going up and down the canyon. Remember that there are over 6,000 petroglyphs in this one section of the canyon in about 1.2 miles. You will need the zoom for higher shots where you will not be allowed to climb.

Directions

From the East

Take Interstate 15 or Interstate 40 to Barstow. On the western side of Barstow take the Exit for State Road 58 towards Bakersfield. At the Junction of U.S. 395, turn north and go 77 miles to the Ridgecrest Exit. The Maturango Museum is straight ahead on the right on China Lake Boulevard in the middle of Ridgecrest.

From the West or Los Angeles area

Go east to Interstate 15 from San Diego and go north to U.S. 395 and follow directions to Ridgecrest.

The museum is open from 10:00 a.m. to 5:00 p.m., everyday except major holidays. You will not need a 4-Wheel Drive vehicle for this trip.

Accommodations

The Heritage Inn and Suites (760) 446-6543 and the Carriage Inn (760) 446-7910 are both great places to stay. They both have restaurants, refrigerators, microwaves and coffee makers in the room. Depending upon the time of year, the Heritage sometimes has a free breakfast included in the room rate and the restaurant is open early enough to get to the museum at 5:45 a.m. Make reservations for two nights if not camping because you need to arrive and go to bed early to be at the museum at 5:45 a.m. for the all-day trip. You will be tired when you arrive back from your long day of driving and hiking. And it's nice to have a shower in your room waiting for you. Both hotels have whirlpools that feel pretty good and they used to, and probably still do, donate 10% of your room bill to the Maturango Museum if you tell them when you check in.

Dinner

With the better than normal accommodations, including microwave and refrigerators, you will be able to cook frozen dinners from Albertson's and go to bed early. This would also be a good time to go out for Chinese food or bring it in. There are three Chinese restaurants in town. Be sure and make a lunch to take with you for the hike or order one from the restaurant at either hotel.

Other Attractions

Bishop, California - Petroglyph Loop

Bishop is about 120 miles north of Ridgecrest on Route 395 on the eastern edge of the Sierra Nevada's. As you travel from Ridgecrest to Bishop, you go through Long Pine and looking out to the west is Mount Whitney, the highest point in the contiguous U.S. at 14,494 feet. Lone Pine was the site location for many movies and has a film fest in October. Continuing up Route 395, you hit Big Pine and off to the east, are the White Mountains with the top peak at 14,246 feet. When you hit Bishop, stop at the Chamber of Commerce or Bureau of Land Management (BLM) office and they will give you a map of the Bishop Petroglyph loop, which will take approximately 3-4 hours. This will be an all day trip to drive from Ridgecrest to Bishop and see the petroglyphs so plan on staying in Bishop overnight. There are many motels, restaurants, and several camping areas. About 40 miles north of Bishop is the Mammoth Mountain Ski Area and Devil's Postpile National Monument.

Yosemite National Park

Check the weather and road conditions and head to Yosemite via Route 120, the Tioga Pass Road. It's about 225 miles to Merced and will take about 6 hours of driving time if you go into Yosemite Village. Add to this any sightseeing time.

Random Comments

If you'd like, from Yosemite cut over through Merced to Santa Nella on Interstate 5 on your way to see Painted Cave, just north of Santa Barbara. A great place for lunch, at the intersection on the northeast side of the intersection of route 33 and Interstate 5, is Anderson's Restaurant and Motel. You can't miss it because there's a big windmill out front. Anderson's is famous for its pea soup that makes a whole meal.

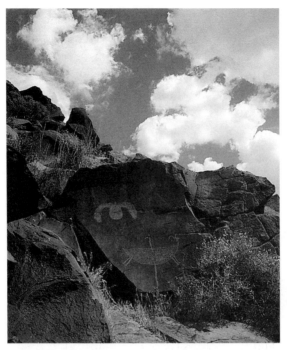

Sheep with atlatl dart - China Lake

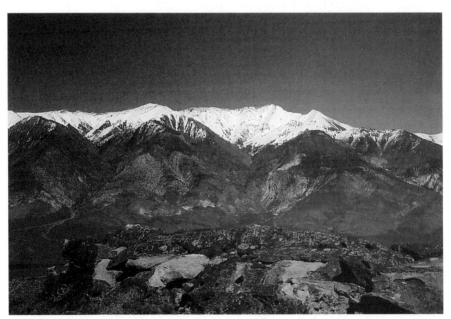

Petroglyphs south of Mammoth Mountain ski area and north of Bishop, CA. Picture taken in June.

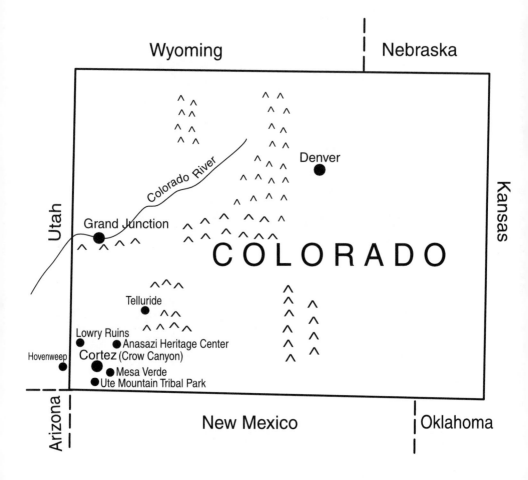

15

Mesa Verde National Park
Colorado

**Anasazi Heritage Center - Crow Canyon Archaeological Center
Hovenweep National Monument - Lowry Ruins - Telluride**

Mesa Verde National Park (970) 529-4465, is probably the best known and contains the most spectacular prehistoric ruins, other than Chaco Canyon, in the Southwest. But as far as a total setting with the beautiful green mesa and the pueblos built in the cliff overhangs, Mesa Verde would be my first choice between the two of places to go.

Mesa Verde is near the Four Corners area where Arizona, New Mexico, Utah and Colorado meet. This was the center for the Anasazi people who lived in this area from about A.D. 1 to A.D. 1300. Throughout the Four Corners area there are many ruins as well as thousands of rock art sites. Many rivers, creeks and washes in the area flow into the San Juan River which runs northwest, almost through the point where all four states come together. Eventually, it empties into the Colorado River which now is part of Lake Powell.

Mancos Rancher, Richard Wetherill, who did most of the excavating of the cliff houses, discovered Mesa Verde. Mancos is a little town just east of Cortez, Colorado and Mesa Verde is between Cortez and Mancos. Richard Wetherill was to Mesa Verde what Heinrich Schlieman was to Troy. Heinrich Schlieman was another untrained amateur archaeologist who in 1873 on the plains of Troy, found several silver vases with silver and gold cups about 25 feet deep in the circuit wall of Troy. For all his amateurism and errors, Schlieman was a pioneer in the new science of archaeology, which revolutionized our ideas of the Greek civilization. He was not only interested in silver or gold, but also in finding evidence that the Trojan War as described by Homer was an historic fact.

Even though archaeologists complained about both Schlieman and Wetherill, it seems both men did a pretty good job considering the place and the time. They both must have had great intuition and instincts to discover what they did.

The rock art site you will be hiking to in Mesa Verde is called Petroglyph Point. It is approximately 3 miles round trip at an altitude of about 7,000 feet and goes through some wonderful country. Not much

has changed from the way it was 1,000 years ago. As you walk along the trail, you are able to look down into the canyons and as you wander through the hundreds of evergreens, you will be overwhelmed by the fragrance of pine trees. The trail to Petroglyph Point starts close to the Chapin Mesa Museum and the chief Ranger's Office at the Park Headquarters. Be sure to register at the office before you leave. This is for your safety, especially if you're alone, and also it is required. Pick up a trail guide and you are on your way. There are several points of interest along the way and the guide will tell you all about each. When you reach the petroglyph panel, the largest in Mesa Verde, take some time to study it.

As you know already, no one knows for sure what any of it means. The Hopi, who are thought to be direct descendants of the Anasazi who lived in this area, have made some interesting interpretations. The main petroglyph (below) is the large figure with its arms held up and is supposed to be Salavi, Leader of the Badger Clan. This is one of the most important Hopi Clans. They were the keepers of the spruce trees. To the right, looking at the panel, the figure of a head that has, what looks like a Fu Man Chu mustache, is Saviki, Chief of the Bow Clan. To the right of him and a little lower is Salavi again, lying sideways in death. The wavy line above is water and the spruce tree is growing out of it.

The story goes that after building houses and kivas in a large alcove in a cliff face, the Badger Clan was joined by the Butterfly Clan and

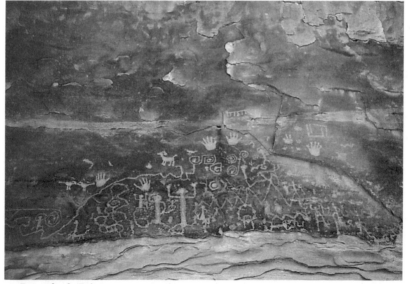

Petroglyph Point

later no rains came; the springs dried up and everyone was arguing. So Salavi told them all to leave and he would stay, but to come back in four years. If the fault of the no rain and drought was his, they would not find him but if he was true of heart, they would see a sign. What they found upon returning in four years, was a sign which indicated that the drought and arguing was not his fault. The sign was a four-year old spruce tree, growing by the now flowing spring below Spruce Tree House. They knew then that he had turned himself into the mighty spruce.

When you get back from the hike you can sit on the porch in the headquarters area and look down at Spruce Tree House. Rest up a little and then climb down and explore the ruins at Spruce Tree House.

Assuming you spend the night in Cortez or are camping close by, you can see Petroglyph Point as well as a ruin or two in one day. The rock art trip takes about 3 hours. You have to spend at least 2 days or more to really do Mesa Verde justice. When you first arrive at the park, head for the Far View Visitors Center about 20-25 miles from the entrance.

Pick up tickets to see Cliff Palace and Balcony House if you want to actually walk into the ruins. You can then decide whether to hike, check out the other ranger-led tours or just poke around the mesa, checking Square Tower Ruins and some of the many non-cliff house ruins.

If you want a good view of Cliff Palace, take the Mesa Top Loop Road and follow the signs to Square Tower House and Sun Temple. There are several sites where you can pull off and have a great view of Cliff Palace across the canyon. The park closes at sunset and opens at 8:00 a.m. Mountain Time.

Directions

The turnoff for Mesa Verde is 10 miles east of Cortez, Colorado, about halfway to Mancos on Route 160.

Time of Year

To miss the crowds, go before Memorial Day or after Labor Day. To see Wetherill Mesa and Long House you have to go in the summer because it opens Memorial Day and closes on Labor Day. Remember you're going to be around 7,000 feet so it is comfortable in the summer and can get cold in the spring and fall. The park is open all year but Cliff Palace and Balcony House tours are open depending upon the weather, from April/May to October/November.

Type of Hike

The hike to Petroglyph Point is moderate and relatively level with an elevation change of only about 200 feet. After you see the petroglyphs, you climb up and come back on top of a mesa. Take your time, as you hike and be sure to bring your binoculars as you can see other ruins across the canyon. You also pass through habitation sights, and depending on the time of the year, you will see many wild flowers, and if you don't actually see any animals, you will notice their tracks as you hike along.

Photography

You will need a wide-angle 28mm. lens if you want to get the whole petroglyph panel. It is quite large and you'll have to step back from the trail. Other than that, you can probably get some good shots with a point and shoot and use a small zoom to get a close up of some of the figures.

Accommodations

Camping

Morefield Campground (970) 565-2133 is on the right about 3-4 miles past the park entrance on the way to the Far View Visitors Center. Adjacent to the campground is a store, showers, laundry and a gas station. There are approximately 400 sites and they all have a grill, benches and a table. It is usually open from April through October.

Motels

In Cortez, there are several accommodations. The Budget Host (970) 565-3738 that used to be the Bel Rau Lodge is on the eastern side of town towards Mesa Verde and has always had nice rooms at a reasonable price.

The Fairview Lodge (970) 529-4421 is right in Mesa Verde National Park. Each room has a balcony and there is a good restaurant called the Matate Room. Since there are no telephones or televisions, it offers a real chance to just look out at the scenery and enjoy the peace and quiet. You will still notice some of the burned areas from the big fire they had here in 1996. I haven't been there since the July, 2000 fire, but I understand most of the damage was done in the first few miles after leaving Route 160 towards the Visitors Center and around the Morefield Campground. It is usually open from late April to late October.

Crock-Pot Recipe

Rump Roast Cortez

> 2-3 pound rump roast
> 8-10 baby red potatoes
> 10-12 small peeled carrots
> 8 ounce package whole mushrooms
> 2 medium onions, sliced
> 1 can condensed mushroom soup
> 2 bay leaves
> 1 teaspoon of thyme or oregano
> Salt and pepper

The night before, sear the rump roast on all sides in a heavy pot. Add onions; saute about 5 minutes until soft. Put onions in a crock-pot, add the soup, liquids and seasoning, mix well, add rump roast. Put the carrots and potatoes and mushrooms on top. Cook 10-12 hours on low.

Crow Canyon Archaeological Center (970) 565-8975 or (800) 422-8975

Just outside Cortez, Colorado, Crow Canyon is a non-profit organization conducting archaeological research as well as educational programs. They allow regular people like us to work side by side with archaeologists excavating sites, and in the labs, identifying and analyzing artifacts.

What might interest you the most is their Cultural Exploration Program. You will get to see rock art and ruins most people never get to see. You also meet Native Americans, both as students and leaders in these programs. You can give them a call for more information and a calendar of their programs.

Anasazi Heritage Center (970) 882-4811

Located in Dolores, Colorado about 12 miles north of Cortez, the American Heritage Center is another "don't miss" place to go. The Center is operated by the Bureau of Land Management (BLM) and is adjacent to the Dominguez and Escalante Ruins, named after the Franciscan Friars who explored much of the Southwest.

The museum has over 2 million artifacts from the area. There is a replica of a pithouse and many hands-on attractions, films, exhibits and special programs. This is the kind of place you would have wanted to visit as a kid. Plan on at least a half of day.

Hovenweep National Monument (970) 562-4282

About 45 miles west of Cortez, located on the border of Utah and

Colorado, is Hovenweep National Monument. It contains some of the best stone architecture of the Southwest. It is fairly isolated and famous for its Square Tower Ruins. Don't be surprised if you are the only one there on some days. Many of the ruins are different from any that you have seen in that they have not been restored and the shapes vary from oval to D shaped plus the regular circular and square types. They were built by the same people who occupied Mesa Verde.

There's an approximate 2-mile self-guided trail that circles and connects the ruins, starting from the Visitors Center. This longer trail is more interesting than the short, half-mile hike. There are also many other outlying ruins that are part of the group and one to the south called Cajon Group has a small pictograph against the back walls of one of the ruins.

Lowry Ruins (970) 247-4082

This is a medium sized pueblo where you again are apt to find yourself all alone, quietly and peacefully roaming through the ruins. You might like this much better than the places that have the crowds because it lets you get a better feel for what living here was like a thousand years ago. Pick up the self-guiding pamphlets and check out the kivas and approximately 40 rooms. At site 7, on your tour, you go down through a very small door into painted kiva which to me was the highlight of the trip. This kiva has appeared in film specials about the Anasazi.

About 50-60 steps from the main pueblo is what they called the great kiva. It's about 50 feet in diameter versus 11 or 12 feet for the 8 smaller kivas in the ruins. You will notice that the roof construction was entirely different because of its size.

Telluride, Colorado

About an hour and a half northeast of Cortez, is one of the most beautiful places in the West, the old mining town of Telluride. In the winter, it has great skiing and usually opens before Thanksgiving and closes in the middle of April. While there are a lot of black runs, almost 50% of the runs are intermediate and okay for old guys. Last year they installed two new high-speed quad lifts. They now have four high-speed quad lifts, two triples, two doubles and a Poma Lift.

One of the most beautiful resorts in the country, it is located in a canyon surrounded by the 14,000 foot San Juan Mountains. The base is around 8,700 feet and the top is 11,890. Telluride is basically two towns, the old mining town of Telluride and Mountain Village, and an upscale

resort town. In 1996, they installed a free gondola that connects the two towns and it only takes a little over ten minutes. Since you can't see Mountain Village from Telluride, the village still keeps its old mining town atmosphere.

In the summer, Telluride becomes an arts and cultural center. They seem to have some kind of a festival every weekend. In 2000, they included the wine, chamber music, three film festivals, blue grass, jazz, mushroom and the Joffrey Ballet. They also have the Blues and Brews Festival with about 45 microbreweries represented and about 15 or 20 bands. They are famous for their "Nothing Festival" when nobody does anything and they hope nobody comes.

A drive on the San Juan Skyway is always an unforgettable experience but especially in the fall with the leaves changing color.

Random Comments

After you spend some time in Mesa Verde, it is a good time to read Nevada Barr's book Ill Wind. It's about a park ranger Anna Pigeon who turns detective to solve a murder mystery. She weaves in all the locations you have just seen which make it more interesting. Nevada Barr was in fact a ranger at Mesa Verde and at several other parks. If you stay at the Fairview Lodge, with no television, it might be a good time to start the book.

The many Tony Hillerman mysteries are fun to read also when visiting the Four Corners area. You will travel on many of the same roads as the main characters, Jim Chee and Joe Leaphorn. You will also learn a lot about the Navajo life and beliefs.

I've never received an answer in Mesa Verde to my question about whether the Anasazi had separate restrooms for men and women.

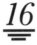

Ute Mountain Tribal Park

Colorado

Attractions are the same as Mesa Verde

While you've probably already really enjoyed your Mesa Verde experience, you might enjoy Ute Mountain Tribal Park even more. (800) 847-5485. There are many more petroglyphs and pictographs and while you are escorted by a Ute Guide, the whole feeling of the place is that you are the first ones seeing this wild area and the wonderful ruins. They have not been restored like the ruins at Mesa Verde and only some of them have been stabilized so they are not dangerous. You are not herded in large groups and told where you can and cannot go. With our great guide, Raymond Thom, it was just like hiking with a small group of friends. A full day is $30.00 and in our group there were 6 people. The guide leads and everyone follows in their own vehicle.

It is directly south and adjacent to Mesa Verde National Park and is about twice as large. It also was discovered by the Wetherill brothers and shares some of the same mesa as Mesa Verde National Park. You enter the park along a dirt road that parallels the Mancos River and goes into Mancos Canyon. On the way you will pass Chimney Rock and stop by a replica of an old pueblo under construction by the current youths of the tribe during summer vacations. They are using the same methods of construction as employed a thousand years ago. This will be the future Visitors Center when it is completed.

As you start up the canyon in your vehicle, the first stop, at about 5 miles is an area on the right close to the Mancos River. It was here that Raymond brought out his atlatl and darts and demonstrated its use and let everyone have a chance to try it.

About 8 miles up the canyon, you can see a tower ruins across the river to the south and many small ruins, plus some granaries on your left.

As you proceed further east the canyon begins to narrow and your next stop will be a large alcove next to what used to be Chief Jack House's Hogan. Along the way on the left you will notice several Ute red pictographs and the alcove is full of them. These pictographs are great examples of the Ute rock art. Chief Jack House was the last Chief

of the Shoshonian speaking Ute Mountain tribe of which there are now approximately 1,700 members living on the Colorado Reservation.

Continuing up the main road, you come to Kiva Point (about 16 miles), which had the largest number of Anasazi petroglyphs in the area. Kiva Point is actually the end of Mesa Verde's Chapin Mesa and you are almost directly south of Cliff Palace at this point. The petroglyphs seem to be Basketmaker II and III.

As you continue on up to the Johnson Canyon turnoff and start climbing up to the southern side of the canyon, you leave the areas of sage and now arrive in the pinion pine, juniper altitude. You will also see ponderosa pines, Douglas Fir and an occasional aspen tree. The pinion pines supplied a great source of food for these early people with the nuts they produced. The nuts are contained in the cones and when they start dropping around January of each year, they are collected quickly before the animals get them. They were roasted and eaten whole or ground up into flour.

After several more miles, circling around the top, you come up to the north rim of Lion Canyon where you park. There is a small park there with picnic tables and restrooms. Now, the hike begins.

You descend a series of ladders to reach a trail that takes you to all the ruins. The trail is fairly good and the pace set by the guide is easy. You will see four major ruins with no rock art except for some painted V's and Dots at Eagle's Nest.

The first ruin you see is Tree House at the head of the canyon. It is named for the Douglas Firs that surround this ruin and block its view until you get fairly close to it. This is a magnificent setting, but difficult to get a picture that does it justice. Backtracking a little, the next ruin, which is a short hike west, is called Lion House. This is the largest ruin with approximately 50 rooms, including kivas. The third ruins are named Morris 5 for Earl Morris who excavated these ruins.

Eagle's Nest is the last ruin but the most spectacular as it is located up high under a large overhang. To access this ruin you must climb a long ladder. It's only about 30 feet but seems a lot higher when you're on it. Coming down was harder than going up. If you see finger indentations in the ladder rungs, they're not old, they're mine. There was one person in our group who refused to climb on the ladder but still enjoyed looking up at the ruins from below. After climbing the ladder, you kind of crawl along the edge of the rock to the small ruin. While some people get a little acrophobia coming and going at Eagle's Nest

you just take your time and pray and everything will be okay. The Ute's want to see you stop over at their casino and don't want to lose anybody. Even if you lose money at the casino you feel it's going to a better place than when you're in Las Vegas.

Directions

From Cortez, you drive about 20 miles south on route 666 until you reach the Ute Mountain Tribal Park Visitors Center on the right at the Junction of 666 and 160. You meet for the tour at 8:30 a.m. and after a quick orientation talk by your guide, you depart for the day. Since you go in your own car, be sure it is gassed and you have all of your other equipment including food and lots of water.

Type of Hike

The hike is approximately 3 miles long but doesn't seem that far as you are continually stopping to see the ruins and look at the views. Except

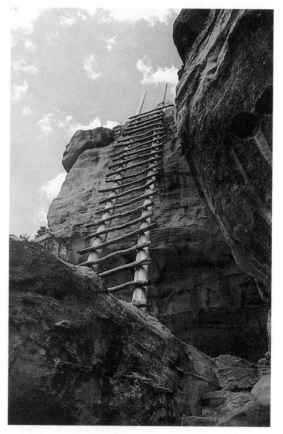

Ladder to Eagle's Nest - Ute Mountain

for going up and down the ladders, which can be "acrophobically challenging," the hike is easy.

Time of Year

While this trip is available all year depending upon the weather, I think the minimum group size is about 5 or 6. Again, the spring and summer and fall seem to be the best times for this hike.

Photography

You can get a lot of use out of your 28-200mm or equivalent lenses on this tour and also take a spare point and shoot camera. Don't carry a tripod or a reflector and try to go as light as possible because it's tough going up and down the ladders with much equipment.

Accommodations

The accommodations in Cortez would be the same as those for Mesa Verde. If you're staying south in the Farmington, New Mexico area, there are several motels and restaurants in that city.

Crock-Pot Recipe

Layered Lamb Stew

> 2 lbs. lamb stew meat or cut up boneless lamb shoulder into 1-inch cubes
>
> 2 tablespoons of salt
>
> 1/2 teaspoon of pepper
>
> 1/2 teaspoon each of dried rosemary and allspice
>
> 1 clove of garlic, chopped fine
>
> Mix the lamb cubes with the spices above.
>
> 2 onions sliced thin
>
> 10-12 baby carrots
>
> 10-12 baby red potatoes, sliced in half or cut up bigger ones
>
> 1/2 head of white cabbage pulled apart in leaves
>
> 1 8 ounce can of tomato sauce
>
> 1 cup of water

Divide the lamb, onion, carrots, potatoes and cabbage into two portions. Starting with the lamb, put half of it in the crock-pot, followed by half the onions, half of the carrots and half the potatoes. Cover with half of the cabbage leaves. Then do it all again the same way.

Mix the tomato sauce and water and pour over layered stew. Cook 10-12 hours on low. You can also substitute beef cubes if you don't like lamb.

Other Attractions

The same as Mesa Verde - Crow Canyon, Anasazi Heritage Center, Telluride, Lowry Ruins and Hovenweep.

<p style="text-align:center">**********</p>

Random Comments

After climbing up the last ladder at the completion of the hike, we were sitting around the parking area drinking some Gatorade and someone mentioned that this is the first place they'd been that didn't have handicapped parking.

Eagle's Nest

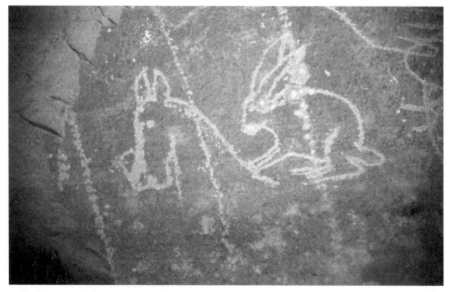

Unusual Ute petroglyph

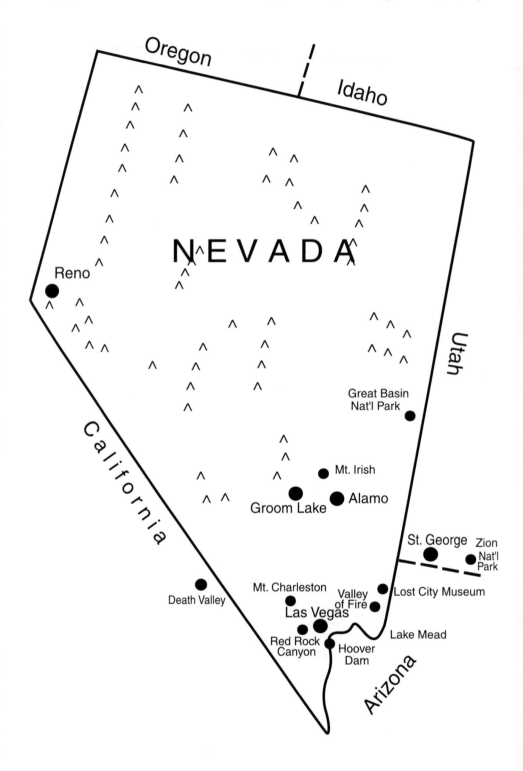

Valley of Fire

Nevada

Zion National Park
Lost City Museum - Lake Mead National Recreation Area
Red Rock Canyon - Mount Charleston - Hoover Dam
Great Basin National Park - Death Valley National Monument

The first weeks in December are a wonderful time to see the Valley of Fire. This very accessible park has several petroglyph sites. The Atlatl Rock Area and Petroglyph Canyon by Mouse's Tank have some of the best early and late Anasazi rock art in Nevada. You can read about Mouse, a renegade Paiute Indian at the Visitors Center.

As the name of the park suggests, as you come over the hill on the road from Interstate 15, toward the west entrance, you see the blazing red sandstone formations that give the park its name. It is very close to Lake Mead and the area where the Virgin River originally flowed into the Colorado River before Hoover Dam was built.

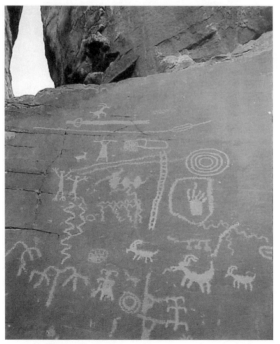

Atlatl Rock - Valley of Fire

The Valley of Fire State Park has a little bit of everything, including a petrified wood section, a nice Visitors Center with rotating exhibits, many interesting rock formations, and camping sites with picnic areas with restrooms and water.

You can easily spend a day here taking short drives and hikes to see not only rock art but also many unusual rock formations and just beautiful vistas. If you come in December, the days are pretty short so you can see both sunrises and sunsets. It is also one of the best times to take landscape pictures because of the angle of the sun. It is also easier to take pictures of the rock art when the glare is reduced.

When you're in the area, you might be treated to a little of the new with the old. One day, while we were there, a formation of Air Force fighter planes flew over, probably on their way to or from a training mission from Nellis Air Force Base in Las Vegas. They were easily recognized as Air Force rather than Navy as the Air Force's idea of a tight formation is that they all go in the same direction on the same day.

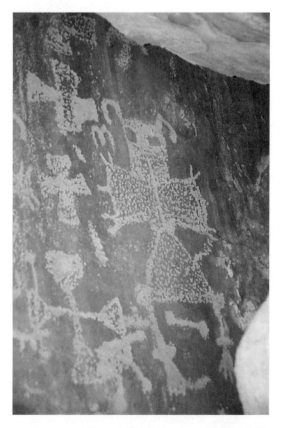

Batwoman - Mouse's Tank Canyon - Valley of Fire

Directions

Valley of Fire is 55 miles from Las Vegas, via Interstate 15. Take Interstate 15 northeast, about a half hour to Exit 75. There are large signs and the Moapa Indian Casino Fireworks and Smoke Shop is right at the exit. This shop has a wide assortment of handcrafted items as well as books, food, but no gas. Follow the signs east to the entrance of Valley of Fire. You can also approach the eastern side of Valley of Fire by going via the north shore road along Lake Mead. This would be a nice way to return to Las Vegas after leaving the park.

Time of Year

You can see the petroglyphs as well as other attractions all year long, as the roads are paved. But, in the summer, it is usually in the 100's. The rest of the year is fine but the light is exceptionally good in the winter when the glare on the patina of some of the petroglyph panels is less severe. The highest temperature you will encounter in December and January is usually in the 70's. It can get down to freezing at night but is usually in the 40's and 50's. In the winter, there are very few people around, especially during the week and you will be able to appreciate the quiet and the solitude.

Type of Hike

The two main rock art sites are very easy to walk to. The Atlatl Rock Area is well marked and you can climb up a steel stairway to view the rock art closely. Don't miss walking around Atlatl Rock and the large rocks in the adjoining areas for there are considerably more petroglyphs both up high and low. This would cover approximately 1/4 to 1/2 of a mile.

Petroglyph or Mouse's Canyon is a couple of minutes north of the Visitors Center. The trail is a little less than a 1/2 mile. Again, look high and low and use your binoculars. There is rock art almost continually on your left, walking in, toward Mouse's Tank. You will be walking in loose sand but it is almost level. At the end of the trail, is Mouse's Tank. As I said, you can read about Mouse, a renegade Indian, at the Visitors Center. A tank in the Southwest is a natural hollow or basin in a rock that collects water after rainstorms. The Indians used them for survival in these arid areas. Be sure to look across the road from the entrance to the canyon for there are many more petroglyphs up high and low in that area.

Plan on spending most of the day at Valley of Fire.

Photography

This is one of the places it is nice to have a 28-200mm. or 300mm. lens with a circular polarizer filter. With this combination, you also need a light tripod for the long shots. If you just have a point and shoot, you can still get the majority of petroglyphs with no trouble.

Accommodations

There are two campgrounds in the park near Atlatl Rock. But this is the time to let it roll in the vernacular of the gamblers, and stay in Las Vegas. First, the room rates during the week in December, before Christmas, are the cheapest they will be all year in Las Vegas. They are 50% less than what you would pay on the weekend, (Friday and Saturday), and 75% less than what the people were paying in November at the Comdex Computer Show. You can stay at the best hotels on the Strip from anywhere from $50 to $150.00 weekdays, during December, before Christmas. There are too many accommodations to list but check out www.lasvegas.com on the internet where you can make reservations and price all the casinos, motels, etc, as well as a lot of other information about what is going on in town and who is appearing at the different casinos. In Las Vegas, every night is Saturday night and Saturday night is New Years Eve.

Las Vegas now rates with San Francisco and New York as far as having great restaurants. Each year we try to go to one upscale restaurant. Last year, we tried Ruth's Chris Steak House after we heard Rush Limbaugh talking about it. It is west of the Strip and I-15 at 4561 West Flamingo Road. We had an absolutely outstanding meal and worth every nickel. The last payment is due next month.

It reminded me of the time we had dinner at Ernie's in San Francisco. After the main course and before the Grand Marnier Souffle arrived, they had bank representatives walking around in Tuxedo's who asked you how your meal was and if there was any requirement for a second mortgage on your house.

Other Attractions

There are many other rock art sites around Las Vegas such as Grapevine Canyon near Laughlin and Mt. Irish, north of Alamo, Nevada. So you might want to make this an annual affair combined with seeing some of the following:

Zion National Park (435) 772-3256

Zion is about 165 miles northeast of Las Vegas in Utah. This would be

a pretty long day trip so it might be best to see it on your way to Las Vegas or on your way out. It is well worth making a special trip. Spring or fall is the best time because it is not as crowded as in the summer. The red and white walls rise over 2,000 feet above the canyon floor where the Virgin River flows.

Off-season you can drive through the whole canyon. In 2,000, they started a shuttle service that runs from May through October and cars are not allowed in the main canyon. Believe it or not, this is by far, the best way to see everything. In the summer, it was like driving at rush hour in the city and was difficult to find a place to park. The shuttle stops at all the shorter hiking trails and you can get off, hike, and pick up another shuttle later on.

Don't miss the Narrows Trail as well as the Emerald Pools Trail. There is a new Visitors Center at the Park, which was constructed in 2,000.

In Springdale, Utah, the town that is adjacent to the Park, there is the Zion Canyon Giant Screen Theatre that is 6 stories high. I hadn't been to a movie in 10 years but thoroughly enjoyed the "Treasure of the Gods." You can even get acrophobia sitting in your seat. So hold on the your armrests securely. In the same complex, is one of the best bookstores in the area. It's called Water, Wind and Time. They have many books on rock art and the prehistory of the Southwest if you've had trouble finding them at other bookstores.

Lost City Museum - Overton, Nevada (702) 397-2193
About a half hour from Valley of Fire, via the east entrance, the Lost City Museum offers many artifacts from the Anasazi occupations. There are also pithouses and pueblos reconstructed just outside the door. There's an excellent museum shop and local artists usually have interesting exhibits of their paintings and handicrafts.

Lake Mead National Recreation Area (702) 293-8906
Lake Mead is over 100 miles long and has over 500 miles of shoreline. You can access it in several places and the western part of the lake is only 30 miles from the center of Las Vegas. You can rent boats of all kinds, swim, fish, water ski and hike.

Red Rock Canyon National Conservation Area (702) 363-1921
Red Rock Canyon is 20 miles west of the center of Las Vegas. It has a 13-mile scenic drive and several hiking trails. You can watch the rock climbers and there are 3-4 places to see rock art. Ask at the Visitors Center.

Mt. Charleston

Located in the Spring Mountains, about an hour northwest of Las Vegas, Mt. Charleston is 11,918 feet high and you can see it from anywhere in Las Vegas. It has many trails for hiking and will usually have skiing by December at the Las Vegas Ski and Snowboard Resort. This was originally known as Lee Canyon.

Hoover Dam (702) 294-3523

If you're into big dams, Hoover is located 30 miles from Las Vegas on Highway 93 to Arizona.

Great Basin National Park (775) 234-7331

One of the lesser known and visited National Parks in the country, Great Basin is about 290 miles north of Las Vegas if you're going in that direction. This is where Lehman Cave is located as well as Mt. Wheeler. You can drive up to about 10,000 feet where there are some picnic areas and the summit is about 3,000 feet higher than that and has a small glacier. There's rock art in the park and some of the caves and rock shelters have some pretty eerie pictographs.

Death Valley National Monument (760) 786-2331

Death Valley is about 140 miles northwest of Las Vegas and never sounded to me like a great place to go. But, in spite of its name, it is actually very beautiful and is a very interesting place to visit. There's much evidence of prehistoric Indians living in this area.

Random Comments

Las Vegas Prayer:

"Please Lord, let me prove winning the $20 million dollar Megabucks won't change me!"

In several states in the West, I've always wondered why they have Braille on the number keys at the drive up ATM's.

They have ATM's with all the money outside the bank and on the inside, they chain the pens to the counters.

Walking around Las Vegas and visiting the casinos, you will immediately notice one peculiar thing. They have moving walks all going into the casinos but none coming out.

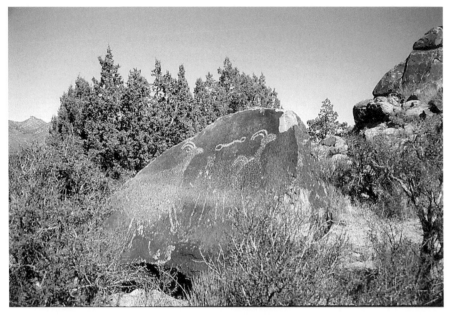

Large mountain sheep, Mount Irish - Nevada

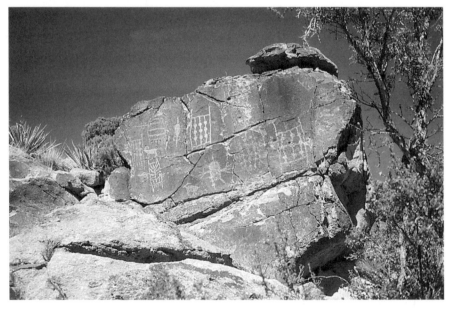

Pahranagat Man Panel just east of Groom Lake and Area 51 - Nevada

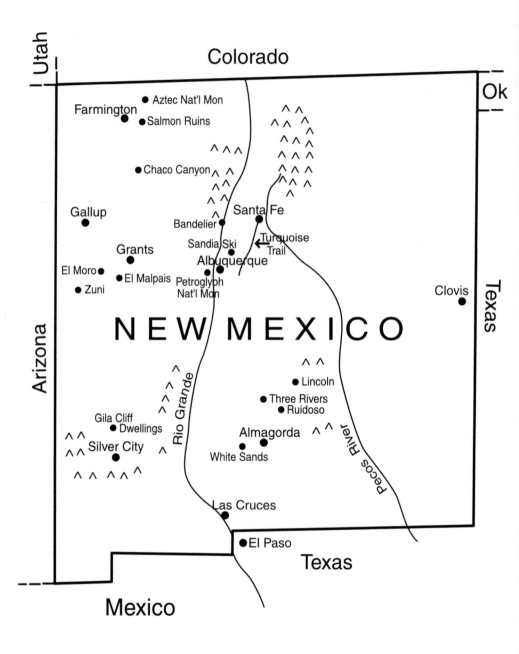

18

Chaco Culture National Historic Park
New Mexico

**Salmon Ruins and Heritage Park - Aztec Ruins National Monument
El Morro National Monument Zuni Indian Reservation
El Malpais National Monument - Acoma (Sky City)**

This is the famous Chaco Canyon, even though it is now called Chaco Culture National Historic Park, (505) 786-7014. It was the center of the Anasazi culture for a brief period from A.D. 850 - A.D. 1300 and has been occupied for thousands of years. It is known more for its ruins and architecture rather than for its rock art.

The feeling here is much like that of the Ute Mountain Tribal Park, but without the trees. It is like going back several hundred years as you wander through the primitive ruins. It makes you wonder about the people who built these magnificent structures that still stand today. There are over 2,000 archaeological sites in the area and 13 major pueblos or great houses containing many ruins and kivas. They are of a quality not seen anywhere else in the Southwest. A thousand years ago, there must have been much more water in this area than there is now, to support the size of the population at that time.

The best part of visiting Chaco is that you can explore all of the pueblos yourself using the trail guides provided at the Visitors Center. Being able to stroll through the ruins at your own pace is a great improvement over being led around on a tour. It is a very peaceful place.

Write down any questions you might have and if you don't run into a ranger at the site, you can ask at the Visitors Center later. You also can participate in ranger led tours if you wish, especially if you haven't had time to read up on the canyon.

You see many of the trees that were cut in A.D. 900-1130 still in place in the structures supporting roofs, windows and doorways. The actual tree ring dating for Chaco was done from samples taken from these beams. The dating, which is an exact science, is called Dendrochronology. It is interesting to note that the date can be pinpointed to the exact year the tree was cut as long as the tree grew within the last 2,000 years in the Southwest.

The builders living in those times knew what they were doing when they constructed these buildings. The architecture is outstanding and there must have been someone in overall charge of the building who had architectural and engineering experience, probably gathered from trial and error or learned in another culture to the south. These architects were the Frank Lloyd Wrights of their time. The walls were constructed by building up two walls of shaped rock, (the veneer), separated by a space that was filled with mud and rubble, (the core). The veneer was sometimes finished in patterns and beautiful designs by using small stones to fill in areas around larger stones. The widths of these walls depended on how high the building would be or what it would be used for. Many of these structures were four and five stories high. The walls were built much wider at the bottom and tapered to the top in order to support the weight of these additional stories. There are many large circular kivas, which are completely underground, and there is evidence that much organization was needed in the construction of all of the buildings.

Pueblo Bonito, the largest of the pueblos, contained about 800 rooms and kivas. It also had plazas or courtyards. Most of the rooms were quite large and Pueblo Bonito was the largest building in the United States until the construction of modern day buildings in New York in the late 1800s.

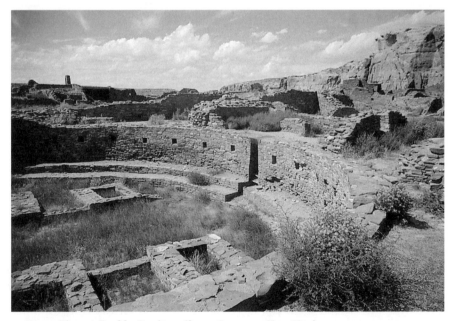

Large Kiva at Pueblo Bonito - Chaco Canyon - New Mexico

The Chaco Anasazi also built dams, irrigation systems, and roads. There are about 400 miles of roads going in all directions that connect about 75 settlements. The northern road links up to the Salmon and Aztec sites. Along that road, there appear to be lighthouses where fires could be built and used for signaling.

There must have been much trading as artifacts discovered at Chaco and some of the outlying settlements came from California and Mexico. They have found many different shells, including abalone that was used for jewelry. Also found were copper bells and parrot feathers probably from Mexico and much turquoise, probably from Cerrillos, New Mexico.

The time of year to plant and to have ceremonies was very important to these people. On Fajada Butte, overlooking Chaco Wash, are two spiral petroglyphs that are placed on a wall behind three rock slabs. (Spirals are very common throughout the Southwest). Sunlight shines through these slabs creating darts of light, called sun daggers, on the spirals to indicate the summer and winter solstices, and the spring and fall equinoxes. Sometimes they pecked petroglyph dots and dashes to count the days before and after the solstices and equinoxes, giving them a crude calendar.

There must have been some form of government or strong leadership, maybe religious leadership, to organize and control all of the building that went on at Chaco. Some people think that these leaders could have migrated from Mexico and enslaved the Chaco Anasazi. If so, they were probably the Toltecs, the predecessors to the Aztecs. They would have had the expertise to accomplish some of the building here at Chaco Canyon and it could explain the differences in construction from other Anasazi sites. Also there is some scattered evidence of what might have been cannibalism in a few sites in the Southwest. A burial site was found in Chaco that had what was probably a Chief and about a dozen women who had holes in their skulls. This compares and is similar to the sacrifices that were prevalent in the tribes further south in Mexico.

A trail in back of the Visitors Center leads to a nice petroglyph site right above the Una Vida Ruins. Plan on staying at least two nights at the campground if you're really interested in seeing all the major ruins and the rock art.

Directions

From the South

Traveling east or west on Interstate 40, take the exit at Thoreau, New Mexico and head north on State Route 371 to Crown Point,

approximately 24 miles. You cross over the Continental Divide at Satan Pass at about 8,000 feet just 6 or 7 miles south of Crown Point. Go another 3 miles north of Crown Point on Route 371 to Indian Route 9. Turn right and go about 14 miles, then turn left on a dirt road that leads north into Chaco Canyon. This road is approximately 20 miles and is rough unless it has been bladed by a grader recently. Don't expect to make good time. It is also dangerous during or after a rainstorm.

From the North or East

If coming from Albuquerque or Santa Fe area, take Interstate 25 to State Route 44/U.S. 550 at Bernalillo, New Mexico. Head northwest about 125 miles to County Road 7900, 3 miles southeast of the town of Nageezi. Turn left and go about 21 miles to Chaco. This is the best road to get into Chaco as it is paved for 8 miles and the dirt road from there into Chaco is better than the southern route.

If coming from Farmington, take State Route 44/U.S.550 south from Bloomington about 35 miles to County Road 7900, 3 miles south of Nageezi and head southwest to Chaco. There used to be another road in there called the Blanco Turnoff that is now closed. They have put up big road barriers now so you don't have to worry about taking that road by mistake even though it still shows on the maps.

This place is in the boonies so fill up with gas and carry everything you need including food and lots of water.

Time of Year

Since Chaco is a little over 6,000 feet, the winters are pretty cold, especially at night, and you can get snow. If you're camping, it can get pretty cool and windy at times. The rest of the year is fine but it can get hot in the summer during the days. You do run into rattlesnakes in the warmer weather.

Type of Hike

Each main ruin takes about an hour or more depending upon how much you want to see and what pictures you want to take. Pueblo Bonito will probably take a little longer. To see Penasco Blanco, you have to take an easy 6-mile round trip hike. On your way up, there are petroglyphs along the walls on your right and when you get towards Penasco Blanco, there are signs to the famous supernova pictograph. The supernova pictograph is thought to reflect the event in A.D. 1054 when a star increased in brilliance by thousands of millions times and then decreased over several months. There are reports from other parts of the hemisphere of this same occurrence at the same time.

Photography

Bring all your camera gear when you come to Chaco and you will be near enough to your car most of the time to be able to get what you need without carrying all the equipment around.

Accommodations

Motels

You can either stay in many of the motels in Farmington, New Mexico, to the north, or Gallup, New Mexico to the south. But it will be difficult to see everything in one day.

Camping

The Gallo Campground at Chaco is the best place to camp if you're going to stay a few days. It is right next to the Gallo Wash, which is a deep burgundy color. (only kidding) Try to get there early to get a campsite in the summer when it's the busiest. There's a nominal fee.

Crock-Pot Recipe

Whatever Stew

 2 lbs. of stew meat (cut to 2 inch cubes)

 2 large onions chopped

 1 can of condensed mushroom soup or celery soup

 1 cup of water, broth, red wine, beer, bloody mary mix or whatever

 8 or 10 baby red potatoes

 A few baby carrots, or string beans or mushrooms or all

 Salt, pepper, bay leaf, teaspoon of thyme, rosemary, oregano, basil
 or whatever you like

The night before, sear the cubes on all sides in a little oil or sear the cubes with your blowtorch. Remove and add chopped onions and saute until soft. Put stew meat, onions, liquid, soup and everything else in the crock-pot in the refrigerator. In the morning, hook up the crock-pot to the inverter and cook on low for 10 hours.

Make some good sourdough bread and if you drink wine, don't forget the Gallo Hearty Burgundy. If you don't want to carry bottles, get a five-liter box of Peter Vella Burgundy or Cabernet Sauvignon, which is also a Gallo product. Also, Franzia's five-liter "Wine On Tap" Cabernet or Merlot is a good bet.

These wines in a box are great to take on camping trips because they are unbreakable and the inner pouches prevent the oxidation you get in partially empty bottles of wine. If you really want to live it up take a

bottle of Gallo Sonoma Cabernet Sauvignon. Assuming you're camping at the Gallo Campground, hide the Cabernet Sauvignon in your car and pretend you are drinking the Hearty Burgundy or Franzia or the really good stuff will disappear very fast if there are other people around.

Other Attractions

Farmington Area

Salmon Ruins and Heritage Park (505) 632-2013
Salmon Ruins is half way between Farmington and Bloomfield, New Mexico on the San Juan River. You can take a self-guided tour through the ruins and go through a reconstructed Basketmaker pithouse.

Aztec Ruins National Monument (505) 334-6174
The Aztec Ruins is situated next to the Animus River in Aztec. New Mexico, which is about 15 miles northeast of Farmington. It is famous for the restored great kiva and is well worth seeing. Aztec Ruins was originally part of the Chacoan culture and was later occupied by the Anasazi from Mesa Verde.

Gallup area, New Mexico

El Morro National Monument (505) 783-4226
El Morro is about 55 miles southeast of Gallup and about 42 miles west of Grants, New Mexico. Inscription Rock contains not only Anasazi petroglyphs but also Spanish inscriptions from the 1600s. There are also several U.S. Calvary names carved in the year 1866. You can hike to the top of the mesa where there was an Anasazi village of approximately 500 rooms.

Zuni Indian Tribal Offices (505) 782-4481
Zuni is about 30 miles south of Gallup and is famous for its inland jewelry and carved animal fetishes. They welcome visitors and even allow you to see some of their scheduled dances. Remember that the dances are religious in nature and are not staged theatricals. Again, photography is not allowed. There are also several rock art sites within a few miles of Zuni and you might be able to get directions to some of them.

El Malpais National Conservation Area (505) 240-0300
El Malpais is just south of Grants, New Mexico and probably won't be of much interest to many people because it is basically kind of a black, eerie volcanic landscape and some caves. El Malpais in Spanish means Bad Land. There are some great rock art sites just outside the Monument that you also might get directions to.

Acoma Tourist Center (Sky City) (800) 747-0181

This is an interesting site that has been inhabited for almost a thousand years. There's a guided tour that takes about 1-1/2 hours and is one of the few places that allows you to take pictures but for a charge of $10.00. They have recently built a Casino on I-40 but to get to Acoma, take Exit 96 about 15 miles east of Grant on I-40 south to the Visitors Center. It's about 12 miles.

Petroglyph National Monument

Albuquerque, New Mexico

**Bandelier National Monument - The Turquoise Trail
Sandia Peak Ski Area - Albuquerque Biological Park - Santa Fe**

On the western side of Albuquerque and within the city limits are some sloping lava cliffs which run for about 17 miles and almost parallel to the Rio Grande River. This area is called West Mesa and is the home of Petroglyph National Monument. (505) 899-0205.

On the lava cliffs, are approximately 17,000 petroglyphs. Some are very old, as this area has been occupied from at least 9,000-10,000 B.C. Most of the petroglyphs are the Rio Grande style, which were done about A.D. 1300-1500.

There are three separate areas near the Visitors Center where you can drive to see the majority of the rock art. Boca Negra Canyon is just north of the Visitors Center and has 3 trails: Mesa Point which takes about 30 minutes, Macaw Trail which takes about 10 minutes and the Cliff Based Trails which take about 20 minutes. There are also restrooms and a picnic area. Be sure you don't miss the two-horned serpent petroglyphs on the Mesa Point Trail.

Rinconada Canyon is south of the Visitors Center and contains approximately 3,000 petroglyphs. Don't miss the ones on the south point of the canyon. It comes out almost to the road.

Piedras Marcadas Canyon has thousands of petroglyphs. You go left along the cliffs, after parking your car on the street. Between the first and second points, is an area called Kokopelli Cove and it contains several hundred petroglyphs. Keep hiking along and go in all the alcoves. Deep in the western part of the canyon are some great petroglyphs, especially one of the Dancing Kachina figure.

The Visitor Center has directions, maps and trail guides. They are some of the friendliest rangers you will encounter. This is probably because they're not out in the middle of nowhere and Albuquerque has a Costco.

There is such an assortment of petroglyphs in the park; it is unlike almost any other site. There are many birds, probably parrots and macaws

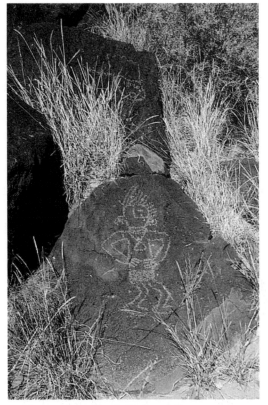

Dancer-Petroglyph National Monument

traded from Mexico; spirals, stars, masks, plants, anthropomorphs, feathered snakes, frogs, bows, arrows, Kokopelli's and many others.

Directions

Traveling on Interstate 40 from the west, take the Unser Boulevard Exit just west of the main part of Albuquerque. Go north about 3 miles to the Visitors Center. On your way to the Visitors Center you will pass Ouray Road about 1.6 miles from I-40. (Don't confuse this with Old Ouray Road a little over a mile from I-40). As you pass Ouray, you will see a canyon opening on the left. This is Rinconada Canyon.

Coming from the east on I-40, take the Coors Boulevard Exit. Take Coors Boulevard north to Western Trail, turn left or west and straight to the Visitors Center.

From the Visitor Center, head north to go to Boca Negra Canyon. You will hit the access road on the left after passing Montano Road. To get to Piedras Marcadas go back to Montano Road and head east to Taylor Ranch Road. Take Taylor Ranch Road north and this turns into

Golf Course Road. Continue north and just before you hit Paradise Boulevard, turn left on Jill Patricia Street. Go west just a little way before it turns south and park your car. Walk between the houses over to the first point on the cliff face to the west.

Time of Year

This is a good place to go year-around as the elevation is 5,000 feet. The summers can be hot during the day and the winters are cool. A good time to go would be in October when they have the balloon festival. Hot Air Baloonists come from all over the world for the first 10 days of October. There have been 700 balloons at the festival and its an amazing sight to see all the different colored balloons from West Mesa looking eastward with the 10,000 foot Sandia Peaks in the background. At this time of year if you're staying in a motel, be sure and get reservations early. Another good time is in the spring. There's still snow on the mountaintops but it can be 80 degrees hiking along the petroglyph trails.

Type of Hikes

You can do all three canyons in one day but the best bet is to arrive in Albuquerque around 12:00 noon to 2:00 p.m. and do Rinconada Canyon and Boca Negra Canyon that afternoon. Spend the night and start early in the morning to do Piedras Marcadas Canyon before the sun gets too high. That will leave you time to see this whole canyon and to be on your way to wherever you might be going by early afternoon.

Rinconada Canyon will take approximately 1-1/2 to 2 hours by the time you take your pictures. All the hiking is easy and it is approximately 2 miles around the canyon.

Boca Negra Canyon has 3 trails and takes about an hour. The Mesa Point Trail is moderate with a little climbing and the rest are easy.

Piedras Marcadas Canyon has a trail that winds around the bottom of the sloping cliffs and by the time you go in and out of all the nooks and corners and back to your car, it will probably be about 2-1/2 miles. Plan on about 3-4 hours because there are lots to see and you will be climbing up and down a little to get pictures. Be sure and take lots of water.

Photography

Morning and afternoon pictures are the best times for these sights as you can get a bad glare from the sun off the dark rock at mid day. A polarizer is necessary and, because of the location of the petroglyphs, you can get some great photographs with the sky and the cliffs in the

background. Doing Piedras Marcadas in early morning will give you the sun at your back most of the time and this is where you will take a lot of pictures. On the other sites you might need a sunshade for a couple of shots, depending upon the time of year, but many will be in the shade and easy to shoot in the afternoon. Since you can climb to almost all the petroglyphs, a long telephoto lens is not required.

Accommodations

There are many places to stay at the I-40 exits just south of the park on the westside of the Rio Grande. At the Coor Road Exit, there are several motels including two Motel 6's, a Holiday Inn, Days Inn and a Comfort Inn. If you want a special trip for dinner, take the tramway up Sandia Peak to the High Finance Restaurant. It is priced accordingly but just the view is worth the trip.

About 20 years ago, there used to be a restaurant in Albuquerque called Al Monte's that cooked your steak with a blowtorch at your table. I don't think it's there anymore but this is where I got my idea for using the blowtorch when you're camping.

Crock-Pot Recipe

Lemon Veal Pot Roast
 1 3 lb. rolled veal shoulder (usually in string)
 2 tablespoons of butter
 1 tablespoon of oil
 Mix the oil and butter and brown veal on all sides.
 1 large onion chopped
 2 cloves of garlic chopped
 Remove veal when brown and add the onion and garlic and saute until soft
 1 lemon
 3 or 4 baby carrots, sliced in three or four pieces
 1 stalk of celery sliced
 1 tablespoon of dried parsley
 1-1/2 teaspoons of salt
 1/2 teaspoon of pepper corns
 pinch of nutmeg
 1 cup of chicken broth

Squeeze the lemon juice into the crock-pot and then grate the rest of the lemon and put in the crock-pot. Put in all above except for the veal and mix it up. Put the veal on top and cook on low 8-10 hours.

Other Attractions

Bandelier National Monument (505) 672-0343
Presently known mostly for their controlled burns, Bandelier contains hundreds of pueblos and cliff houses. It was named after Adolph Bandelier of Swiss nationality who spent several years in the 1880s, exploring and mapping the ruins.

You can be completely alone here because of the 70 plus miles of trails and you could easily spend a week and never see anything twice.

Without having to take some of the longer hikes, you can see some rock art on an easy hike from the Visitors Center. Head northwest in Frijoles (bean) Canyon and stop at the oval shaped Tyuonyi Ruins. Then continue northwest in the Canyon to see Long House, which has some rock art on the walls in back of the ruins. Continuing on you will come to Ceremonial Cave, about 150 feet above the bottom of the canyon and entered by a series of ladders. On your way back to the Visitors Center, stop at Talus House.

The Turquoise Trail
If you're going to Santa Fe from Albuquerque or vice versa this is an interesting route which takes you through several old mining towns including Cerrillos which was famous for its turquoise mines. The former ghost towns today contain restaurants, arts and crafts stores, bed and breakfasts, museums and much more.

It was only 20-30 years ago that the towns were almost vacant. Cerrillos used to have a great antique shop and Madrid had only a few hippies living there.

The scenery is wonderful and this is the road to take to reach the Sandia Peak Ski Area if you don't take the tram. Take I-40 from Albuqerque east to Exit 175. Head north on Route 14. It eventually comes out on I-25 just south of Santa Fe.

Sandia Peak Ski Area (505) 242-9133
This area offers four chair lifts and over 30 trails and is reached by the tramway ride from downtown Albuquerque or around the eastern side off the Turquoise Trail. It's usually open from mid-December through March and has ski rentals, ski school and a Lodge with a cafeteria. The Senior All Day Lift tickets were $25.00 last year.

Albuquerque Biological Park (505) 764-6200
This park includes the Aquarium and the Rio Grande Botanical Garden, which are on the northwest side of Central Avenue, east of the Rio Grande River. The Rio Grande Zoo is a couple of miles southwest, also along the river. The world class zoo has about a thousand animals and is well worth half a day.

Santa Fe Convention and Visitors Bureau (505) 955-6200
Everyone has probably been to Santa Fe or read about it. At an altitude of 7,000 feet it has great weather, beautiful scenery and has been occupied, not counting the Indians, for almost 400 years, The different cultures bring a special feel and charm to the town. It has just about everything that you would want and is impossible to cover in this short description. The list below covers some of the major attractions:

- Rafting
- Skiing
- Large Artist Community
- Santa Fe Opera
- Several museums
- The Indian market in August

- Many great restaurants
- All types of accommodations
- Great shopping
- Dance
- Theatre
- Missions

In addition to the above, there are eight Pueblo Indian Cultures near Santa Fe and many of them now have casinos:
- Nambe Pueblo
- Picuris Pueblo
- Pojoaque Pueblo
- San Ildefonso Pueblo
- San Juan Pueblo
- Santa Clara Pueblo
- Taos Pueblo
- Tesuque Pueblo

There's only one Santa Fe and it rates right up there with San Francisco and New Orleans in its own unique way.

Three Rivers Petroglyph Site
New Mexico

White Sands National Monument - Ruidoso - Lincoln - Trinity Site

Three Rivers (505) 525-4300, is another spectacular rock art site located just north of Tularosa, New Mexico in the Tularosa Basin. It is approximately 200 miles west of Clovis, New Mexico where the famous Clovis Point was found imbedded in the bone of a woolly mammoth and dated approximately 9300 B.C. Hunter/gatherers have occupied this area for over 11,000 years.

The majority of the over 20,000 petroglyphs at Three Rivers were done by the Jornada Branch of the Mogollon who lived in the high desert at about 4,500 feet from approximately A.D. 900 to A.D.1400. They were probably the descendants of the nomadic tribes that roamed the area much earlier. They started to farm corn, beans and squash and built homes in the area. There is one of their villages a short hike from the parking lot at Three Rivers.

The Mimbres Branch of the Mogollon lived to the south and west of Three Rivers in the mountains and mountain valleys. The famous

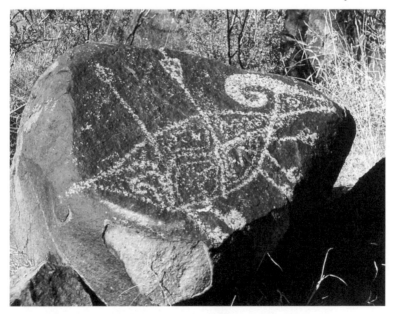

Mountain Sheep with Arrows - Three Rivers - New Mexico

Mimbres black and white pottery contains many of the same figures contained in the rock art of the Jornada.

From the basalt ridge, where the majority of the petroglyphs are found at Three Rivers, you can look across the basin and see the San Andres Mountains covered in snow during the colder parts of the year. If you look south, you can see White Sands National Monument and to the east, The Sacramento Mountains.

To the west of the main site, about 1/4 mile is a small island of rocks sticking out of the desert. It also has several petroglyphs but also many rattlesnakes. If you go over there, be careful when climbing on the rocks to get pictures.

There's a great variety of figures including animals, tracks, cougars, sheep, anthropomorphs, birds, fish, masks, faces, hands and reptiles. Some of the petroglyphs resemble corn and there is one petroglyph that looks exactly like Tlaloc, the Rain God, like the pictograph at Hueco Tanks, Texas.

Directions

Three Rivers petroglyph site is about 3-1/2 hours south of Albuquerque, New Mexico and about 3 hours north of El Paso Texas. From Tularosa go north 17 miles on Route 54 to the turnoff for Three Rivers. Turn east or right and its 5 miles to the parking area. From Carrizozo, New Mexico, go south on Route 54, 27 miles to the turnoff. There's usually a Bureau of Land Management (BLM) host and also an excellent campground, a picnic area and extremely clean restrooms.

Type of Hike

The trail going to and among the rock art is fairly easy and depending upon how far you go, it will take a half a day, probably more. If you give it a full day, you can take in the partially restored Mogollon Village and the small island to the west. If you start early you might even go a little further for additional rock art. The total hiking distance will be about 2 to 3 miles but it seems shorter as you are constantly looking at the petroglyphs and taking pictures. As usual, take plenty of water and a snack.

Time of Year

At a little over 4,500 feet, Three Rivers is open year-round but it's pretty hot in the summer. In the winter and spring, you can have some great days that are perfect for hiking and give you great shots of the rock art with the snow covered mountains in the background.

Photography

You can carry everything with you here and a tripod is helpful so you can pick up the depth of field using very small apertures. This will keep the foreground which contains the petroglyphs, and the wonderful distant scenery, all in focus, while still using a circular polarizer.

Accommodations

Accommodations are a little hard to come by close to Three Rivers. This is probably a good time to camp for a couple of nights. Besides the campground right at Three Rivers, which is really neat and well kept, there's another absolutely great campground about 8-1/2 miles northeast of Three Rivers towards the mountains. It sits at the mouth of Three Rivers Canyon and at the base of the 12,000-foot Sierra Blanca. It is almost at the junction of the northwest border of the Mescalero Apache Indian Reservation and the southeast border of the White Mountain Wilderness Area. At about 6,500 feet there are great views and a small stream of water running through the campground. It also has some nice trees and restroom facilities.

In Carrizozo, to the north, there are a couple of small motels and in Alamogordo to the south is the nearest town that has many motels and restaurants. It is also on the way to White Sands National Monument if you're going that way. If you're going north towards Albuquerque, about 1-1/2 hours from Three Rivers is Socorro, which has several accommodations.

Dinner

Jornada Burgers

Since you'll probably be camping out at Three Rivers, this is a good recipe for one of the nights. Tonight you will be cooking on your Son of Hibachi or using one of the barbecue pits.

 1 lb. of lean ground beef

 1 4-ounce can of chopped mild green chilies

 1 tablespoon of dried cilantro

 1/2 teaspoon of coarse salt or any salt

 1 avocado sliced

 1 red onion sliced

 1 tomato sliced

 Ketchup

 2 Kaiser Rolls or 4 hamburger rolls

Mix the meat, chilies, cilantro and salt together and make either two or four patties depending upon your appetite. After grilling, serve on a bun with ketchup and slices of onion, tomato and avocado.

Attractions

White Sands National Monument (505) 479-6124

White Sands is 15 miles southwest of Alamogordo, New Mexico, just past Holloman Air Force Base. The miles of pure white gypsum sand dunes rippled by the wind are almost unbelievable. You can drive into the monument about 8 miles on white roads that keep changing with the drifting sands. As you wander around the white sand dunes, it's almost like being in another world or on the moon.

The best time to go is in the early morning or late evening, especially on moonlit nights. This is a great place to get pictures for next year's Christmas cards without being out in the cold.

Covering over 250 square miles of white sand, the monument is completely surrounded by the White Sands Missile Range. The whole area can be closed for a couple of hours or so if there's any testing to be done.

Other Attractions

Other places nearby you might be interested in are:

- Ruidoso Downs where they have the famous quarter horse races.
- Lincoln, New Mexico, site of the Lincoln County Wars made famous by Billy the Kid and Sheriff Pat Garrett.
- The Trinity Site where the first atomic bomb was detonated.

If you're headed west towards Silver City, the Gila Cliff Dwellings National Monument is an interesting place to visit.

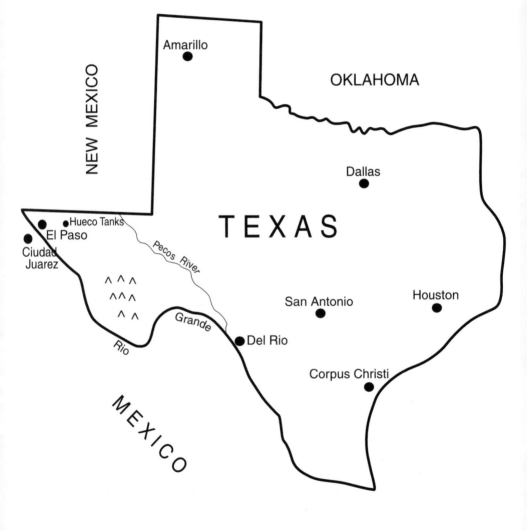

Hueco Tanks State Historical Park
Texas
Ciudad Juarez, Mexico

Hueco Tanks is located about 32 miles east of El Paso, Texas. This is in the far western part of Texas, just south and east of New Mexico. The park is relatively small but it is one of the major rock art sites in the United States and has been used by people living and traveling throughout this part of the country for 10,000 years.

The natural rock basins, indentations, and holes in the rocks collect rainwater. These are called hueco's in Spanish. Tank is probably an Americanized version and is used to refer to the same indentations. Since this area is in the arid northern part of the Chihuahuan desert, water becomes a magnet for people and animals alike.

The park is only about 1-1/2 miles square and besides the huecos, it is also full of rock shelters and caves, and when you walk around the park it's almost like a maze. You will also see all kinds of plant life, many birds and of course, reptiles.

It is interesting to note that Folsom Points have been found here which indicate the Paleo-Indians probably hunted the giant bison and maybe the mammoth elephants in this area. While there is no evidence of rock art from that time, there are a few Archaic pictographs, mostly abstract, with a few anthropomorphs and zoomorphs. Most of the rock art seems to have occurred from about A.D. 200 to A.D. 1400. and was done by the Jornada Branch of the Mogollon. This is the same clan that made the petroglyphs at Three Rivers, New Mexico. While most of the Three Rivers rock art are petroglyphs, the rock art at Hueco Tanks is primarily pictographs.

The rock art is extremely well done and some of the Tlaloc (water god) representations and the masks are especially beautiful. There are over 200 masks in the park that might indicate a cultural tie-in to the kachina masks used today in Hopi and other tribal ceremonies. These masks could also have been used in the late Anasazi period.

You used to be able to explore the park by yourself and try to find some of the 3,000 pictographs that are scattered throughout the park,

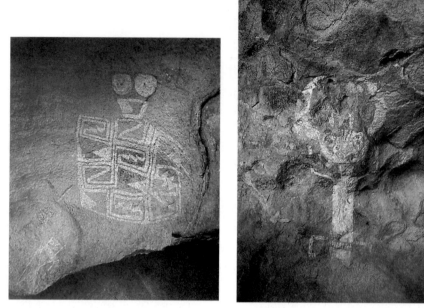

Tlaloc, the Rain God - Hueco Tanks Horned Dancer - Hueco Tanks

but as of 1998, they limited the number of people to 50 a day without a guide in the North Mountain section. There are regular guided tours in the West Mountain, East Mountain and East Spur sections of Hueco Tanks on Wednesday through Sunday.

Even if you were allowed to go by yourself, you probably couldn't find the majority of the rock art. Even before the new restrictions, you had to know someone who knew where the rock art was. Jim Olive was nice enough to come down from Salt Lake City to lead Mike Owen from Boston and myself around. Without Jim we would have been completely lost. He belongs to URARA (Utah Rock Art Research Association) and when he lived in Texas he spent ten years exploring Hueco Tanks. To get up to date on the new rules on camping and tours, call (915) 857-1135. They now will accept reservations for access to the park and tours.

Directions
From El Paso go east on Route 62/180 for 30 miles and then take Ranch Road 2775 north for 8 miles to the park.

Time of Year
The park is open all year and the busiest time is in the winter. If you're camping at that time though, some of the mornings can be pretty frigid.

The altitude is about 4,500-5,000 feet. The summers are very warm in the area.

Type of Hike

There's no telling how far you will walk on the hikes around the park. But, you can cover a lot of ground up and down and around during the day. Some of the hiking is climbing around on rocks and crawling under rocks to see the rock art. It should take you a couple of days to see most of the best sites. But, depending upon what is covered on the tours and how much exploring you do, it could take longer.

Photography

You definitely need the widest angle and fastest lens you can get at least a 28mm. Fast color film or slides will also help. Most of your shots will be taken in the shade, sometimes lying on your back, trying to get as far away as possible in order to get the rock art framed in the picture. Most of the pictographs are in the darker areas of the shelters and caves so a lamp is a big help. A propane lamp with two mantels is best. Many people don't like flashes used on the painted rocks and the rock art will probably appear washed out if a flash is used.

Accommodations

Camping

The campground at Hueco Tanks is very nice. With all the changes going on, it's best to call and try to get reservations for both the tours and campground at the same time. The number is (915) 857-1135. There is electricity and water, restrooms, and showers in one of the restrooms.

Motels

El Paso has many motels and restaurants and is the closest place to stay. Near the airport, which is just north of Route 62/180 on the eastside of town, and on the way to Hueco Tanks, are several choices of well-known motel chains. The Corral Motel is a nice little place to stay. It's west of Airway Blvd on the south side of 62/180.

Crock-Pot Recipe

Hueco Ham

> 1 precooked spiral sliced ham - Cook's has a good one. The one basted with brown sugar is excellent. They usually run 7-8 pounds with the bone in.

You need the oval Rival Crock-Pot for this. Cover and cook on low for 6-8 hours. Great with coleslaw, warmed up beans or salad. There will

be plenty for everyone and will make good sandwiches for at least a couple of days. Take slices off the bone and put in zip lock bags and keep in cooler. If you go around Easter, all the hams are on sale about that time.

Hueco Soup

Use the bone that night to make split pea or bean soup. Use any small pieces of ham to throw into the soup. To make the soup, just throw the bone in the crock-pot, add a 16- ounce package of split green peas plus the following. Add a diced medium onion, one diced carrot, a couple of sliced celery stalks, a couple of cloves of garlic chopped fine and about two quarts of water. Or use the amount of water specified in the directions on the package of split green peas. Cook on low overnight, or about 8 hours at the electrical outlet at your campsite. It gets thicker the longer you cook it. Add salt and lots of pepper when done. Make a little salad and this will really fill you up.

Other Attractions

Ciudad Juarez, Mexico

Just across the Rio Grande River from El Paso is Juarez. While you are not required to show papers going to and from Mexico if staying less then 72 hours, it is best to carry proof of citizenship which means a passport or a birth certificate just in case.

Bullfights are held from about Easter to Labor Day, usually on Sundays. You see all kinds of vendors selling everything. The "knock off" watches made in China for $20-$30 look like the real Rolexes and, Omegas, Cartiers and others. Stay away from the "knock off" Timex watches. They cost more than the real ones in the U.S.

You can bring back anything for your personal use and can spend up to $400.00.

Random Comments

One of the best things about El Paso is that you hear a lot of Country/ Western music from the old classic artists. Kinky Friedman is especially entertaining and has some great lyrics. You'll also hear Jerry Jeff Walker, Ray Price, Lefty Frizell, Hank Williams Sr., Johnny Horton, Floyd Cramer, Marty Robbins, Buck Owens, Bobby Bare plus others.

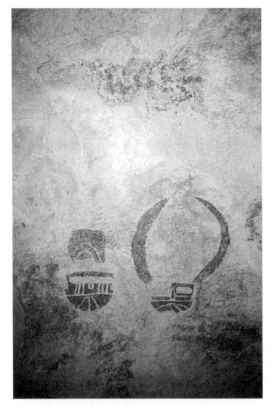

Jornada style masks - Hueco Tanks

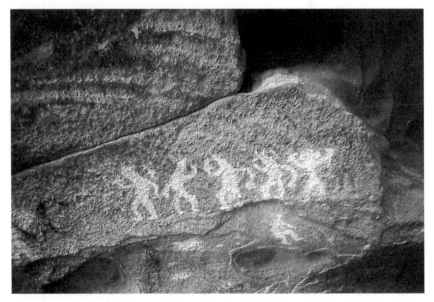

Apache dancers - Hueco Tanks, probably AD 1600 to 1800

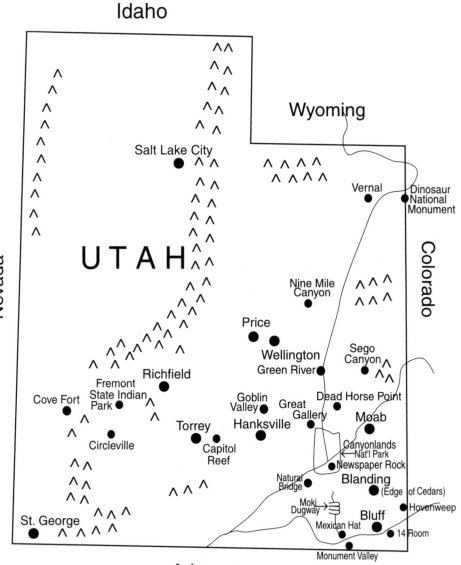

Butler Wash Petroglyphs
Utah

**Fourteen Window Ruins - Valley of the Gods - Monument Valley
Edge of the Cedars State Park - Hovenweep National Monument
Natural Bridges National Monument - Trail of the Ancients
Wolfman Panel**

This is a really neat trip for beginners and provides a variety of other attractions including rafting, ruins and rock art.

At the confluence of Butler Wash and the San Juan River there are several panels of outstanding Basketmaker II style Anasazi petroglyphs. (Notation: One thing to remember is that there is no Basketmaker I. That earlier period now falls under the Archaic). The best way to see these petroglyphs is to take the one-day raft trip from Sand Island to Mexican Hat. The trip stops for lunch, which they provide, and stops at Butler Wash and Riverhouse Ruins.

This is an easy raft trip with the rapids just fast enough to be fun. An added bonus are the petroglyphs at Sand Island itself. They stretch for several yards along the wall, in back of the campsites, facing the river. Don't miss the mountain sheep flute player, which is very unusual. If you camp here you will probably be staying exactly where the Indians did centuries ago.

The Basketmaker II rock art is approximately 1500 B.C. to A.D. 500 and usually the arms and feet hang downward looking like pendulums. At Butler Wash, there is one panel that consists of several human size anthropomorphs (representations of a human form in rock art) with small round heads, and horizontal curved lines above the heads. The bodies are decorated and, projecting out of the left ear on some of these anthropomorphs, there is what looks like a shish-ka-bob you'd throw on your grill today. The only other place we've seen these ear appendages is in pictographs at Canyon de Chelly.

The rock art covers about a half-mile and is on the north side of the San Juan River on both sides of Butler Wash. If the river is running fast and you arrive at Butler Wash early on your way to Mexican Hat, you might have time to go up the wash a little and see some of the other

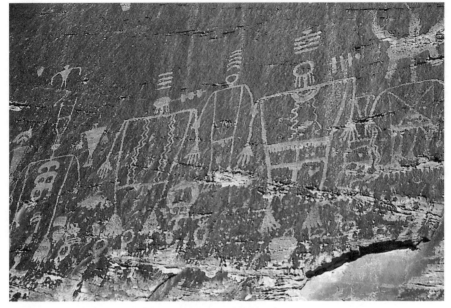

Large 6 foot Basketmaker II Anthropomorphs

scattered rock art and ruins. The last time we were there, there was a scarecrow dressed like a Navajo on the trail just up Butler Wash on the way to the ruins. It seemed like a warning to not go any further even though the ruins are shown to be on Bureau of Land Management (BLM) Land on the topographical map.

The next stop is Riverhouse Ruins, which has a great pictograph of a snake above the entrance to the cliff house. This is just a short hike from the river of about a quarter of a mile so be sure and take some running shoes in addition to the sandals you'll probably be wearing in the raft.

Directions

The raft trip starts in Bluff, Utah, at Wild Rivers Expeditions. The phone number is (800) 422-7654 or (435) 672-2200. These are great people and they take care of all your needs. Just park your car at Wild Rivers and they take you by van to Sand Island. You launch there at about 8:00 in the morning and get picked up by van in the afternoon at Mexican Hat. You are back to your car by 4:00 or 5:00 that afternoon. You can pick up petroglyph stickers for your car there and any last minute things you might need for the trip. They'll even provide sealed ammo cans to protect your camera equipment while going through the rapids.

Time of Year

This trip is available from about April until late fall. Spring is a good time because the river is running fast and leaves you a little bit more

Pahranagat Man near Alamo - Nevada

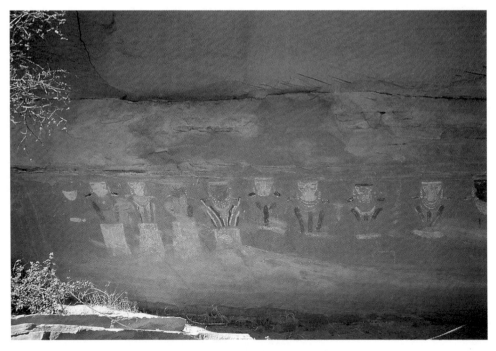

Thirteen Faces East - Canyonlands National Park - Utah

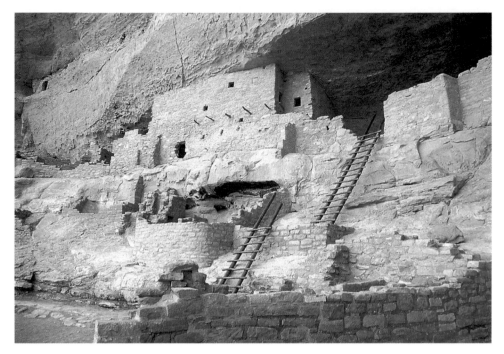

Long House Ruins - Wetherill Mesa - Colorado

On the Sunflower Trail - Smith Mesa - Utah

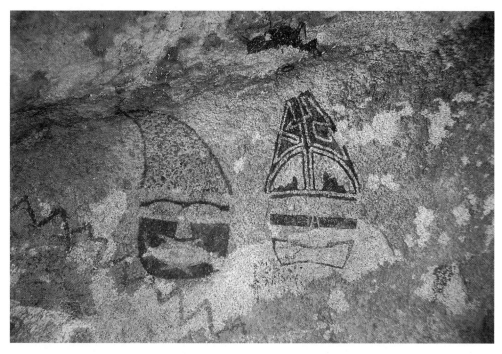

Masks - Hueco Tanks - Texas

Shadow and Chance looking for arrowheads - Utah

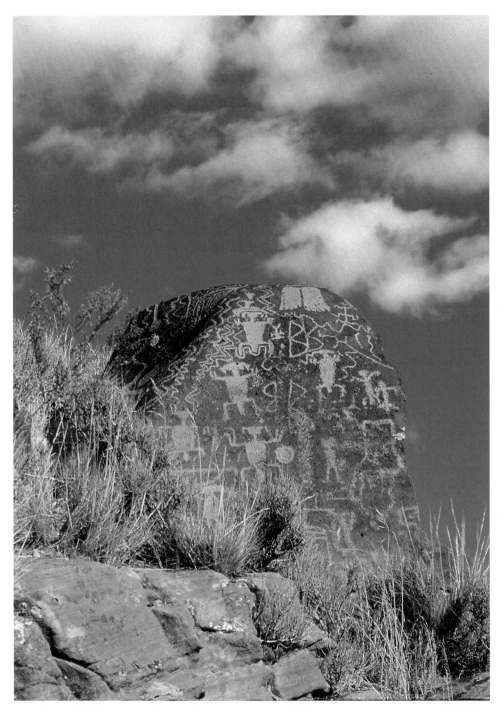

Santa Clara River - Utah

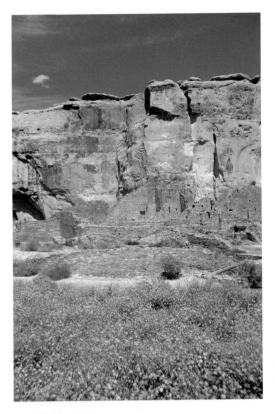

Pueblo Bonito - Chaco Canyon - New Mexico

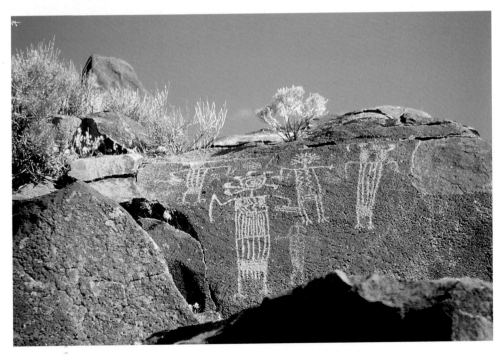

China Lake Naval Air Weapons Center - California

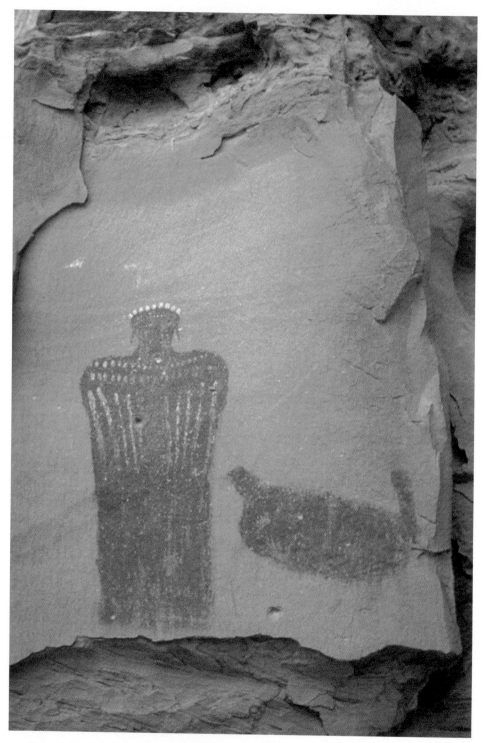

Cleopatra - Barrier Canyon Style Pictograph - Utah

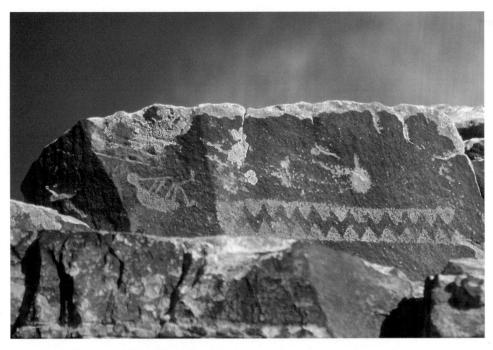

Flute Player or Kokopelli - Arizona

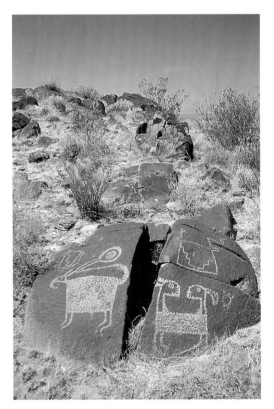

Unusual two-headed sheep - Three Rivers - New Mexico

Crazy Jug Point - North Rim of Grand Canyon - Arizona

time at the archaeological sites. In late May and June, you're liable to get some bugs along the river so if you're camping, it might be best to head up to a higher altitude away from the water. Once you're on the water on the raft, the bugs are no problem.

Type of Hike

The petroglyphs at Butler Wash are almost on the river. The only walking will be along a level path below the rock face where you can observe the rock art and take whatever pictures you want. As we mentioned, the Riverhouse is about 1/4 mile from the river.

Photography

No special cameras or zoom lenses are required for taking pictures as you are able to get quite close to the rock art and the ruins. Since you are so close and these petroglyphs are so large, a wide-angle lens would be helpful. Depending on the time of year, a circular polarizer lens will help eliminate the glare from the patinated surfaces.

Accommodations

Besides the camping facilities at Sand Island, in the town of Bluff, there is the Recapture Lodge which is highly recommended and the Kokopelli Inn and Desert Rose Inn. The Recapture Lodge phone number is (435) 672-2281. Kokopelli Inn is (435) 672-2322. Desert Rose Inn is (435) 672-2303.

Crock-Pot Recipe

Butler Wash Brisket of Beef
 3-4 pound beef brisket
 medium onion, slices and broken apart in rings
 1- 8 ounce package of fresh mushrooms (sliced or whole)
 1/4 cup leftover coffee (regular, decaf. or 50/50)
 McCormick's Montreal Steak Seasoning

Put onions in bottom of crock-pot, splash some coffee on the brisket to moisten and then sprinkle liberally with Montreal Steak Seasoning. Put the brisket on top of the onions and put mushrooms on top of the brisket. Cook on high for 5 hours or 10 hours on low, depending on how long it will take you to get to Bluff from wherever you are. You can also use 3 hours on high and 4 hours on low or any combination that works out for you. You can serve this with Idahoan Real Potatoes and string beans or asparagus cooked in your coffee maker. Be sure to slice the brisket across the grain in thin slices.

If you want to zip it up a little, forget the mushrooms, add a couple of more onions on top of the brisket and make a sauce of 1/3 cup water, 1/2 cup of chili sauce, 2 tablespoons of brown sugar, 2 tablespoons of vinegar and a dash of Worcestershire Sauce or hot sauce if you like that.

Other Attractions

Bluff is a good place to base camp and day trip to the other attractions in the area.

Fourteen Window Ruins

This ruin is known by three different names depending on who you talk to. Besides Fourteen Window Ruins, it is sometimes called Seventeen Room Ruins or Echo House. This might end up being your favorite hike of this trip. It has a little bit of everything, but if you have any problems with balance or fear of heights, you should forget about it because of the suspension bridge over the San Juan River. If you do this hike, be sure to wear a life jacket. If you don't have one with you, maybe you can rent one from Wild River Expeditions.

Suspension Bridge over San Juan River

Plan on a half day. From Bluff, go east on Route 163 towards Montezuma Creek. After you pass St. Christopher's Mission on your left, pull over and stop and look straight across the river and you will see the ruins in a large alcove in the cliff. About 3.4 miles from the intersection of 163 and 191, in Bluff, keep an eye out for a dirt road running off to the right. Take this road down the hill to a small parking area full of rocks with graffiti all over them. This is where the suspension footbridge over the San Juan River begins. This was originally used by Navajo children, who came across the bridge from the reservation in order to catch the school bus. I'm sure they went across a lot faster than you are going to. After you cross the bridge, you don't have to wear the jacket over to the ruins. Just leave it in the bushes until you come back. As you go across the bridge, which has a few boards missing, just look straight ahead and keep going. In the spring, when the river is really running, this is quite an experience. Don't hold your breath, force yourself to breathe and keep going. Don't think about coming back. It's actually easier when you do.

On the other side of the river, which is on the Navajo reservation, walk down the road and keep left to circle around the fields to the ruins. Don't cut across their fields. You lose sight of the ruins for awhile when you're walking back west. Then you arrive at a trail going up to the ruins from the left side. There's also another trail going up the right side.

On the left-hand side of the ruins there are a hundred or so painted handprints. Some are very faint. There are both negative and positive handprints. The positive prints were put on the rock by dipping a hand in paint and pressing against the rock. The negative prints were applied by putting a hand on the rock and blowing paint around the hand from a reed. There are conflicting ideas as to why handprints are located all over the Southwest. Many think it is because the person who put the handprints there wanted to be recognized by God when he reached the spirit world.

Right in the middle of the ruins, you can get some pretty good photographs and you will also notice some carved steps in the rock called Moki steps, which the Anasazi used to climb up to get to the ruins. As it faces north, and is also shaded, the ruins will be very cool and it is a good place for a snack or lunch, especially in hot weather. It is very beautiful when you look out at the river and see the Navajo's working in their fields on the flood plain of the San Juan River, much as the Anasazi did over a thousand years ago.

Valley of the Gods

Twelve Miles west of Bluff on Route 163, is the Valley of the Gods. It is a mini Monument Valley but without the people. It's a great place to camp or have lunch, and you probably won't see another soul. Here you can enjoy the sights as well as the solitude.

Monument Valley Navajo Tribal Park (435) 727-3287

Forty miles southwest of Bluff is Monument Valley and the scenery you've seen in many, many movies. Sunrises and sunsets are especially beautiful here and you can arrange a tour at Goulding's Trading Post or from any of the Navajo guides around the Visitors Center. If you want to, you can actually drive part of the route yourself on dirt roads, but for this I'd be sure to use a 4 Wheel Drive. There are some pretty good ruts going down and coming back up the hill. If you take the tours though, you get to go further into the Monument and see rock art as well as different scenery and cliff dwellings. You can also stay at Gouldings Trading Post (435) 727-3231 which is just a couple of miles north of the Arizona border. It has a view of Monument Valley, a restaurant, a replica of the old trading post and a great gift shop on the upper level.

Edge of the Cedars State Park (435) 678-2238 Blanding, Utah

About 50 miles north of Bluff, this museum contains over 100,000 Anasazi artifacts, and outside are some partially excavated ruins. In the museum, artists have also painted replicas of rock art found in Utah. The "Holy Ghost" replica from Horseshoe Canyon (formerly Barrier Canyon) is particularly impressive. Don't miss this museum.

Hovenweep National Monument (970) 562-4282

This Monument is located over 40 miles east of Bluff on the Colorado border. It was occupied by the same culture that lived in Mesa Verde, the Pueblo III period of the Anasazi. This monument is not as frequently visited as many others and you might find that you are the only one walking around the self-guided trails and looking at the ruins. This is many people's favorite spot because of its remoteness and solitude. Because of dirt roads, be sure and check the weather. If you come in from the west, I think it's all paved now.

Natural Bridges National Monument (435) 692-1234

Sixty-five miles northwest of Bluff, is Natural Bridges National Monument. Much as it implies, this monument has several rock bridges within its boundaries, but most interesting to you will be the Anasazi ruins and the rock art. You can see many of the ruins from the overlooks

and binoculars are especially handy. To see the rock art, you'll have to take short trails down into the canyon. The elevation change is about 400-500 feet so remember when you go down, you'll have to come back up the 400-500 feet. Or, if you like, you can take the longer trails down in the canyon.

Horsecollar Ruins is probably the most unique ruin because it is different from anything you have seen before. Mormons or Cowboys probably named it in the 1800's because the doors of the ruins resembled the leather horse collars used at that time.

The Visitor Center can tell you where most of the petroglyphs are. The Bridges are located in White Canyon which runs 40 miles all the way northwest to Hite, Utah on the Colorado River.

Trail of the Ancients

In Bluff, you can pick up a map of Utah's Trail of the Ancients at any restaurant, motel, gift store or probably any place you stop at. This lists several interesting archaeological sites that you can stop at along the route, including Butler Wash Ruins Overlook, Mule Canyon Ruins, Westwater Ruins, Cave Towers, Comb Ridge and the Muley Point Overlook among others.

Coming up or down Route 261, between Mexican Hat in the south to Route 95 in the north, you run into the Moki Dugway. This is a tense drive either going up or down, especially if you have acrophobia. When it says not recommended for trailers, it means it. It's steep and "switchbacky" and goes up or down over 1,000 feet in no time. As you navigate up or down this Dugway you spend a lot of time thinking about why you didn't go the long way around by Blanding. Personally, I don't think I want to use this road again unless I have a parachute.

Wolfman Panel

About 5 or 6 miles west of Bluff, there is another great Basketmaker II site which you should visit in the late afternoon for the best pictures. The left side of the panel has what looks like a skier upside down. I call it the Frank Taylor Panel, after a great friend. We looked like this quite often on the 60-meter jump at St. Lawrence University.

If you ask the right people, you might get directions. If you poke around the Recapture Lodge and talk to people you might get directions to this site and some other neat sites in the area. I found that the guys with ponytails know more than any one. Also, the guys with beards know a lot. If they're wearing shorts, be sure they don't have big thighs

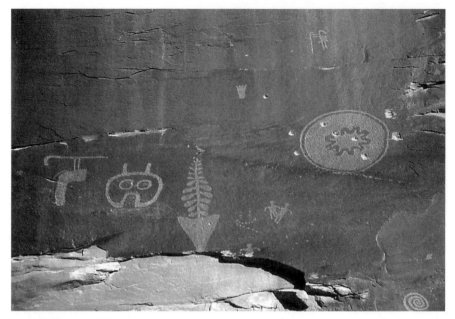

Wolfman Panel - ski jumper on left missed the takeoff

and calves because all they'll tell you about are their 3-day back packing trips in to see sites and their treks to Nepal. The best of all worlds is to find a guy with a ponytail, a beard, shorts, and skinny legs, as long as he's not wearing all-leather Fabiano Italian boots, "the boots that conquered the Alps." He should know everything about the area.

Random Comments

If you take this trip in May, it's a good time to get your wife a self-propelled lawnmower for Mother's Day. The grass is starting to grow pretty fast and it makes it a lot easier for her to have the self-propelled mower when you're out of town.

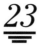

Fremont Indian State Park

Utah

Capitol Reef National Park - Circleville - Cove Fort - Scenic Highway 12

One of the most accessible and concentrated rock art sites is in the southern part of Utah is Fremont Indian State Park. This is one of Utah's newest parks and contains almost 600 rock art panels and petroglyphs in the thousands. Most of these were done about A.D. 900-1250. While most are petroglyphs, there are some pictographs and a couple of mixed ones where the figure is both pecked and painted. On the south side of the canyon, there was once a large Fremont village that was discovered during the construction of Interstate 70.

The park runs through Clear Creek Canyon and many people still refer to this site as the Clear Creek Petroglyphs. Most of the petroglyphs are on the beautiful red brick colored walls on the north side of the canyon and they run for about 5-6 miles along the creek. Also, across the creek on the south side are some interesting pictographs. One is a blanket and another is a cave full of painted hands.

At the Visitor Center, which opened in 1987, you can pick up a set of guides and maps that allow you to tour the whole park by yourself. These guides give you a little history and some interpretation of the rock art. Dee Hardy, the archaeologist showed us an interaction site one morning at the Spring Equinox. The interaction showed shadows moving across petroglyphs and is right near the Visitors Center. Sometimes there are beams of light like darts that hit the center of spiral petroglyphs. Other times, it's a dagger-like shadow that crosses a petroglyph. There are several panels in the park that look like they have the possibility for interaction during a solstice or equinox. These were probably done to indicate the beginning of planting seasons, the shortest and longest days of the year and sometimes they are accompanied by dots or perpendicular lines probably indicating the number of days before or after the interaction. Again, this gave them some kind of a calendar so they wouldn't plant too early and have their plants killed by frost. Even today in New England and northern New York, you never plant tomatoes until after Memorial Day, but you have to know when Memorial Day is.

After spending about an hour going through the museum and seeing the artifacts and the replica of a pithouse, you learn much more about the Fremont. At the museum, you can also buy an atlatl kit for about $30.00. It comes with a roughed out atlatl and two metal spears and makes a great present for anyone interested in archaeology and prehistoric weapons.

As you leave the museum, you start your first walk around what is called the Parade of Rock Art, which is right outside the Visitors Center. They have made this section wheelchair accessible so that everyone can get an idea of what rock art is without having to climb or hike. For the rest of the hikes, be sure and take binoculars to see up close the fine work of the people who did this art.

There is so much to see that it's worth taking at least a full day and probably another half-day or so to cover the whole park. You will find it challenging to find all of the petroglyphs outlined in the brochures and

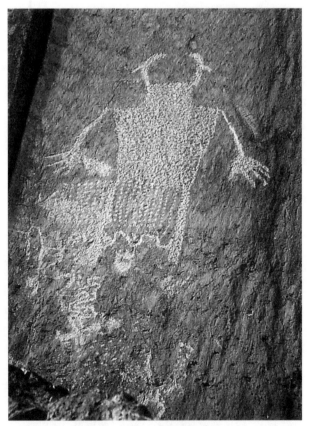

Logo for Fremont Indian State Park

there's even many more you will see that aren't mentioned. Don't miss Panel #96 in the park if you have time. With permission of the rangers and depending on the weather, you can hike up this steep area and at the same time see many other petroglyphs and newspaper rock.

Fremont Indian State Park is on the way east to Green River, Moab, and Grand Junction, Colorado. It is open all year and in the winter, when there are fewer visitors, you can wander around by yourself and never see another soul.

This site was discovered during the construction of Interstate 70 and the museum was built to house all the artifacts found at that time. As you look at some of the wonderful Fremont style rock art along the canyon, cars and trucks are going past on Interstate 70, oblivious to fact that they are passing sites, which are thousands of years old. The canyon was originally an east-west migration trail for the Archaic as well as the Fremont Indians and dates back as far as 5000 B.C. There's also a few historic rock art panels including a train and a horse looking out of a house.

Directions
Fremont Indian State Park is located in the south central area of Utah. It is 142 miles northeast of St. George, Utah and about 158 miles south of Provo Utah. It is located right off of I-70 at Exit 17. This is 17 miles east of the intersection of I-15 and I-70. Coming from the East, it is about 24 miles west of Richfield, Utah on I-70 and there are good signs for the turnoff at Exit 17.

Time of Year
The altitude here is approximately 6,000 feet so it is a good place to go most of the year, depending on whether you are camping or staying in Richfield. If tent camping, late spring, summer or early fall is fine. It gets pretty cold at night during the rest of the year at this altitude.

Type of Hikes
All of the 12 trails listed in the guides are easy to moderate hikes and most of them take about 30 minutes or more. If you try some of the other hikes, check with the rangers. Some can take an hour or two and are a little dangerous at the tops of talus slopes.

Photography
Definitely take your tripod and zoom lens with you in order to get some of the high rock art. Since most of the glyphs face south, you definitely

need a polarizer lens, but you don't need a tripod on the closer ones, even with 100 ASA film.

Accommodations

Camping

The Castle Rock Campground is a nice little place to stay for a night or two. It has water, toilets, tables and grills. From the Visitors Center, go back to the Exit/Entrance 17, cross over the freeway and continue back west over a dirt road. Follow it around for a short distance and it turns south and you are at the campground. Since there are only 30 sites or so, it is best to call for reservations if possible. (800) 322-3770. There are other spots in Richfield and also many places to primitive camp off the dirt roads.

Motels

Richfield is the closest place for accommodations and has several motels in all price ranges including a Best Western, Super 8 and a Days Inn. The Topsfield Lodge is the place to go for a good dinner.

Crock-Pot Recipe

Jambalaya

> 2 tablespoons of olive oil
> 3 cloves of garlic, chopped fine
> 1 green pepper cut in thin strips
> 1 small yellow onion chopped
> 1 stock of celery sliced
> 1 cup of white rice
> 1 can of stewed tomatoes
> 1 cup of water
> 1 shot of Tabasco sauce or more if you like
> 3/4 cup cooked ham chopped
> 4 or 5 Louisiana Sausages sliced (or Chorizo or any kind of hot Italian sausage)
> 1 teaspoon of oregano
> salt and pepper
> 1-2 pounds of cooked, shelled shrimp

Saute the garlic, pepper, onion, and celery in olive oil until soft - 4 or 5 minutes. Pour in crock-pot. Add everything else and cook on low for 6 hours. Add the shrimp and heat until warm. (Notation: you've already

done the sauteing at home. Throw everything in the crock-pot that night, keep in the refrigerator and start it when you leave in the morning).

While you're doing this in the car, it will always taste better if you play Hank Williams or Joe Stafford's recording of Jambalaya.

Other Attractions

Capitol Reef National Park (435) 425-3791

This is another one that could be a trip to do all by itself. Take Route 119 out of Richfield to Route 24 about 10 miles. Turn right on Route 24 and go to Torrey, Utah, approximately 60 miles. From Torrey, it's 11 miles to the Visitors Center and the Park. The Capitol Reef Inn and Cafe in Torrey has ten large comfortable rooms and a wonderful restaurant. If you've been eating your own cooking, this is the place to splurge a little. They close towards the end of October and open again in about April. Be sure you get reservations.

There are also several other motels in town and another great restaurant just across the Highway and down a little from the Capitol Reef Inn called Cafe Diablo. Don't miss their pumpkinseed-crusted trout for dinner. These two informal restaurants can compete with some of the best in San Francisco.

Capitol Reef was named for the Waterpocket Fold, which is a reef-like cliff that runs 100 miles north and south through the park. The large, white sandstone domes reminded early pioneers of the Capitol and other buildings in Washington D.C. There are some famous Fremont petroglyphs one mile east of the Visitors Center on Route 24 heading towards Hanksville. With some luck, you might have the rangers tell you about some other sites.

Circleville, Utah

South on Route 89, from Fremont Indian State Park is the small town of Circleville, Utah. You can still see the cabin where Butch Cassidy lived as a child about 2 miles south of town on the western side of Route 89. At that time, his name was Robert Leroy Parker. Just lately, Howard Hook of Johnson Canyon which is about 10 miles east of Kanab, Utah, showed us where Dan Parker, Butch Cassidy's brother, had carved his name in 1888 by a panel of Anasazi rock art. Johnson Canyon was the main north-south dirt road for years before Route 89 was built. In prehistoric times, the Indians going south towards the Grand Canyon used this route as a trail. The Kanab area is where they have filmed over a hundred movies, mostly westerns.

Just north of Circleville is an interesting small herd of buffalo.

<u>Cove Fort, Utah (435) 438-5547</u>

At the junction of I-70 and I-15, is the Cove Fort Historic Site. It served as a way station for people traveling between Fillmore and Beaver, Utah. It is fully restored with furnishings of the late 1800's. People traveling back and forth found safety from the Indians and plenty of food, water and feed for their animals. At one time, it also served as a Pony Express Pick Up and Delivery Station. A short tour takes about an hour.

<u>Scenic Highway 12</u>

Heading south out of Torrey, Utah, is the famous Highway 12. This road takes you over Boulder Mountain at about 10,000 feet and down into Boulder, Utah, where you can visit Anasazi Indian Village State Park. (435) 335-7308. Then it goes down to Escalante via a ridge that falls off both sides. It doesn't seem to bother the people who take this road all of the time, but if you're a first timer, it's pretty scary. I've never looked over either side to see how far it falls off but it's quite a ways. If you have acrophobia, it can be quite a challenge and you just have to look straight ahead and not look to either side.

The Bureau of Land Management (BLM) Escalante Resource Office in the town of Escalante is one of the entrance sites for the new Grand Staircase-Escalante National Monument. Continuing on down to Route 12 takes you to Bryce Canyon National Park and back to Route 89, only about 60 miles north of Zion National Park.

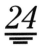
The Great Gallery

Utah

**Goblin Valley State Park - John Wesley Powell River History Museum
Capitol Reef National Park**

The life-size Barrier Canyon style pictographs in Horseshoe Canyon, (formerly Barrier Canyon), are considered by many to be the best examples of prehistoric rock art not only in America, but the whole world. On a scale of 1-10, this is about a 12. This is definitely one of the best and most beautiful of the well-known pictograph sites in the Southwest, famous for its beautiful rock art.

As you hike into Horseshoe Canyon, the whole setting is spectacular. The isolation of this canyon gives you a sense that nothing much has changed here in thousands of years when it was a home to the Archaic culture. When you first come upon the main panel, which is almost 200 feet long with a ghostly, mummy-life figures, it's almost overwhelming. This is and was definitely a spiritual place and the quiet setting among the cottonwood trees and shade in front of the panel gives you a very solemn feeling.

As you look at one after another of the large figures that have no arms or legs, you know that an artist or artists of great ability did these. There are many of these large size pictographs with some being surrounded by smaller human and animal figures. The large ones have all kinds of designs and decorations and in some cases are combinations of paint with incised designs on the body. Some have the large bug eyes characteristic of many of the barrier canyon sites in Utah.

After you look at this site for awhile, you will finally remember to take some pictures. But the pictures don't seem to do this site justice. Sometimes you just have to look around and record it in your memory.

You'll be happy to know that a ranger from the Hans Flat Ranger Station goes down to the site everyday to help with questions and to help protect this site from any intentional or unintentional vandalism. On your way to the main site (Great Gallery), you will see on your left a site they call the High Panel. It is not marked but you will see a trail going up to it. Further along on your right, you will see a large alcove

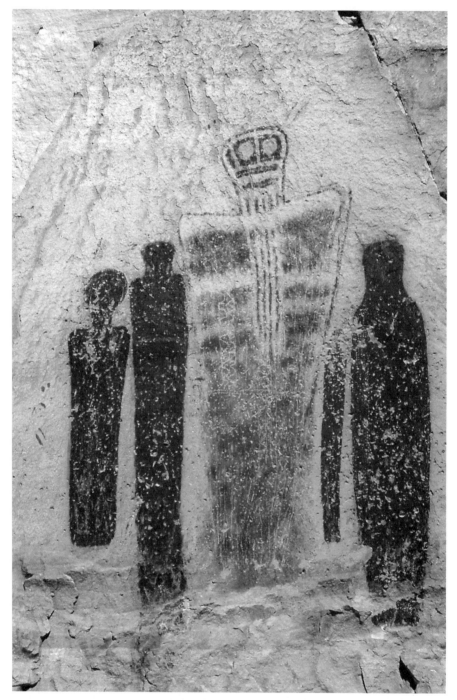

The Holy Ghost - Great Gallery - Utah

which is also full of pictographs, but smaller than the Great Gallery. Just past the Great Gallery, on the same side, there is another panel with smaller figures.

While the age of these Barrier Canyon style pictographs are uncertain, it is definitely pre-Fremont because at other sites Fremont rock art has been superimposed over the earlier barrier canyon pictographs. Clay figures that resemble the rock art have been found near the site and unlike the rock art, they could be dated. These went back to approximately 6000 B.C. But no one knows for sure if the rock art was done at the same time.

Directions

Horseshoe Canyon is a separate little section of Canyonlands National Park in Utah. It is west and detached from The Maze, Needles and Island in the Sky sections of the park. To get to the site, you have to come in from the western side of the Green River. Either come south from Green River, Utah on Route 24 off of Exit 147 on I-70, 9 miles west of Green River, or go north from Hanksville, Utah on route 24. This is the same Route 24 that goes through Capitol Reef National Park, west of Hanksville.

Coming south from the intersection of I-70 and Route 24, you go approximately 23 miles. The dirt road turns left or east just south of the road from Goblin Valley State Park and is between mile marker 136 and 137.

Coming from Hanksville, go approximately 22 miles and turn right or east. If you miss the turn, turn around at the Goblin Valley Road and go back south until you come to the dirt road on your left. Be sure you gas up in either Green River or Hanksville because you won't be seeing any more gas stations in this area. Once on this dirt road heading east, go about 25 miles. Take the left turn or north for the Great Gallery. The right turn would take you down to the Hans Flat Ranger Station. Once on the road going north, you go about 5 miles and you will see a road to your right going east/southeast. Take it to the trailhead for the Great Gallery, about 2 miles. Just for your information, sometimes there are signs but at other times, they seem to be missing, probably taken by Basketmaker I people (or sign collectors). If it's raining, or the roads are wet, forget this trip; it's almost impassable.

When you're coming out of the Great Gallery and are going to Green River for the night, an alternate route back is to leave the trailhead and

go the 2 miles to the main road. If you turn right on this dirt road, it will take you into the town of Green River passing under Interstate 70.

Time of Year

It can get pretty hot down in the canyon in the summer, but if you leave early in the morning about 6-7 a.m. and take plenty of water, you can be out of the canyon by 1 or 2 p.m. This will give you time to see all of the sites and spend an hour or so at the Great Gallery. The rest of the year is excellent and even in the winter, you get some beautiful sunny days that are great for hiking, but don't forget the days are much shorter. In the winter you probably won't see many people so it's best to take some companions and at least 2 cars. You are a long way from anything. If you're in Green River and doing this trip toward the end of September, they will be having Melon Days. Don't leave without trying a watermelon or cantaloupe.

Type of Hike

This is definitely a "take a slower walker than you" hike. By the time you cross the trail a couple of times and wander around to see the different sites, the hike is approximately 6-1/2 to 7 miles round trip. The first part of the hike takes you down about 800 feet into the canyon. And the walking is easy on mostly slick rock. There are cairns, (conical heaps of stone built as a trail markers) set up so you don't wander off the trail. Once in the canyon, head south and the hike is pretty sandy up to the Great Gallery and back. Then of course, you have to climb back out. Take your time coming up and you won't have any problems.

The whole hike with stops at the panels will take about 6 hours. Some like to spend more time at the Great Gallery so you want to plan on spending most of the day for this hike. The sand will slow you up a little. Just a walking stick is all you need, as there is nothing real steep and be sure and take lots of water and lunch or a snack. This is more difficult than most of the trips in the book so be sure you are in shape, go prepared and take lots of water.

Photography

Serious photographers can take a tripod but if your walking stick converts to a monopod, it should be sufficient and save a lot of weight. Take lots of pictures, especially close ups so you will be able to see and study the detail later. The best time to see the Great Gallery is in the morning when the sun is shining on the rock art or later in the afternoon when they are all shaded.

Accommodations
Camping

You have a couple of choices here. You can camp at the trailhead that has a restroom (but no water) or stay over at the campground in Goblin Valley State Park. Goblin Valley has hot water showers, which are heated with solar panels. The only other place we've stayed with hot water showers is Homolovi State Park in Arizona. There may be others we don't know about because most of the time, we just do primitive camping. There's also a campground in Green River.

Motels

Both Green River and Hanksville have several motels; The Best Western River Terrace in Green River is nice and also has a good restaurant. It is right across the street from the John Wesley Powell Museum.

Crock-Pot Recipe

Old Guys Pork Chops with Prunes

 8 center-cut boneless loin pork chops - 1 inch thick
 1 tablespoon of olive oil
 1 tablespoon of butter
 2 medium onions, sliced thinly and chopped
 1 small cinnamon stick
 1/2 cup chick broth
 8-10 baby red potatoes
 1 cup pitted prunes
 3 tablespoons of honey
 1 lemon - juiced and chop up the rest

Salt and pepper chops and brown in oil and butter mixture. Remove. Add onions to the pan and saute for about five minutes. Add chicken broth, cinnamon stick, honey, lemon juice and rind to the crock-pot. Add onions and potatoes and mix the whole thing together. Put the pork chops on top and the prunes on top of the pork chops. Cook 10 hours on low or 5 hours on high.

When serving, spoon the hot juices over the chops and potatoes. You won't believe how good this is. This is the regular recipe. If you'd like, you can change the prunes to apricots.

Other Attractions

Goblin Valley State Park (435) 564-3633

Besides having a real nice campground, this park has thousands of

unusually shaped rocks of every size and description. Your imagination will get carried away trying to identify what some of these rocks resemble. One of them even looks like Mickey Mouse to me. The brochure at the park will give you more detail on the geology, erosion, etc that created these goblin type rock structures.

John Wesley Powell River History Museum (435) 564-3427
Green River, Utah

This museum also has a Visitors Center where you can get information on a number of attractions in the area. You might even hear about a few more rock art sites. Mostly it covers John Wesley Powell, the famous one-armed explorer of the Green and Colorado Rivers.

There are some other rock art sites in the area but since there has been some recent vandalism, we don't want to put directions in the book.

Capitol Reef National Park (435) 425-3791

If you're heading south towards Hanksville, Utah, after seeing the Great Gallery, it doesn't take long to go to Capitol Reef National Park, which is covered in the chapter on Fremont State Indian Park.

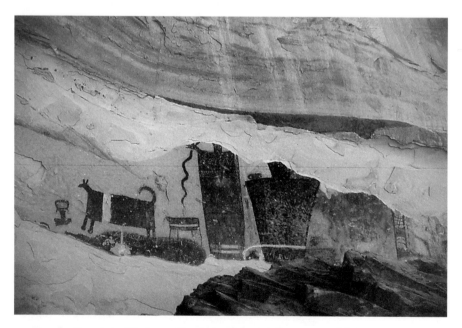

Temple Mountain Wash - notice large Fremont figures on right superimpoosed over Barrier Canyon Anthropomorth

Random Comments

One night after coming out of the Great Gallery, I camped north of Interstate 70, west of Route 24. There was a big thunderstorm with anvil tops just looming over the Great Gallery area with frequent lightening strikes. It was just getting dark and the sun was setting in the West reflecting off the beautiful red clouds and a couple of minutes later, the full moon came up in the East. I started to grab my camera to get some pictures but finally had to just sit there and watch it because there is no way you can capture this whole scene. Not far away, there were pictographs that were thousands of years old, and I imagine the Archaic Indians might have seen this same tableau.

In the morning while it was still dark, I opened my eyes and there was a big shadow moving across the tent caused by the full moon that hadn't set in the West. Half asleep, I couldn't figure out what could be out there. I zipped open the flap of the tent a little bit and there was a big cow looking at me from about 3 feet away.

If you live in the Southwest, it's always nice to go out in the desert, preferably near a rock art site on a full moon night and have a gala dinner. Take china, crystal, tablecloths, sterling and candelabras, the whole works. Cook whatever you like and sit around and watch the sunset and the moon come up. It's something you'll always remember.

25

Moab
Utah

Sego Canyon - Newspaper Rock - Dead Horse Point State Park

Moab is a great place to set up base camp for a few day trips. It is close to Arches National Park, Canyonlands National Park, Dead Horse State Park and the Manti-La Sal National Forest. The Colorado and Green Rivers flow through this area and it is a center for mountain biking, river rafting, 4 Wheel driving, hiking and backpacking. Butch Cassidy spent a lot of time in this part of the country.

They have a great Visitors Center (435) 259-8825 at the corners of Center and Main Streets where you can pick up brochures for just about anything you want to do. Be sure to pick up the brochure, "Moab Area Rock Art Auto Tour" with directions to several sites. This will get you started without a lot of walking and you will see some wonderful Archaic, Fremont and Anasazi petroglyphs and pictographs. This area is where the Anasazi and Fremont cultures overlapped and you will see great examples of each style of rock art. There's also a wonderful Ute rock art panel in Arches National Park.

In one day you can see the following sites and, except for the Court House Wash pictographs, you can almost drive up and take pictures from your car. The Court House Wash pictographs are Barrier Canyon style from the Archaic Period which was from approximately 6000 B.C. to 1000 B.C. From the parking area it is about a half mile hike over a wash and up to see the rock art. It will take you about an hour and a half and you should do this hike first thing in the morning before the sun hits the pictographs and washes them out making them almost impossible to photograph.

There's another great petroglyph site right on the golf course, south of town that you can drive up to. This panel is about 100 feet long and contains the famous Moab Man. There's been a little vandalism over the years, but it's still an excellent site. The Potash road sites are excellent and there are signs and pullouts as the road runs right along the western side of the Colorado River. The second stop indicated on the brochure will take you to the famous large bear with the small bow and arrow hunter right on its nose. It is probably better to do this site later in the

afternoon as many of the glyphs are easier to see in the shade. In the morning, there is a glare from the sun that reflects off the varnish making them more difficult to see. Be sure to look up high as these glyphs cover a lot of area. Down further, you will also be able to see dinosaur tracks.

The Kane Creek Boulevard takes you down the eastside of the Colorado River and contains several sites with the best being Moonflower Canyon and the Birthing Rock. The large Moonflower panel on the left, going out Kane Creek Boulevard has a fence around it. The Birthing Rock is the last site on the dirt road and is just down the slope sitting all by itself. It is one large rock with petroglyphs on all four sides. Keep your eye out for all the waterfowl and game that gather near the river.

Directions to all of these sites are in the Moab Area Rock Art Tour Brochure.

In Arches National Park, there is a historic Ute rock art site called the Wolf Ranch Panel. This is a very well done petroglyph of a horse and rider and it compares favorably to the great Ute pictograph panels at Ute Mountain Tribal Park. They are at the start of the trail to Delicate Arch which is a must see. You will recognize the arch as the same on the Utah License Plates. The hike is about 3 miles round-trip from the

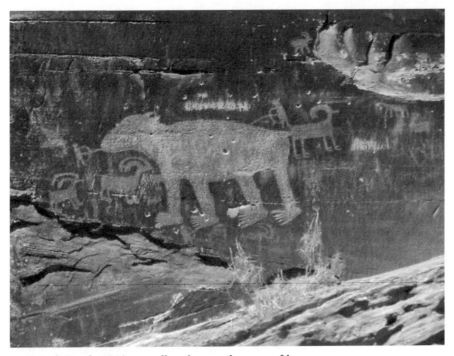

Potash Road - Notice small archer on the nose of bear

Wolf Ranch-Delicate Arch parking lot and has another one of those disagreeable suspension bridges, but it's only about 100 feet long. Ask the rangers about other rock art sites at the Visitors Center.

Directions

Moab is 32 miles south on Route 191 from the Crescent Junction Exit on Interstate 70. Crescent Junction is 85 miles west of Grand Junction, Colorado on Interstate 70 and 22 miles east of Green River on I-70. Moab is just over 50 miles north from Monticello on Route 191.

Time of Year

Again, spring and fall are the best time weather wise to visit the area but the summers not bad. Be sure to check ahead so you don't end up in Moab on one of the big Jeep Safari or Mountain Bike get-togethers which are usually over the three day holiday periods. Things can get pretty crowded. If you like music, a great time to go is September for the Moab Music Festival.

Type of Hike

The only hike of any distance is the lower Court House Wash hike. Which is about one mile round trip. There is some climbing and scrambling over rocks.

Photography

Since there isn't much hiking, be sure to take your tripod and illuminator with you. You can also get by with a point and shoot but a circular polarizer is always helpful depending upon the time of day. Be sure to hit the lower Court House Wash before the sun hits it.

Accommodations

Moab has over 30 motel/hotels including most of the major ones and this does not count the bed and breakfast condominium and ranches accommodations. You shouldn't have any trouble getting reservations during the week. For a big dinner, the Center Cafe, just east of the Visitors Center is excellent, as is the Sunset Grill. There are many good restaurants in town with about any kind of food you would like. You might want to eat and pick up a tee shirt at the Slickrock Cafe. The food is excellent and the shirt is a take off on the Hard Rock Cafe. Try the Uranium Burger.

There are many campgrounds in the Moab area. A favorite of many is north of Moab. Take 191 to the Junction of Route 313, the road to Dead Horse Point. Turn left on 313 towards Seven-Mile Canyon and go a couple of miles and you will find a camping area down on your left.

Right in town is the Canyonlands Camp Park which handles not only RV's but has many tent sites plus showers. The entrance is a little hard to find but it's at 555 South Main on your left going south.

Crock-Pot Recipe

Moab Meatloaf

- 2 lbs. lean hamburger
- 1 package Shillings meatloaf mix
- 1 egg
- 2 slices of bread crumbled
- 1 small onion chopped
- 1/2 green pepper chopped
- 2 stalks of celery sliced
- salt and pepper

Mix it all together and shape into a loaf. Put it in the crock-pot and cook for ten hours on low. Use a spatula to remove the loaf from the juices or just cut it in slices in the crock-pot.

Use ketchup on the meatloaf, cook some Idahoan Real Mashed Potatoes and put peas in the filter in the coffeemaker. Run 2 cups of water through the coffee maker without the decanter in place. This will keep the water in the filter basket and heat up the peas in no time. For the potatoes, run through a cup of water in the coffee maker, pour hot water in a bowl, add 1/2 cup of Idahoan Real Potatoes, wet and let stand one minute and fluff with a fork.

Other Attractions

While there are hundreds of rock art sites in this area, there are two places you can't miss. One is north, just off I-70 at Thompson Springs and is called Sego Canyon. The other is south on the way to Monticello. Turn right on Route 211 which goes to the Needles Section of Canyonlands National Park. Down this road is the famous Newspaper Rock. Both can be visited in an hour or so on your way to or from Moab but you might want to spend at least a day in the Needles Section of Canyonlands.

Sego Canyon

Head north out of Moab on Route 191 to Crescent Junction. Turn right on I-70 for 5 miles to the Thompson Exit 195. Go straight north about 1 mile until you reach the old town of Thompson. Go over the railroad tracks and continue north. About 3-1/2 miles north of the railroad tracks, you will see the rock art area on your left with a small parking area and restroom.

This site is Thompson Wash and is administered by the Bureau of Land Management (BLM). This is another outstanding site and arguably one of the best single sites in all of Utah if not the Southwest. It contains both petroglyphs and pictographs. There are several styles of rock art done over many thousands of years - from Archaic, to Fremont to Historic. The Barrier Canyon style pictographs are absolutely beautiful. More so, since they have been restored from the graffiti that had been put on them over the years. With the bug eyes and interior decorations, you will immediately see the similarity in style to the Great Gallery and the photograph of the Head of Sinbad in the color picture section.

Across the road and north a little is another great panel with a haunting group of large anthropomorphs, all in a row, almost like a family.

Newspaper Rock

This is the extremely large panel located in Indian Creek State Park on your way to the Needles Section of Canyonlands National Park. Fortunately, an overhang protects it and since the petroglyphs are on the nicely patinated surface, they stand out exceptionally well.

Head south out of Moab about 40 miles to Route 211 which heads west towards the Needles Entrance in Canyonlands. Approximately 12 miles on Route 211 brings you to Newspaper Rock. It is on your right after you wind down the hill. Most of the figures seem to be Anasazi but there's also Archaic, Fremont and Historic (Paiute or Ute) figures put there over a number of years as they traveled through Indian Creek Canyon. There are hundreds of figures that are well worth some study.

Across the road on the south side is a neat little campground for which there is no charge.

As long as you are in the Newspaper Rock area, you may want to continue west and see the Needles Section of Canyonlands National Park. This park is a favorite of many people who live in Utah.

It is remote and wild and is divided into three sections. Different roads access the other two sections (The Maze and Island in the Sky). Canyonlands is not as crowded as Zion or Bryce National Parks.

Dead Horse State Park

Also close to Moab are Dead Horse Point State Park and the Island in the Sky section of Canyonlands. From these areas you have great vistas of the canyons and the Green and Colorado Rivers. You can also see in the distance, the mountain ranges of the Henry's, The Abajos and The La Sals. In the spring, they are all snow covered and contrast beautifully

with the red rocks and the blue skies. It is impossible to get a picture of
all the views. Just enjoy it. Stop at the Visitors Center for trail maps and
orientation and then drive out to the point that overlooks Canyonlands
National Park. To get there, take Route 191 north to Highway 313 and
follow the signs to Dead Horse Point. It's about 35 miles from the center
of Moab.

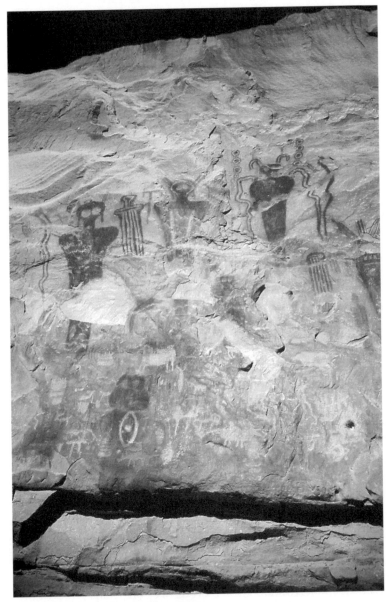

Sego Canyon Pictographs - Moab

Nine Mile Canyon
Utah

The College of Eastern Utah Prehistoric Museum

Nine Mile Canyon might contain the largest concentration of rock art in the world, with thousands of sites along the 40-mile long, extremely scenic canyon. Nine Mile Canyon received its name from the creek, which passes through it which was named Nine Mile Creek by the John Wesley Powell Expedition in 1869. The creek was at the nine-mile marker on that trip.

You can spend a whole day in the canyon and probably only see 10% of the rock art, which are mostly petroglyphs. You will see so many petroglyphs with so little hiking that it will amaze you. Be sure and take binoculars or a spotting scope on a tripod, which will help bring the higher rock art into view. You can even see much of the rock art without even getting out of your car.

While the canyon was probably inhabited for 10,000 years, all or most of the rock art is Fremont in style. They occupied the area from approximately A.D. 300 to A.D. 1300. Since the creek runs through the canyon, you will see lots of wildlife, especially birds.

There are many brochures and guides that you can pick up in Price and Wellington so that you can take a self-guided tour and not miss many of the major panels. Most of the guides set the mileage where the paved road ends or where the road to the canyon leaves Route 6 on the eastside of Wellington. By following the mileage with these directions, you can locate the panels without any trouble. Most of the panels are on the north or left- hand side of the road. Don't forget that odometers vary from car to car so be sure to look 1/10th of a mile or so on either side in case you can't find what you're looking for.

The rock art is well done and since it is on well-patinated surfaces of sandstone, it stands out very well. The typical Fremont anthropomorphs have trapezoidal bodies and horns on the heads. There are many mountain sheep and deer in the panels and some really interesting horned snakes. There are also, long necked sheep that look like giraffes, pregnant buffaloes and wild turkeys. Since crude wooden pens were found, it is thought that some of these turkeys might have been domesticated.

You will also see many ruins, granaries, and cists. The pithouses of the Fremont were similar to the older Anasazi pithouses. It was later that the Anasazi moved into the pueblos and the Mesa Verde type cliff dwellings.

Don't miss the famous hunting scene, which is actually a mile and a half up Cottonwood Canyon and sits right next to the road. Also, don't miss the Fremont Family which is about 2.3 miles further east from the road to Cottonwood Canyon. It is on the left-hand side and just above eye level behind some cottonwood trees. There's also a great snake on a spiral here.

You can easily spend 2 or 3 days or more here exploring around the main sites and up the various canyons that feed into Nine Mile. Every year, someone finds a new panel. Remember to be very careful when you walk because there are many ruins in the area. Also, there are some private ranches so be careful where you go. But, these are really friendly people and the fellow who runs Nutters Ranch stopped and helped me change a flat tire one-day.

Directions

From Route 6, turn north on Soldier Creek Road a couple of miles east of Wellington. There's a big sign there for Nine Mile Canyon. The road

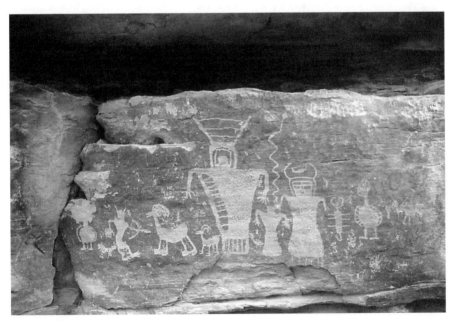

The Fremont Family - Nine Mile

goes north and at the Soldier Creek Coal Mine, the road turns to gravel and goes up over the summit towards Nine Mile. Just follow the directions on the necessary guides you pick up in Price or Wellington at any of the motels or the BLM office in Price.

Be sure you gas up and bring food as there are no gas stations or any other services once you leave Wellington. There is a large gas station on the northwest corner of Soldier Creek Road and Route 6, which opens early in the morning and has lots of food, gas, ice, etc.

Time of Year

Spring and fall are the best. Summer is okay but some days it can get up to 100 degrees. Along the creek in June, you can run into gnats, especially after sundown. The altitude is approximately 5,500 feet.

Type of Hikes

Most of the hikes are short - a few hundred feet or more and there is a little climbing if you want to get some close up pictures of some of the higher rock art. A few of the hikes can run a quarter of a mile or so but all are very easy.

Photography

Take all the photography equipment you have and lots of film. In one day, you can shoot at least 10 rolls of 36-exposure film with no trouble. To get whole panels and close ups of the most interesting petroglyphs, you will need a tripod and a zoom lens or telephoto for shooting some of the higher panels. This can save you a lot of climbing and also in some of the places, you can't figure out how they got up there to do the rock art anyway. You also need your illuminator to illuminate as well as shade some of the glyphs for better pictures.

Accommodations

There are many motels in Price and a few in Wellington. Just take your choice. If you're eating dinner out in Price, Fairlaino's is a good Italian restaurant or Ricardo's for Mexican food. If you're going to camp, you might as well head up to Nine Mile. In the summer, don't camp near the creek because the bugs will eat you alive at night. You can head up Cottonwood Canyon to the plateau and find a spot for primitive camping.

Crock-Pot Recipe

Nine Mile Norwegian Chicken Breasts

 1 tablespoon of olive oil

 4 boneless chicken breasts (remove skin and break breasts in half)

6-8 slices Jarlsberg cheese

8-ounce pack of sliced fresh mushrooms

1 can of condensed cream of chicken soup (leave condensed and don't mix with water)

2 ounces of water

1 package of Pepperidge Farm or Stovetop Chicken Stuffing Cubes

1/4 pound of butter

Rub the bottom and sides of the crock-pot with olive oil. Line the bottom with the 8 half chicken breasts. Put slices of cheese on top and overlap if needed. Put sliced mushrooms over cheese. Mix the condensed soup and the two ounces of water and spread over the whole thing. Spread the stuffing cubes over all of that and then drizzle the butter over the stuffing mix. Cook on low 8-10 hours.

Other Attractions

The College of Eastern Utah Prehistoric Museum (435) 637-5060

This museum is an absolute must stop. Try to stop before going up into Nine Mile Canyon if possible as you can pick up one of the best guides for Nine Mile by Mary and Jim Liddiard. It has different colored covers with a picture of bolo man.

The museum has two different sections. The prehistoric Indian section has a replica of a Fremont pithouse and large photos of the rock art in the area. It contains many artifacts and you can easily spend more than an hour in this section.

If staying in Price, try to reach Price by 3 p.m. so you have time to spend at the museum before going to Nine Mile the next morning.

The Dinosaur section includes skeletons from the dinosaur quarry about 30 miles away and several dinosaur tracks that were found in the coal mines of this district. There's also a skeleton of a mammoth that was discovered in Huntington Canyon and is approximately 11,000 years old.

Vernal

Utah

McConkie Ranch - McKee Springs - Cub Creek
Utah Field Museum of Natural History - Flaming Gorge National
Recreation Area - Dinosaur National Monument - Green River Trips

Vernal is located in northeast, Utah in the Uinta Basin, very close to the Wyoming and Colorado borders. It is 5,000 feet above sea level in the Ashley Valley about 10 or so miles from the Green River flowing out of Flaming Gorge to the north.

While it is famous for its geology and is the gateway to Dinosaur National Monument, it also contains some of the most spectacular Fremont rock art in Utah. Called the Classic Vernal Style, most are petroglyphs of very large commanding anthropomorphs, unlike the smaller figures not too far south in Nine Mile Canyon. They resemble more the great panel of Fremont figures just east of the Visitors Center in Capital Reef National Park. There are also some pictographs and some which are a combination of both petroglyphs and pictographs.

Most of the figures are highly decorated with necklaces, headdresses, earrings and belts. Some are holding shields and others seem to be holding only heads, probably from their enemies.

No one knows whether this rock art reflected ceremonial dress or everyday wear.

Vernal is famous for its Parcel Post Bank which even today is still used as a bank. After World War I it was cheaper to ship bricks by the mail (called parcel post), than it was to ship the bricks by railroad. The building is constructed solely of bricks that were sent through the mail, seven at a time to different addresses in Vernal from Salt Lake City. After this was discovered the post office department changed the rules so there would be no future mail order buildings.

McConkie Ranch

The largest rock art site is at McConkie Ranch in Dry Fork Canyon. It is listed in the Utah Historical Register. There are over 100 panels of rock art of outstanding quality. One of the best panels in the country is located there and is called "The Three Kings," and contains figures 7 to 9 feet

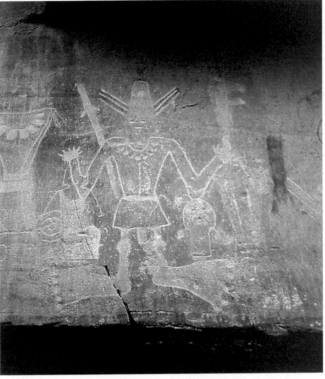

Big Foot or the Monkey Wrench Gang - McConkie Ranch

tall and still has red paint on what appears to be a pecked shield. Pictures of this panel have appeared in National Geographic.

There's also a very unusual petroglyph toward the end of the trail that looks much like a porcupine. You will see just one great panel after another. This site is on private land so check in at the little hut at the ranch and leave a donation to help maintain the trails. The owner of the ranch is Jean McConkie McKenzie and she and her family are nice enough to allow visitors to visit the site as well as protecting it from vandalism over the years.

McKee Springs

This is another wonderful site and you have probably seen pictures of it in magazines and on the covers of rock art books. It is in the northwest part of Dinosaur National Monument in Utah right off the road to Island Park. Not as large a site as McConkie Ranch but nonetheless, spectacular, it contains the same, large, broad-shouldered anthropomorphs. It sits just up a little hill looking down at McKee Springs Wash. This also is probably one of the best petroglyph panels in the world. There are other

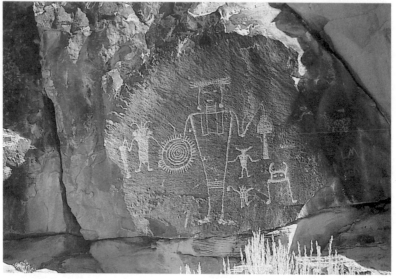

McKee Springs

sites in the wash. Just before you get to the main McKee Springs Site, coming from Vernal, look up high on your right to see an imposing anthropomorph panel.

Cub Creek

Right after you enter the Utah entrance to Dinosaur National Monument, called the Quarry Entrance, go about 50 yards to a box on the right hand side that contains pamphlets for the self guided road tour called the "Tour of the Tilted Rocks." This tour will take you to see several petroglyphs sites as well as other interesting rock formations and attractions. The rock art is quite different from the other two sites. Don't miss the large lizard petroglyphs.

Directions

McConkie Ranch

Start your mileage at the corner of Main Street and 500 West in the center of Vernal. Go north to 500 north which is Route 121 and head west. At about 6 miles, you hit 3500 West, turn right or north and go about 4 miles to McConkie Ranch. There is a parking area right by the small hut.

McKee Springs

Again go north from the corner of Main Street and 500 West. At 500 North, go east about 5 miles to where the road forks which is Brush Creek Road. Go about 4 miles and turn left on Island Park Road. Follow this northeast for about 4 miles and turn right or east. Go about 10-1/2

miles until you see the petroglyphs up a small hill to your left. If you happen to miss it and hit the Rainbow Park Turnoff, turn around and go back about 1-1/2 miles.

Cub Creek

Take U.S. 40 east out of Vernal to Jensen, Utah, about 13 miles. Turn left on route 149 towards Dinosaur Quarry. Go about 7 miles to the Quarry Entrance. That's where you will pick up the brochures for the car tour and they will be in that box just ahead on the right.

Time of Year

Vernal is in the northeastern Great Basin Desert at an altitude of over 5,000 feet and it can be cold in the winter. May through September are the best months especially if you're camping, but most people visit the area in June, July and August probably because they are bringing kids to see Dinosaur National Monument. At that time, the days can be hot but it always cools off at night. You get some thunderstorms in the summer and the road to McKee Springs can be impassable because of the clay areas. You'll probably have to wait at least 24 hours for it to harden up after the rain.

Type of Hikes

McConkie Ranch

To do the main part of McConkie takes about half a day. There is some climbing around and it is considered moderate. Once you climb up to the bottom of the sandstone cliffs, it is fairly level. "The Three Kings" site is in a separate area and will take you about an hour to see. When you get underneath it, you can climb up the rock on the left-hand side and with a telephoto lens, get some pretty good shots. There is no other way to get close to this panel unless you can climb like a monkey and get up from behind it, which is extremely dangerous.

After walking along the main site, you come to a sign that says "The End." You can either return or continue on beyond a couple of more points with lots more rock art. This will take you over to the porcupine panel and will take an extra couple of hours.

McKee Springs

This is almost a drive-up site. Park right below the panel and walk up the trail. You can go along the different panels and return. It takes about a half hour and is easy - not more than 1/4 mile to 1/2 mile round trip.

Cub Creek

These are all mostly drive-up sites also. But be sure to take your binoculars. The only real hike, would be a short uphill one so you can

get a picture of the large lizards at station 14 on the Tour of the Tilted Rocks.

Photography

At McConkie Ranch and McKee Springs, you can walk right up to the rock art so you don't need anything special except a wide angle lens would be nice to get these large panels all in one frame. At Cub Creek, you definitely need a telephoto and a tripod. Many of the petroglyphs are up high.

Accommodations

Camping

There are several campgrounds around Vernal, both private and public and quite a few in Dinosaur National Monument. There's also a lot of public land around for primitive camping.

Motels

On the western side of town, there is a Weston and a Super 8 and downtown, there are 2 Best Westerns, an Econo Lodge and a Rodeway Inn. On the eastern side of town is a nice little motel called the Split Mountain and is within walking distance of a restaurant.

Crock-Pot Recipes

Whatever Adjustable Chili (whatever you do, it's still good)

 1 or 2 lbs. of chili ground round steak or hamburger

 1 or 2 cans of tomatoes, stewed, crushed, whatever's on sale

 1 can of tomato paste

 1 or 2 bay leaves

 3 to 6 large cloves of garlic, chopped

 3 big onions, chopped coarsely

 3 big green peppers, chopped coarsely

 2 tablespoons of chili powder or more if you like it

 1 tablespoon of sugar

 1 teaspoon of cumin, and either basil, rosemary , oregano or all of them

 pinch or 2 or 3 of cayenne pepper, whatever you like

 salt and pepper

The night before, break up the hamburger or ground meat and brown. Pour off the grease. Put in the crock-pot. Saute the onions, peppers and garlic until soft. Put in crock-pot. Put all the rest of the stuff in the

crock-pot and mix it up. Do all this the night before and put this in your refrigerator until the morning. When you leave, hook up the crock-pot to the car inverter and cook this 4-6 hours on low as you travel to Vernal.

When done, add:

1 or 2 cans of kidney beans, pinto beans any kind of beans you like.

It only takes a little while to heat the beans up. This is even better the next day if you have any leftovers.

If you're making bread, corn bread goes great with this chili.

Other Attractions

The Utah Field Museum of Natural History State Park and Dinosaur Gardens (435) 789-3799

If you spend any time in Vernal, don't miss this museum which has prehistoric and historic Indian artifacts as well as dinosaur exhibits.

Flaming Gorge National Recreation Area (435) 784-3445

About 40 miles north of Vernal, and after a steep climb, you reach Flaming Gorge. The 90-mile Lake/Reservoir was created when a dam was built in 1963. While most of the lake is in Wyoming, the Utah portion has the best scenery. The boating, camping, fishing and the wildlife you see here are outstanding.

Dinosaur National Monument (435) 781-7700 (In Utah)

This Monument covers over 300 square miles and is located both in Utah and Colorado. The main Visitors Center and Monument Headquarters is in Colorado (970) 374-3000, about 40 miles east of Vernal. And the quarry site entrance is located about 20 miles from Vernal using the same directions as you take to Cub Creek.

Famous for the Jurassic Age Fossils contained in the gray sandstone; you can see bones of the dinosaurs that lived here 150 million years ago.

River Trips

If you're interested in going down the Green River, there are several companies that run 1-5 day raft trips.

Random Comments

If you want earrings made of sterling silver of the best petroglyphs in the area and throughout Utah, be sure to stop at the Randy Fulbright Studio in Vernal at 216 East Main Street. He also has many other beautiful items.

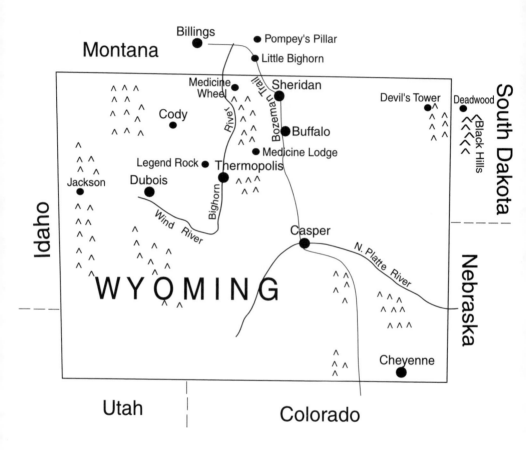

Legend Rock State Petroglyph Site
Wyoming

**Medicine Lodge State Archaelogical Site - Buffalo Bill Historical
Center Jackson Hole - Medicine Wheel - The Bozeman Trail
Little Big Horn National Monument, Montana
Pompey's Pillar, Lewis and Clark Trail - The Black Hills
Badlands National Park, South Dakota**

Legend Rock is one of the great petroglyph sites in the Big Horn Basin
of Wyoming. There are about 100 panels along a fairly good path that
runs the length of the lower part of a cliff that faces south. Across the
parking lot there are more panels up a little higher, along the base of
another cliff. This site has a gate so you need to get the key to this gate
in Thermopolis. To do this, you go to Hot Springs State Park (307)

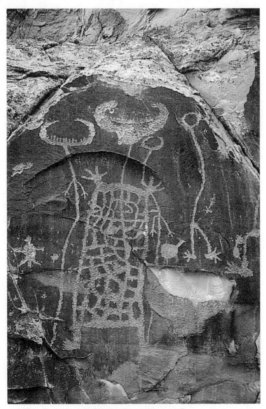

Dinwoody style anthropomorphs

864-2176, right in the city of Thermopolis and follow the signs to the State Bathhouse, (mineral baths). When you ask about Legend Rock, the people at the desk in the Bath House will give you a key to the locked gate at Legend Rock and a map on how to get there. If you're not going to be returning by way of Thermopolis, they will even give you a stamped return envelope to mail the key back to them. Be sure you close and lock the gate when you go in, and again when you come out of the site.

Most of this rock art is what they call the Dinwoody Style named for a site near Upper Dinwoody Lake near Dubois, Wyoming. Some of this rock art is 2,000 years old and covers the period from 1B.C. to about A.D.1200. Of special interest at this site are the bird petroglyphs, the Kokopelli petroglyphs, the unusual anthropomorphs and a very special rabbit petroglyph. The rabbit petroglyph looks very much like the rock art of southern New Mexico, which was the Jornada style of the Mogollon Culture. It is also very similar to the figures found on Mimbres pottery

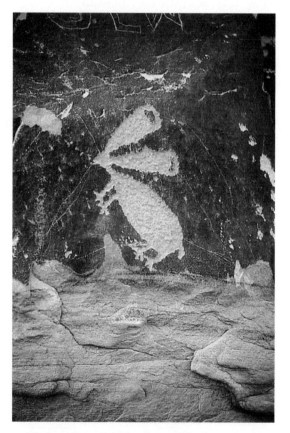

Mimbres Type Rabbit - Legend Rock

that has been found in the next valley over from the area of Three Rivers, New Mexico. The pottery dates roughly A.D. 800 to A.D.1000. The Mimbres was also a subculture of the Mogollon.

Directions

Legend Rock is about 26 miles northwest of Thermopolis on State Highway 120. Take route 120 towards Cody, Wyoming for 22 miles. You want to take the second Hamilton Dome turnoff. Turn left on this paved road and follow it for approximately 5-1/2 miles, where you reach a fork in the road. Keep right at the fork onto a gravel road and go approximately 2.3 miles to the second cattle guard. Cross the second cattle guard and immediately turn left. Keep left and this will take you down to the green gate that your key will unlock.

Continuing down the hill from the gate, you will come to a parking lot and the base of the cliff where the petroglyphs are located.

Time of Year

You could probably access this site most of the year but spring, summer and fall would probably be the best. But if it's rainy or the roads are wet, you could have a little problem with coming back up the hill to the gate from the site. It would be best to have a 4-Wheel Drive, but with dry roads, a regular auto could do it easily. If you really want to see Medicine Wheel, it's best to do this trip in July or August.

Type of Hike

This is a drive to site if you have the key to the gate and once you're there, it's basically easy meandering along a good trail at the base of the cliff. Total distance for both sites would be 1/2 to 3/4 of a mile.

You'll probably want to spend a half day at this site but if you wanted to race through, you could probably do it in 1-2 hours.

Photography

You don't need any special camera because you're right next to these petroglyphs for the most part. Any 28 to 50 mm. lenses are okay. To frame better, I would recommend use of the 28-200mm lens.

Accommodations

There's a Holiday Inn (307) 864-3131 right in Hot Springs State Park and it also has a restaurant called the Safari. There's also an excellent restaurant called The Legion at the Golf Course, which was formerly the American Legion Club. They even have tablecloths at dinner.

If you are camping, there is a campground just north of town or for primitive camping, there are several places on public lands off the beaten path, north of town.

Crock-Pot Recipe

Lloyds Baby Back Ribs

These are some of the best ribs you'll ever have. Fully cooked, and already with sauce on them, you can microwave them, heat them on the engine or do them in the crock-pot. For microwaving, just follow the instructions on the package. To do it in the crock-pot, just put them in for 4-6 hours on slow or 2-3 hours on high depending upon how you like them. Some people like the meat just falling off the bone.

It goes great with corn on the cob. If you're camping, either boil the corn and water on your propane stove or soak the unhusked ears in your cooler water and just put on the campfire coals, turning every so often for about 12-15 minutes. If you cook them on a grate, over the fire, it takes 20-25 minutes.

Other things to accompany them are Bush's Baked Beans, and some coleslaw from the deli section of the grocery store.

Other Attractions

There are so many great places to see in this part of the country that you can easily spend a week or more enjoying Wyoming and a little bit of southern Montana. This is also a great trip for western history buffs.

Medicine Lodge State Archaeological Site (307) 469-2234

In the Big Horn Basin, a few miles east of the Big Horn River and just a little east of Hyattville, Wyoming, sits the Medicine Lodge site, which has been occupied for over 10,000 years. Excavations have uncovered countless artifacts from many cultures that occupied this area. It is known mostly for its petroglyphs and pictographs, which run along a wide cliff just on the other side of Medicine Lodge Creek. They are very different from the Legend Rock petroglyphs and well worth the trip.

Cody, Wyoming

The Buffalo Bill Historical Center (307) 587-4771 contains four separate museums and probably has the best collection of western art and artifacts in the country. The four separate museums are:

Plains Indian Museum

Contains art and artifacts from the Sioux, Cheyenne, Arapaho, Crow, Blackfoot, Pawnee, Kiowa and other tribes.

The Buffalo Bill Museum

Contains almost everything about Buffalo Bill from his beginning to his end.

Cody Firearms Museum

Contains more than 4,000 firearms and covers their development from 1600 to the present.

Whitney Gallery of Western Art

Contains original works by George Catlin, Frederick Remington, and Charles Russell as well as many other famous artists.

To see everything takes almost a full day and even longer if you're really interested in one or more of the museums. There are many places to stay in Cody and the town is like entering the West as it was in the old days.

The entrance to Yellowstone National Park is only 50 miles east of Cody on an extremely scenic road.

Jackson Hole

If you're going west into Yellowstone National Park and then on down south towards Salt Lake City, you hit Jackson Hole and the town of Jackson, Wyoming. There are all kinds of accommodations in the town of Jackson and Teton Village at the Jackson Hole Ski Resort.

Everytime we go through Jackson Hole, it reminds me of the first time I went skiing there during a blizzard. I lost my new white skis in a deep snow after a fall on the steepest hill I was ever on. Don't take the tram to the top - it has nothing but double black diamond runs. The Mangy Moose at the bottom makes up for it through and has great music and appetizers.

Medicine Wheel

If you're going east after seeing Cody, cut back to Lovell, Wyoming to see the Medicine Wheel. The safest time to go is from about July 15 to August 15. The rest of the time, it could possibly be covered by snow since it's at 10,000 feet. If you want to take a short detour to the Big Horn Canyon National Recreation Area on your way to Medicine Wheel, stop just east of Lovell on Route 10 and 14A at the Big Horn Canyon Visitors Center. The Center is full of information, maps and friendly people.

Now, head east to climb over the Big Horn Mountains. Do this in good weather if possible because the view from Medicine Mountain is unbelievable. A little more than half way to Burgess Junction,

approximately 30 miles, turn off towards the Medicine Wheel parking lot. It is approximately a 3- mile round trip hike to see the Medicine Wheel. Take your time at this altitude. The wheel is about 80 feet in diameter with 28 spokes. Probably used to determine the summer and winter solstices and the equinoxes. There is a fence around it that usually has a lot of colored cloths hanging from it that have been put there by the Indians. It is a sacred place to the Plains Indians and they still go there to pray.

Sheridan and Buffalo Wyoming

The Bozeman Trail/Fort Phil Kearny, and Fetterman Battlefield

If you come by Medicine Wheel over Route 14A and Route 14, you arrive in the Powder River Basin near Sheridan and Buffalo, Wyoming, which is part of the old Bozeman Trail. John Bozeman charted this trail, in 1863 to go to the Montana Gold Fields of Virginia City and Bannack, from the Oregon Trail along the North Platte River in Wyoming just west of the Colorado border. Blackfoot Indians killed Bozeman at at the age of 32 in 1867, near the Yellowstone River in Montana.

The Bozeman Trail goes through the Powder River Basin, which were the best hunting grounds of the Indians. But the military broke the original treaty and built forts here to protect miners and pioneers going up to the gold fields and this led to the Indian Wars of 1864 to 1867.

The forts and the trail were abandoned in 1868 when the railroad came to Montana through Idaho. The section from Buffalo to Sheridan was the site of many conflicts with the Indians. It is especially interesting to anyone brought up hearing the names of Fort Phil Kearny, the Fetterman Massacre, the Wagon Box Fight, Portugee Phillips, the Little Piney, Old Mountain Man Jim Bridger, Red Cloud, Dull Knife, and Crazy Horse.

You can visit the site of Fort Phil Kearny (307) 684-7629 and obtain a map to locate the Fetterman Massacre and the Wagon Box Fight. Each has several plaques explaining what happened. In 1868, Red Cloud, the great Indian leader, burned the forts along the Bozeman Trail after they were abandoned. He never fought again and died in 1909 in South Dakota at the age of 87.

Little Bighorn Battlefield National Monument (406) 638-2621

Everyone is familiar with Custer's Last Stand in June of 1876 and the Plains Indians last efforts to maintain their way of life. The Battlefield is about 50 miles north of Sheridan, Wyoming, on Interstate 90 just over the border into Montana. At the Visitors Center, just below Custer's

*Tombstone where Custer's body was found.
After being buried here for one year, the
body was moved to West Point, New York*

Hill, you can buy a tape or CD for your car, with a Guidebook and maps, and follow the whole battle as you drive around. You can still see the indentations of the riflemen entrenchments or rifle pits where Reno and Benteen dug in, as well as many other sites you have heard about since you were kids. This is a minimum of a half day trip or longer.

<u>Pompey's Pillar (406) 875-2233 - Lewis and Clark Trail</u>
Go north and west from the Little Bighorn on Interstate 90 about 30 miles to Exit 484. Take the gravel road north about 15 miles to Pompey's Pillar. This is where William Clark carved his name on a rock on July 25, 1806. Pompey's Pillar is also mentioned in the Lewis and Clark's Journals and was a smoke-signaling site for the Indians for years before Lewis and Clark arrived. It was named after Charbonneau's and Sacagawea's son, "Little Pompy" and means Little Chief in Shoshone. This is the same Sacagawea whose likeness is on the new one dollar gold colored coin. There are also several early Indian petroglyphs at Pompey's Pillar which were also mentioned by Clark in his journal.

William Clark, of the Lewis and Clark Expedition carved his name at Pompey's Pillar - Yellowstone River - Montana

The Black Hills, Wyoming and South Dakota

If you have the time, the Black Hills Area is worth the visit. There is Devil's Tower National Monument, the Town of Deadwood, Mt. Rushmore National Monument, Crazy Horse Memorial, Jewel Cave National Monument, Wind Cave National Park, and Custer State Park with over a thousand free roaming buffalo.

Badlands National Park, South Dakota

This park is on the north end of the Pine Ridge Indian Reservation. As you go through this area where Black Elk and many of the famous Sioux lived, you might appreciate the following legend:

"Tell your people,
that since we were promised we should never be moved,
we have been moved five times."

Indian Chief, 1876

Random Comments

The following folk tale was going around when NASA was preparing for their moon shots. The story goes that Astronauts were training in the Badlands of South Dakota, just to the north of the Pine Ridge

Reservation. One day, a Sioux Elder and his son came across the space crew. The Elder, who spoke only Sioux, asked a question, which his son translated. "Who are these people in the baggy suits and helmets?" A member of the crew said that this land was very similar to the surface of the moon, where they were going. The Elder seemed really excited and asked if the baggy suited men would take a message to the moon with them. The NASA crew thought this was great, but had to tape his message because he couldn't write. He recorded it in the Sioux language and they were very interested in what he said. But the son refused to translate it.

They took the tape south to the Pine Ridge Reservation to see if someone else in the tribe would translate it for them. But these people only laughed. NASA finally called the official from the Denver Bureau of Indian Affairs who knew the Sioux language. The BIA agent said the message translated roughly as: "Be warned, they come to steal your land. Don't sign treaties."

Will Rogers said "I have Indian blood in me and I have just enough white blood for you to question my honesty."

Conclusion

I hope you enjoyed the book and you will be able to or have already visited some of the rock art sites as well as the other attractions. I also hope that you see some of the beautiful country, have some great meals, meet some new friends and enjoy yourself.

You may have noticed that the book is sprinkled with a few photographs that are not part of the site chapters and I have not given directions. I wanted to show you a few different styles of rock art and highlight a smattering of the literally thousands of rock art sites in the West and Southwest.

To conclude, I'd like to leave you with a quotation from George Catlin (1796-1872). He was the father of ethnology in America. He met and lived with some 48 tribes in the United States from 1830-1836. This was before they were exposed to any white people, living as they probably had for hundreds of years. If he had known about or been interested in rock art, or there had been another person like Catlin in the Southwest, there is no telling how much it would have helped us interpret rock art today.

"I love a people who have always made me welcome to the best they had...who are honest without laws, who have no jails and no poor-house...who never take the name of God in vain...who worship God without a Bible, and I believe that God loves them also...who are free from religious animosities...who have never raised a hand against me, or stolen my property, where there was no law to punish either...who never fought a battle with white men except on their own ground...and, oh! how I love a people who don't live for the love of money."

George Catlin
from
Last Rambles Amongst the Indians of the Rocky Mountains and the Andes
London, 1868, pp. 354-355.

Appendix 1

Rock Art Site Etiquette

All groups and individuals who visit rock art sites need to realize that any visit may endanger the rock art. URARA, other research organizations, researchers and enthusiasts must recognize that the act of visiting a site can be destructive to the site.

This is much more than "don't touch the rock art." A rock art site is not just the glyphs on the rocks; it includes the glyphs, the rocks and cliffs, and the surrounding area. To start to understand the rock art you have to consider the whole site. For researchers and individuals to appreciate a site the glyphs and the surroundings should be as they were when the panel was made, or as close as possible.

Clay Johnson wrote the following list after many years of studying rock art and rock art sites:

Minimize the numbers of vehicles going to the site. Stay on existing roads. Do not "pioneer" vehicle trails or parking areas.

Do not camp or build fires within 1/4 mile of rock art.

Do not disturb lithics, firepits, rock arrangements or other artifacts and site features.

At rock art sites stay on trails where they exist. Do not disturb rocks, vegetation, or microbiotic soil crusts.

Do not climb or disturb rocks in chimneys, slots, or gaps in the rock cliffs at rock art sites.

Do not hike or climb above rock art panels.

Do not touch in any way the rock art or the cliffs within 100 feet of the rock art.

Where possible stay at least 10 feet from the rock art.

Do not attempt to remove graffiti, chalking, lichen, or bird droppings from rock art.

Do not apply any substance including liquid, powder, plastic, cloth, paper, or even a strong floodlight, to or over rock art.

Do not allow pets, children, or careless associates to behave improperly around the rock art.

Follow the rules of the site landowner or public land manager where they are more restrictive than above.

If some of the above seems overly restrictive due to site location, rock type, salvage status or other factors, remember the essence of etiquette and ethics is to behave better than strictly necessary.

Use binoculars to study, and telephoto lens or freehand sketches to record panels and panel details.

Study the panel as an integral part of the site.

Be constantly aware of the effects of your actions and others at rock art sites. Make your behavior a model.

Speak out when needed to prevent damage to rock art.

Take time to appreciate the beauty of the site surrounding the rock art. Look at the mountains and canyons, the waters, the plants, the wildlife. Listen to the native sounds. Feel the sun and wind. Sit still until the birds come out and the lizards climb your leg.

Take time to appreciate the intricacy and detail of each rock art panel itself rather than trying to see the maximum number of panels. Don't interpret the panel, just sit quietly and watch. Give the rocks time to speak to you.

Reprinted with permission from Clay Johnson

Archaeological Site Etiquette

Archaeological sites such as cliff dwellings, pithouses, pueblos and other ruins have been around for at least 800 years and some for thousands of years and are very fragile.

In addition to what is covered under Rock Art Site Etiquette, please observe the following rules:

1) Do not sit, stand or climb on any walls

2) Do not pick up rocks, as they could have been part of the original structure.

3) If you pick up a shard to look at it, replace it exactly where you found it.

4) Do not take anything from the site, including all artifacts or plant material.

5) Follow rules for fires and camping as under Rock Art Etiquette. Stay 1/4 of a mile from the ruins.

6) If you see anyone damaging rock art, either intentionally or unintentionally, or removing artifacts, please report it to the nearest authority. It is against the law.

Appendix 2

Rock Art Organizations

American Rock Art Research Association (ARARA)
Arizona State Museum
University of Arizona
Tucson, Arizona 85721-0026
(520) 621-3999

Bay Area Rock Art Association (BARARA)
1959 Webster Street
San Francisco, California 94115

National Pictographic Society (NPS)
221 Gowen Place
Winslow, Washington 98110

Rock Art 2000
San Diego Museum of Man
1350 El Prago
San Diego, California 92101-1616

The Rock Art Foundation, Inc.
4861 Fredericksburg Road
San Antonio, Texas 78229-3627

Southern Nevada Rock Art Enthusiasts (SNRAE)
sunray@vegas.infi.net or call (702) 897-7878

Utah Rock Art Research Association (URARA)
P.O. Box 511324
Salt Lake City, Utah 84151-1324

Glossary
A Few Common
Rock Art Terms

Abstract	In rock art, a style containing wavy lines and/or dots going every which way and can't be identified as being anything in particular.
Anthropomorph	A human form or figure found in rock art sometimes stylized. This human figure could also portray a spirit or a god.
Desert varnish	The dark streaks on canyon walls and the dark coverings on usually sandstone rocks or patina caused by windblown clay dust particles that adhere to the rock and then are fused to the rock and colored by water containing iron and manganese oxides.
Kokopelli	An anthropomorph with a hump back and playing a flute. Appears all over the Southwest in different styles.
Panel	A group of petroglyphs or pictographs, sometimes both, appearing on one section of rock.
Patina	See desert varnish
Petroglyph	Rock art done by pecking, abrading or carving.
Pictograph	Rock art done by painting.
Polychrome	Is a pictograph that contains multiple colors.
Quadruped	An animal with four legs that cannot be definitely identified.
Talus Slope	Rocks and debris below a wall or a cliff face which are narrow at the top and wide at the bottom. For some reason, the rock art also seems to be at the top of the talus slope which takes a steep climb.
Zoomorph	An animal form or figure found in rock art. It could also portray animal like figures to spirits or gods.

Bibliography

Castleton, Kenneth B. M.D. *Petroglyphs and Pictographs of Utah. Volume One: The East and Northeast.* Utah Museum of Natural History, Salt Lake City,1984.

Castleton, Kenneth B. M.D. *Petroglyphs and Pictographs of Utah Volume Two: The South, Central, West and Northwest.* Utah Museum of Natural History, Salt Lake City, 1987.

Catlin, George. *Letters and Notes of the Manners, Customs, and Condition of the North American Indians.* Two Volumes, Second Edition, Wiley and Putnam, New York, 1842.

Cole, Sally J. *Legacy on Stone: Rock Art of the Colorado Plateau and Four Corners Region.* Johnson Books, Boulder, 1990.

Grant, Campbell. *Rock Art of the American Indian.* Thomas & Crowell, New York, 1967.

Grant, Campbell. *Canyon de Chelly: Its People and Rock Art.* University of Arizona Press, Tucson, 1978.

Grant, Campbell and Baird, James W. and Pringle, J. Kenneth. *Rock Drawings of the Coso Range.* Maturango Museum, China Lake, 1968.

Heizer, Robert F. and Baumhoff, Martin A. *Prehistoric Rock Art of Nevada and Eastern California.* University of California Press, Berkeley, 1962.

Hinchman, Sandra. *Hiking the Southwest's Canyon Country.* The Mountaineers, Seattle, 1990.

Martineau, LaVan. *The Rocks Begin to Speak.* KC Publications, Las Vegas, 1973.

McCreery, Patricia and Malotki, Ekkehart . *Tapamveni: The Rock Art Galleries of Petrified Forest and Beyond.* Petrified Forest Museum Associates, Petrified Forest, 1994.

Patterson, Alex. *A Field Guide to Rock Art Symbols of the Greater Southwest.* Johnson Books, Boulder, 1992.

Schaafsma, Polly. *Indian Rock Art of the Southwest.* School of American Research, Santa Fe and University of New Mexico Press, Albuquerque, 1980.

Schaafsma, Polly. *The Rock Art of Utah*. University of Utah Press, Salt Lake City, 1994.

Schaafsma, Polly. *Rock Art in New Mexico*. Museum of New Mexico Press, 1992.

Slifer, Dennis and Duffield, James. *Kokopelli: Flute Player Images in Rock Art*. Ancient City Press, Santa Fe, 1994.

Slifer, Dennis. *Signs of Life: Rock Art of the Upper Rio Grande*. Ancient City Press, Santa Fe, 1998.

Waters, Frank. *Book of the Hopi*. Penguin Books, 1963.

Index

To purchase additional copies of **Rock Art and Ruins for Beginners and Old Guys,** visit your favorite Bookstore, visit us on the Internet at *www.rockartguide.com,* email us at *oldguy@infowest.com*, or use this

Order Form

Fax orders: 1-866-281-3400, Listen, Wait for Beep, Press *9. Send form.

Telephone orders: Call Toll Free 1(866) 281-3400. Have your credit card ready.

E mail orders: *oldguy@infowest.com*

Postal orders: Albert B. Scholl Jr., P. O. Box 910526, St. George, Utah 84791-0526

Ship to:

Name: _____

Address: _____

City: _____ State: _____ Zip Code: _____

Telephone: _____

E-mail address: _____

Sales tax: Please add 6.25% for orders shipped to Utah.

Quantity	Item	Price	Total
	Rock Art and Ruins for Beginners and Old Guys	$19.95 US Funds	
		Subtotal	
		Sales Tax Utah residents add 6.25% ($1.25 per book)	
		Shipping	
		Total in US Funds	

Shipping:

US: $4.50 for the first book and $2.00 for each additional book.

International: $12.00 for the first book and $6.00 for each additional

Payment: ___ Check ___ Credit Card __ Visa __ Mastercard

Card number: _____

Name on card: _____ Exp. date:___ / ___

Signature Required month year

Please visit us on the Internet: *http://www.rockartguide.com*

To purchase additional copies of **Rock Art and Ruins for Beginners and Old Guys,** visit your favorite Bookstore, visit us on the Internet at *www.rockartguide.com,* email us at *oldguy@infowest.com*, or use this

Order Form

Fax orders: 1-866-281-3400, Listen, Wait for Beep, Press *9. Send form.

Telephone orders: Call Toll Free 1(866) 281-3400. Have your credit card ready.

E mail orders: *oldguy@infowest.com*

Postal orders: Albert B. Scholl Jr., P. O. Box 910526, St. George, Utah 84791-0526

Ship to:

Name: _____

Address: _____

City: _____ State: _____ Zip Code: _____

Telephone: _____

E-mail address: _____

Sales tax: Please add 6.25% for orders shipped to Utah.

Quantity	Item	Price	Total
	Rock Art and Ruins for Beginners and Old Guys	$19.95 US Funds	
		Subtotal	
		Sales Tax Utah residents add 6.25% ($1.25 per book)	
		Shipping	
		Total in US Funds	

Shipping:

US: $4.50 for the first book and $2.00 for each additional book.

International: $12.00 for the first book and $6.00 for each additional

Payment: ___ Check ___ Credit Card __ Visa __ Mastercard

Card number: _____

Name on card: _____ Exp. date:___ / ____

Signature Required month year

Please visit us on the Internet: *http://www.rockartguide.com*